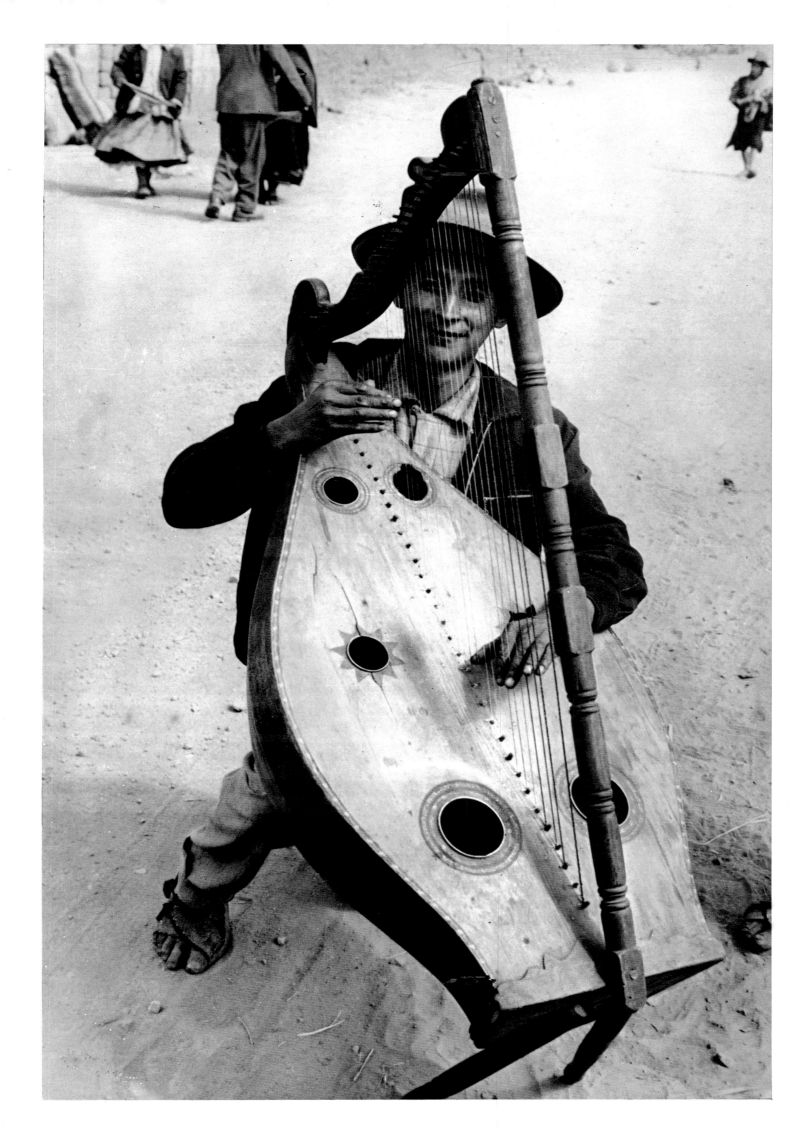

The arts and man

the ARTS

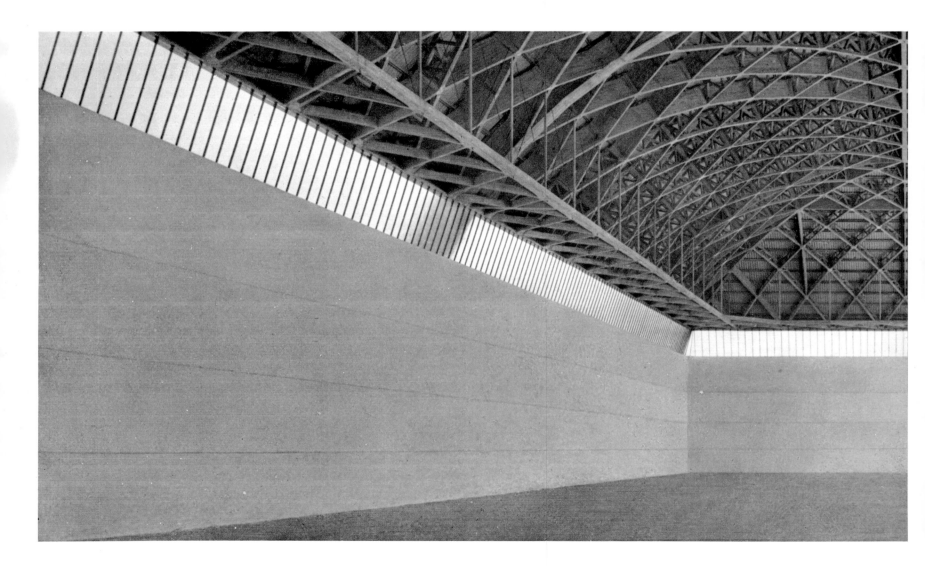

and MAN

A world view of the role and functions of the arts in society

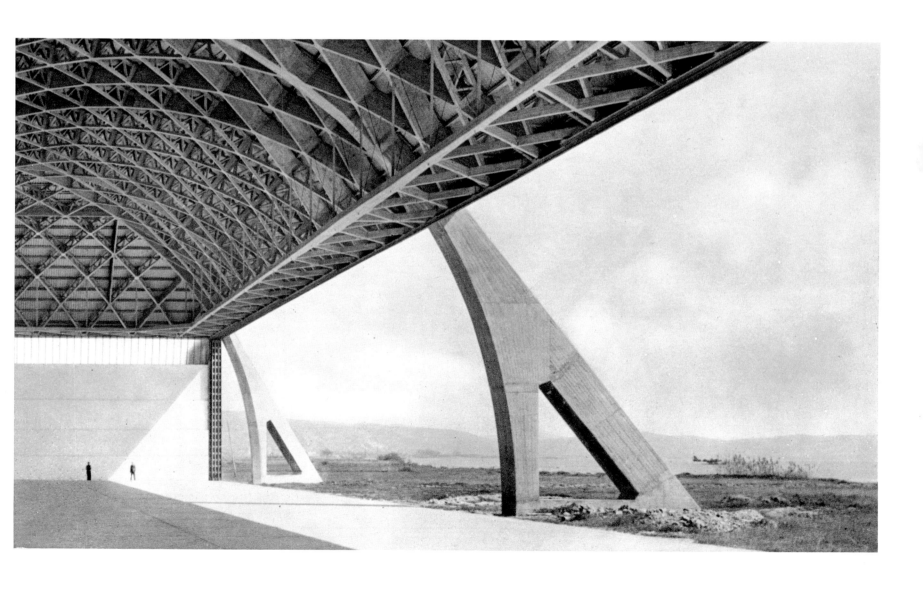

Englewood Cliffs, N.J.: Prentice-Hall Inc.
Paris: Unesco
1969

First published in 1969
by U N E S C O
of Place de Fontenoy
in the City of Paris, France.
Printed by Imprimeries de Bobigny, Paris

Book design and jacket by Rolf Ibach

LC-75-87973
SBN-13-046813-4

Printed in France
SHC.68/D.37/A

Preface

The Universal Declaration of Human Rights, affirmed for the peoples of the world by the Charter of the United Nations, states that: 'Everyone has the right freely to participate in the cultural life of the community, to enjoy the arts. . . .' The fundamental need for personal involvement in the aesthetic level of human existence is the underlying principle on which this right has been based; and it is to this end that Unesco directs the attention of its world-wide public to the significant contribution made by the arts to every facet of man's life.

This book attempts, through the use of words and pictures, to analyse and describe the ways in which the arts, in their various aspects and manifestations, embody the human spirit and serve the human objective. At the same time, this work is concerned with making a comprehensible description of the many functions of the arts, explaining these functions in terms of the art disciplines, professions, traditions and art forms which have evolved throughout man's history. Lesser-known and understood forms and areas of art, such as industrial design and the new art products of the mass communication media, are discussed along with their longer-established counterparts in the light of the contribution they make to the daily lives of all members of the human community.

Some of the world's most respected contemporary authorities speak in these pages about those areas of the arts with which they are most intimately connected. What they say varies as widely as they themselves do as individuals and as the national and cultural backgrounds from which they come. The opinions they express are, of course, their own and do not necessarily reflect the views of Unesco. Each of these texts was written expressly for this publication. The chapters prepared by Herbert Read and André Maurois were among the last things they wrote in their enormously productive lives.

In the few introductory pages that follow the reader first has a glimpse of some of the many ways in which the aesthetic impinges upon both individual and social consciousness.

Opening the series of more specific discussions, Herbert Read, the distinguished English art historian and critic,

envisages art and society as inseparable concepts, putting forward the view that contemporary civilization is in danger of becoming 'aesthetically impotent' due to 'alienation' or the progressive divorce of human faculties from natural processes, scientific rationalism which tends to destroy the mysteries of holiness and beauty, and growing mass systematization which is inimical to art, the arts being the products of individuals. The author here offers one solution: 'education through art', which recognizes that art is a binding force in society, and that the absence of this element has fatal consequences for civilization.

The next view is presented by Kamaladevi Chattopadhyay who once worked with Gandhi and Nehru to develop India's great indigenous arts. Here she speaks of the crafts as the creation of ordinary people, part of the flow of events of the common life. She sees no real dividing line between the so-called 'fine arts' and the crafts, both being expressions of the human spirit in material form. Drawing upon the ancient traditions of the East, she points out that the craftsman, like any other artist, is engaged in a total operation involving the emotions, the mind and the body, and that he is seeking rhythm, form and harmony for life through art.

Pier Luigi Nervi, the noted Italian architect-engineer, speaks of the architect and his role in contemporary society, and he calls for a return from what he describes as architectural discussion and theory, which has little to do with the physical world and human need, to the appropriate and responsible job of the architect: the art and science of constructing buildings which are adequate in terms of durability, beauty and economy.

The Argentine poet and director of his national institute of industrial design, Basilio Uribe, expresses his views about the twentieth-century discipline of industrial design which he sees as having a structural role to play in the establishment of necessary relationships among the human environments: technical, economic, aesthetic, cultural.

Richard Buckminster Fuller, the American who refuses to be put into any professional category and prefers to be known as a 'comprehensivist in an age of specialists', believes that

all human beings are born 'artist-scientist-inventors' but that life progressively squelches the individual's innate drives and capabilities. He calls for a new kind of education and social structure which encourages the development of man's intuitive-inventive-aesthetic powers.

An author read and loved by a public far beyond his native France, André Maurois, points to the great contribution made by the literary arts to the life of man, and demonstrates how the great authors, poets and playwrights have provided substance for the imagination, order for the mind and a model for life.

William Melnitz, who worked in the great theatrical movements of Berlin in the twenties, sees the theatre as a synthesis of many arts and skills which had their origins in the rituals, myths, religions, education and entertainment of all peoples of the earth.

In the short space of half a century the cinema has developed from a simple form of entertainment particularly marked by its technical novelty to an art form which, with television, has become an integral part of our culture. This evolution is presented in a concentrated picture by Grigory Kozintsev, the Soviet film maker and director who has both participated in it and notably influenced its course.

The musician, composer, educator, Yehudi Menuhin, who makes his home in Europe as well as in the United States of America, speaks of music and shows that it is an art intimately connected with the very physiological functions of man, relating the musical elements of rhythm, tension, counterpoint, with man's heartbeat, breathing, blood pressure, etc. Thus he illustrates his thesis that music penetrates directly to the subconscious mind, and becomes immediate revelation requiring little interpretive effort. Music begins where words end, it is devotion to the timeless and the infinite.

Accompanying and supporting these thoughts and comments on the arts is the continuing parade of images, from Africa, the Americas, Asia, Europe, the Middle East, all parts of the world, which make visible the creative artist at work in his studio, the performing artist and the artisan at their craft, as well as the public, which becomes the art audience, consumer, amateur and patron of the arts.

Contents

Introduction

Art as discovery
 intensification
 expression
 record
 communication
 interpretation
 reformation
 enhancement
 order
 integration

Man views his place along the path of human activity with mixed feelings of pride and doubt. There is the promise of a tomorrow liberated through human imagination yet threatened by alienation, disintegration. This point at which man finds himself today is a point of departure. In man's future home among the stars and galaxies, his measurements, his horizon, his entire perspective will be altered. The universal environment will bring changes in man's relation to earth and man's relation to man. Human communication will become ever more complex and difficult. Social structures will change and all of the established human institutions will be altered in some way. Because man's aesthetic nature is a reflection, a manifestation of all of the other aspects of his personality, it is especially important that an examination now be made of those ways in which the arts function in the life of man and contribute to his well-being and continuing evolution.

Every child, every man, every culture gives form to its feelings and ideas through art. Art is the essence of that which is human; it is the embodiment of the human experience and goal. A civilization gives evidence of the will and participation of the individual, and art functions in a society much as it functions in the life of an individual; it becomes the emblem of a group just as it is the mark of a single man. Art can and should be an experience shared by all men every day of their lives; this does not mean that all men must be painters, architects, authors, composers, nor does it mean that they must spend all of their days in museums, their evenings in theatres and concert halls. Rather it means that man's innate sensitivities to the arts must be allowed to develop and, by early encouragement and education, must be given opportunity for growth so that the whole man can emerge.

The art experience embraces all forms of involvement within the domain of the aesthetic: the production of works of art on the part of the professional artist, the craftsman, the layman, the child, as well as the active appreciation of art on the part of the universal art audience which looks at, listens to, reads and uses the work of art with personal interest, understanding and love. The ultimate dimension of the art experience is that which enables each man to become aware of the aesthetic of his own environment, which brings to his attention the endless variety of forms and colours, the richness of textures, the force, rhythm and sound of human interaction, the poetry of nature and man.

Art functions in man's life in many nameless ways. In any analysis of the role of art in human existence, one can only attempt to describe those qualities of the art experience and object that appear, at a specific moment in time and space, to be of particular value to man. Each individual, each civilization, each age, will arrive at different points of emphasis according to its own need and history. Other men in other times and places have and will continue to describe the functions of art differently, for art, like man, is ever changing, ever evolving, ever new; but let us now, speaking out for our own frame of reference, consider those ways in which art functions in the life of man.

Art as discovery

To be alive is to be aware, active, involved. Art increases our state of aliveness by expanding and deepening our state of awareness. Art discovers, heightens and refines life experiences. Art serves to clarify our feelings. Until we express emotions we do not know what they are. The artist's vision, both analytic and panoramic, makes perceptible at once the parts and the whole. Through art, man can discover the fundamental forms and processes of his universe and can give them new energy and function. What we call 'creativity' in human beings may, in fact, be human discovery of a cosmic truth. Perception in and through art includes not only that finding the artist makes about his work, but the discovery the work makes about him. The work of art sums up and reflects the discoveries the artist has made about his environment and about himself.

1

3

4

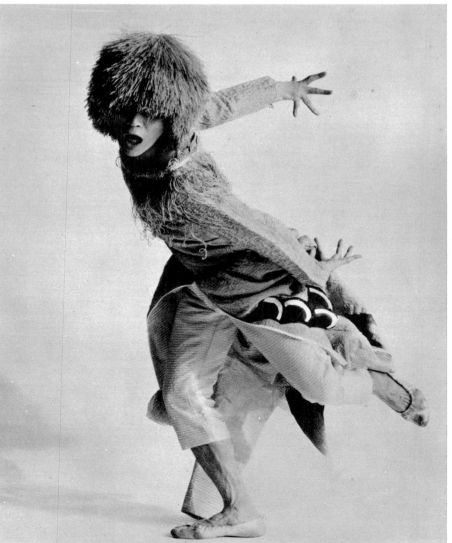

5

Art as intensification

The life experience of man is a concert of involvements. Art intensifies man's involvement with life; it gives evidence and symbol of human energy; it vivifies human experience. Art deals with the emotional realm of man; it supplies stimulus for his capacity to feel and react, it expands his area of sentiment. The art experience sharpens and rewards the senses, and thus it develops all human faculties. Art is among the human disciplines that allow for and depend upon the intense commitment of man to constructive action. The role of art in education has great meaning here; the art experience which involves the feelings of children and men encourages incentive and allows for commitment. Art makes leisure time and all time a thing of interest and beauty. The challenge of art is to enflame and intensify in order to evoke deep emotional and intellectual responses, and unite them with those responses felt by human beings in their relationships of man to nature and man to man.

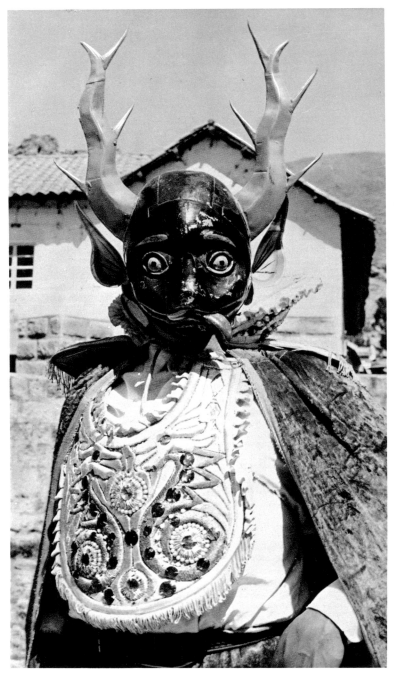

6

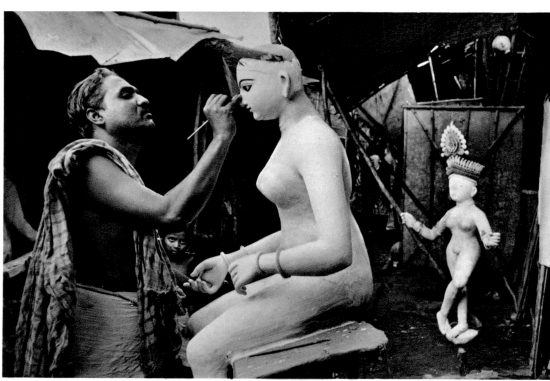

8

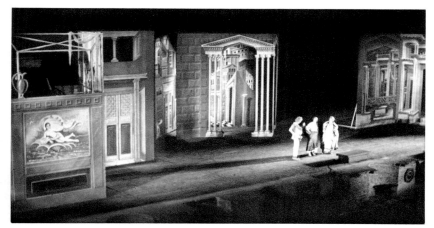

9

Art as expression

Man's life differs from that of most other organisms in that individualization has become more important to him than strict conformity to type. Individual capacity, viewpoint, choice and action are qualities that make us human. Self-expression, as manifested in art, distinguishes individuals as well as cultures. The artist's product makes the man unique as much as his thumb-print and signature single him out. Art gives voice to the self.

Never far from the pressures of conformity is the human need for fanciful escape, release from the self-inflicted tensions of daily life. We need only to look at the long and fascinating history of games to find evidence of this. Play assumes an all-important role in the world of the child; in the adult's life, the need for play persists, but the quality of play, the complexity of the games change and increase as the individual matures. The arts offer man an opportunity for play, another form of self-expression.

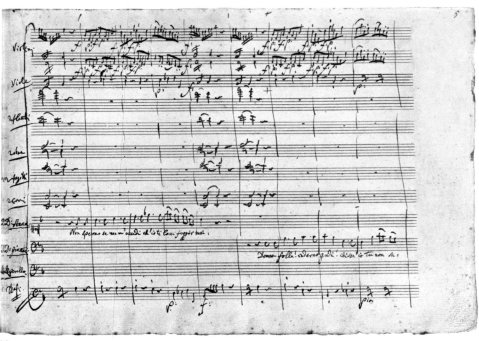

10

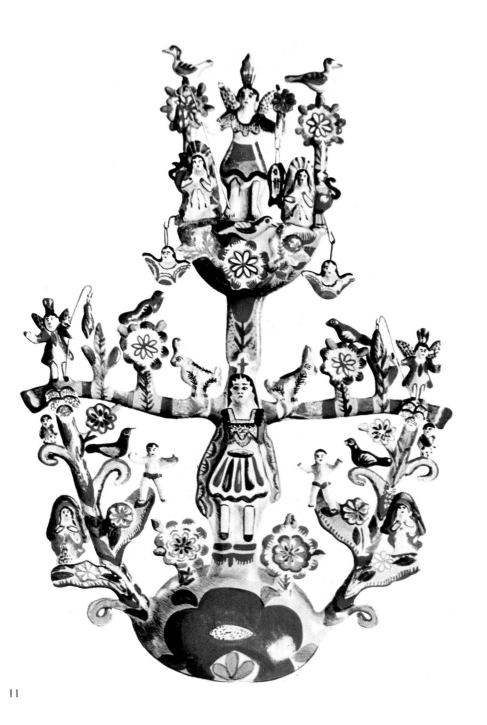

11

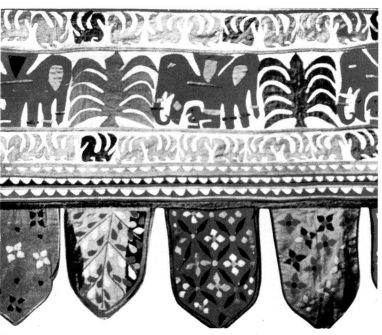

12

13

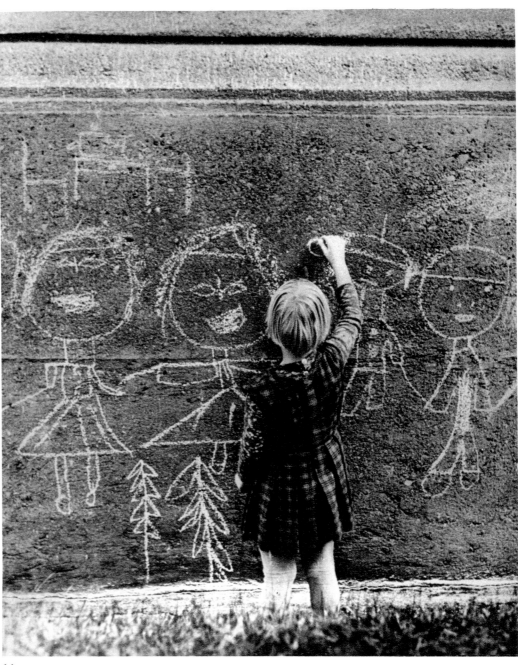

14

Art as record

A distinguishing feature of the human spirit is its need to record personal and group experience. There is no more accurate description of a certain time and place than is given to us by the artifacts we find from the remains of that civilization. When we trace the history of man up to current times we can find recorded and reflected in the arts of each period, the life and death, the beliefs and fears, the joys and sufferings of human beings. The work of art stands as summary and chronicle of the human experience. Man has need of leaving a record of this life experience, but many children and adults are frustrated in their attempts to record their observations in the complicated signs and symbols of a highly technical society. Record making in the natural and personal symbols of art enables all men, all children, to record the uniqueness and significance of their own lives.

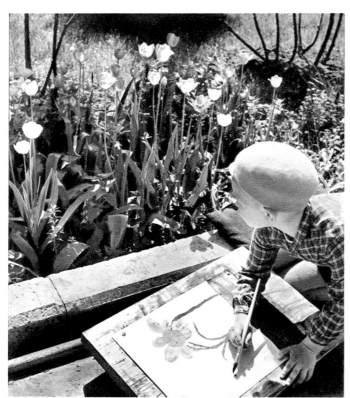

15

16

17

Art as communication

One of the greatest of human gifts is the highly developed capacity to communicate; it is through the act of communication that men can relate themselves to other men near and far in time and space. For the purpose of communication men have invented symbols and this symbol-making function is one of man's primary activities. A whole system of communication sprang from the earliest drawings and paintings. The alphabet and all written language are outgrowths of these earliest recorded images. The visual and musical arts offer man a means of communication that goes even beyond the scope of words. The painter, the composer have invented symbols that can be passed from man to man so that concepts and feelings can be conveyed directly. The photographer and the film maker, too, communicate in immediate terms. Art as a tool, as a medium of communication, has many implications for the life and education of man. In these times when the development, even the survival, of man depends upon full and successful intercultural communication we cannot afford to overlook or ignore any area or form of communication. The aesthetic level of human interaction is one which is indispensable in the life of all persons.

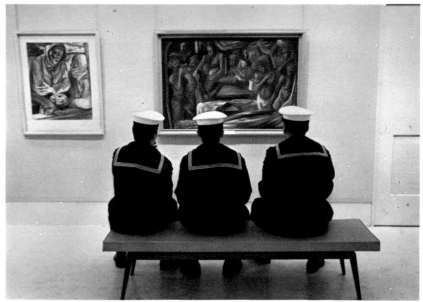

18

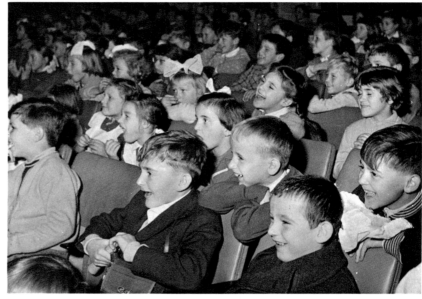

19

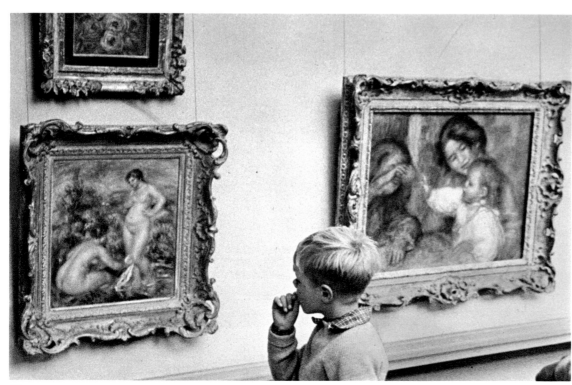

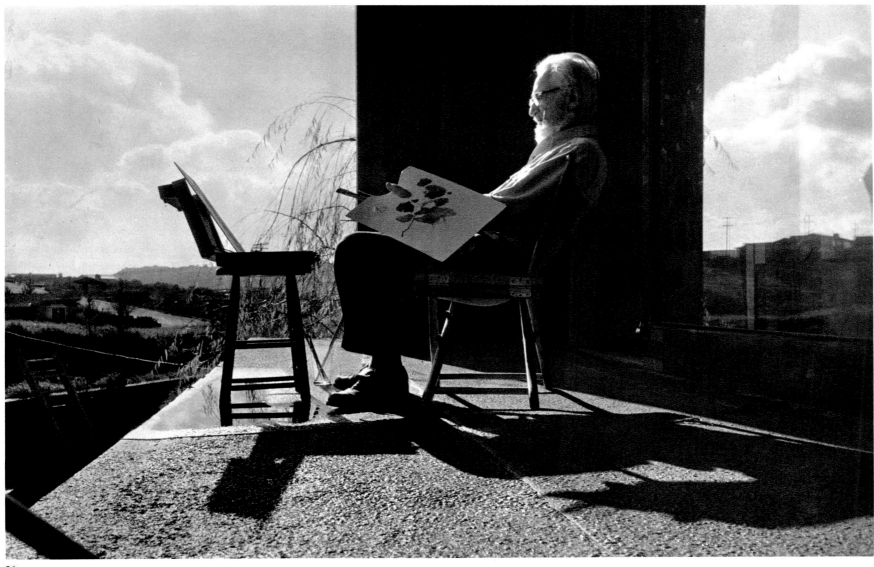

21

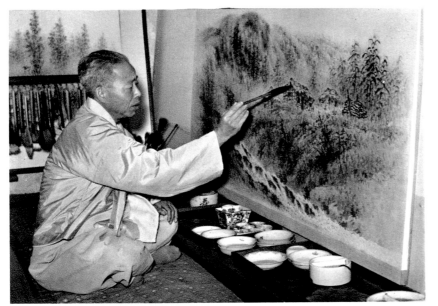

22

Art as interpretation

If, in the human order of things, each man is an individual with a particular set of senses and special arrangement of capacities, then each man's vision is different, and the record each makes of his life and environment will be a unique interpretation. Caught up in the complexity of civilization, man often loses sight of his human objective. The artist then not only records the physical facts of his being, but must act as interpreter, translator of the human experience. Art acts as diagnosis, definition and rationale for the human condition.

Art as reformation

The artist consciously or unconsciously seeks to change and improve upon the human condition. When all things as they are please a man, the stimulus for creative activity is absent. Whatever the architect's and designer's area, the poet's subject, the composer's musical form, he, as a member of the human race, is concerned with the betterment of mankind. The artist traditionally has taken part in many kinds of reformation, for it is the very essence of his craft to 're-form' his environment. He takes the pigments and fibres, wood and clay, rock and metal from their natural organic or inorganic states and gives them new form; he takes the everyday visions, sounds and values of men and re-forms them as well.

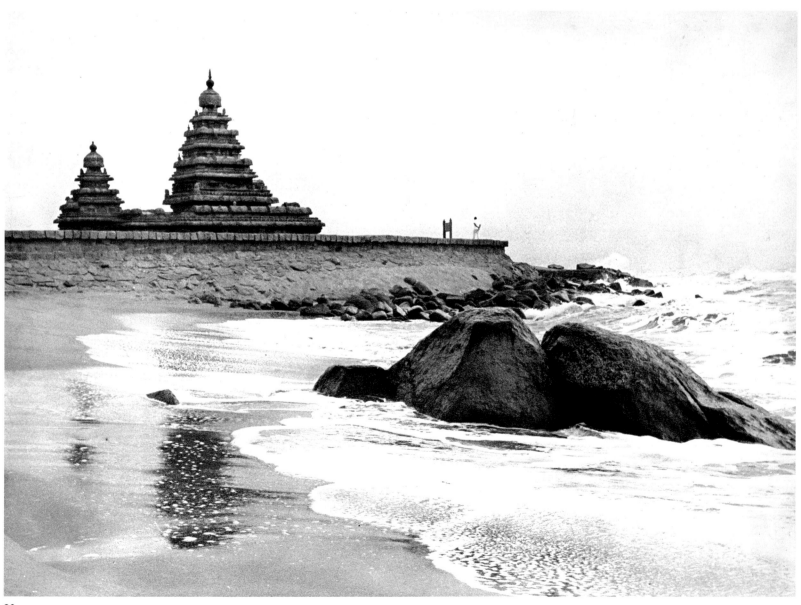

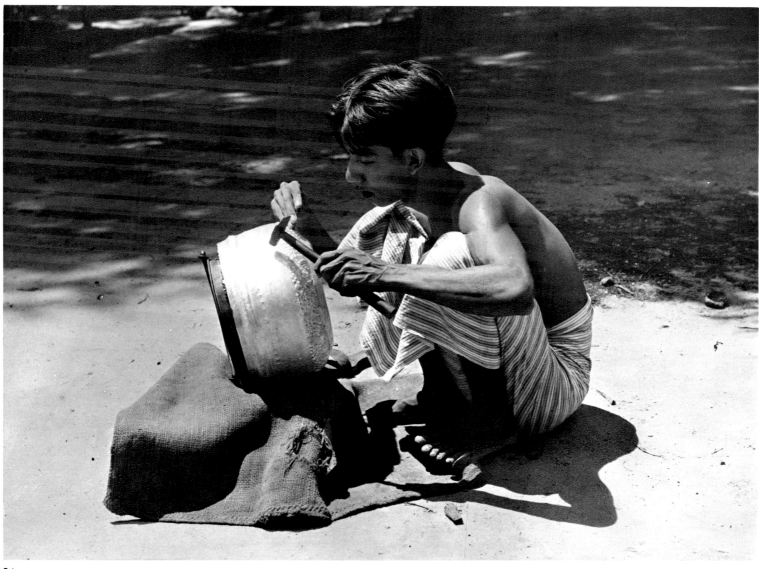

Art as enhancement

Just as the artist attempts to re-structure his environment, he also seeks to enrich it. Art can touch every phase of human life and make it that much more comfortable and beautiful. We know that what may be deemed beautiful by one person, one culture, one age, may not be considered beautiful by another. But this is the very factor that makes the aesthetic object a human thing; it brings men together in agreement and at the same time separates them as individuals who see things in their own ways. Another function of artists is to discover and establish new forms of beauty.

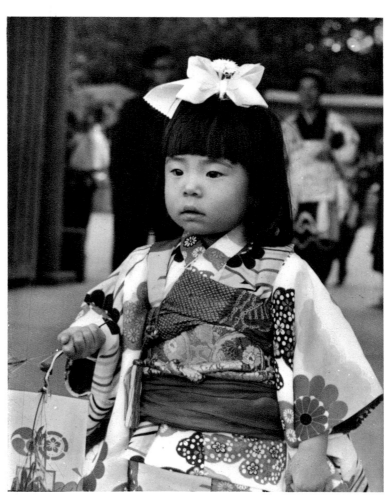

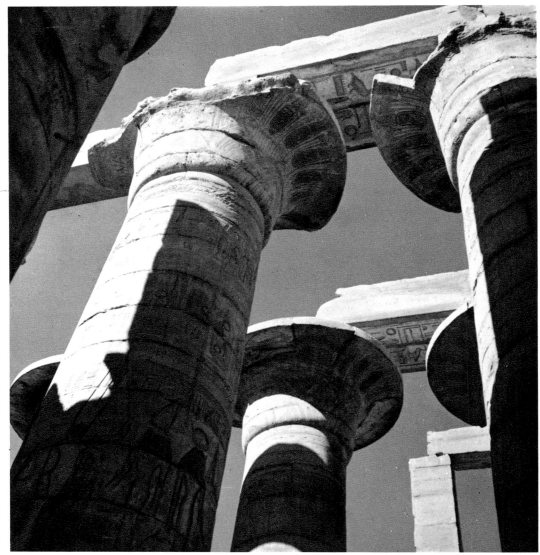

26

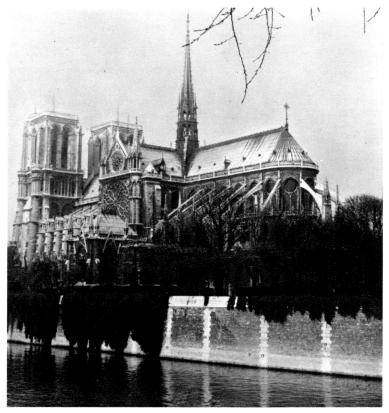

27

Art as order

There is an internal relatedness, a coherence of things. The physical world, the universe, provide a highly structured and intricately formed environment for man, and man is a unit in the endlessly complex pattern. He is a form, within a form. Man's need for, search for relationship and order, springs from a primordial sense of consistency. The aesthetic experience enables man to bring the bits and particles of his life into an ordered structure, and it provides for the interaction of the human organism with its environment. Man, the artist, seeks to untangle the most essential strands of existence and weave them into a beautiful fabric of intense validity. The art experience, for child and man, is the manifestation of the human search for order out of chaos; it gives incentive to our forming power and makes dynamic the order that we may find.

Art as integration

Man is filled with the urge to form, with the need to find harmony and build order. But it can happen that as societies become more organized, more compartmentalized, man becomes more confused and alienated. For there can be order without integration; man can establish a system that puts the fragments of his existence into a rigid order, he can tightly regiment the moments of his life, thus making for himself an orderly plan by which to live, but the very neat and precise order he builds can become a series of separate prisons that divide and hold the many aspects of his being apart, and thus lead to his disintegration. Man not only needs to establish an orderly arrangement of the parts of his life, but he must integrate the parts into a meaningful whole. The synthesis of intellect and emotion is possible on an aesthetic level of experience. Establishing relationships between the world of fantasy, imagination, thought, and the physical world of objective reality is another of the functions of art, as when the artist externalizes his vision, he gives form to it and it becomes a fact. Art serves to integrate. When a man is intensely involved in his craft, he is at one with it and thus he is at one with the universe and with himself. An aesthetic awareness will help us reintegrate, 'rehumanize' society. In our search for new meaning, new direction, new harmony for our lives, we can turn to art, for the plan and the model are there.

d'ARCY HAYMAN

29

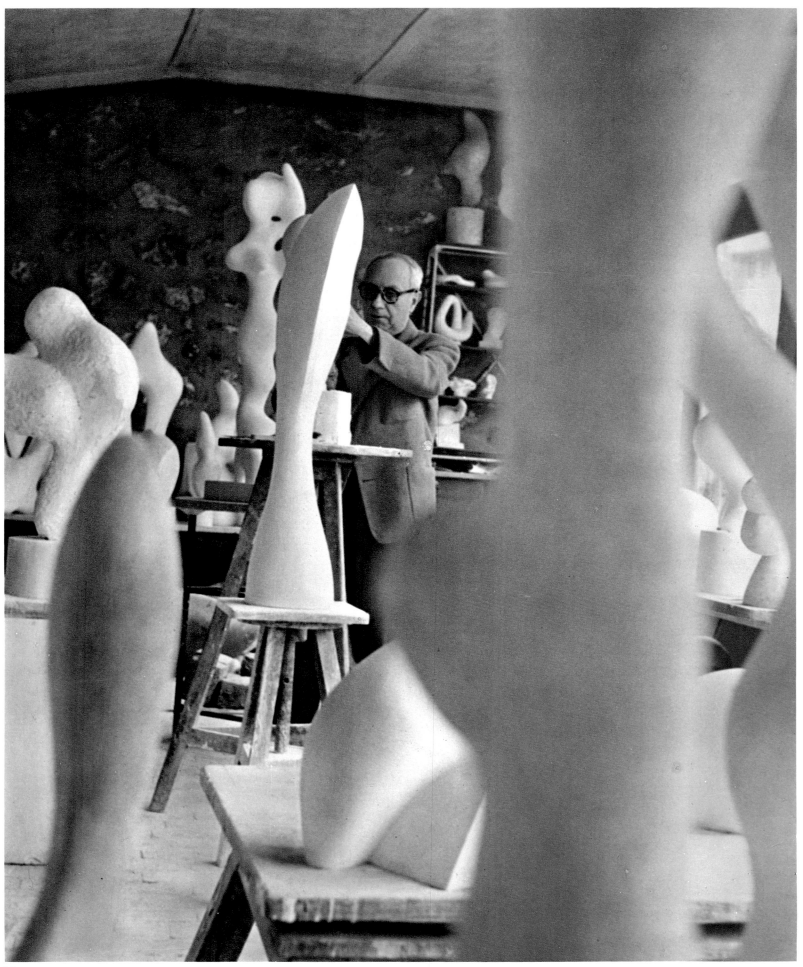

Chapter I # Art and society

Herbert Read

'Art' and 'society' are two of the vaguest concepts in modern language—I say *modern* language because these words have no exact equivalents in the ancient European languages, which are much more concrete in their terminology. In the English language the word 'art' is so ambiguous that no two people will spontaneously define it in the same sense. Sophisticated people will try to isolate some characteristic common to all the arts —they then find themselves involved in the science of art, in aesthetics, finally in metaphysics. Simple people tend to identify art with one of the arts, usually painting. They are confused if they are asked to consider music or architecture as art. Common to both sophisticated and simple people is the assumption that whatever art may be, it is a specialist or professional activity of no direct concern to the average man.

'Society' is equally vague as a concept. A society may be taken to mean the total population of a country—it may even mean mankind as a whole. At the opposite extreme it may mean a few people who have come together for a common but special purpose—the members of a religious sect or a club. But just as we have a science of art, aesthetics, which tries to bring order to a confused subject, so we have a science of society, sociology, which tries to give logical coherence to this second concept. The two rarely overlap, but there have been attempts to create a sociology of art, and various utopias, and works such as Plato's *Politicus*, are concerned with an art of society, with government or social organization conceived of as an art rather than as a science.

Very few philosophers, though Plato is one of them, have seen that art and society are inseparable concepts—that society, as a viable organic entity, is somehow dependent on art as a binding, fusing and energizing force. That has always been my own view of the relationship, and I should like to give some account of what such a relationship involves (or has involved in the past) and of the fatal consequences that follow from the absence of any such relationship in our contemporary civilization.

Both art and society in any concrete sense of the terms have their origin in man's relation to his natural environment. The earliest surviving works of art are the fairly numerous Palaeolithic cave-paintings and a few figurines in bone or ivory of the same period. We have no precise knowledge of the origins or purpose of these works of art, but no one supposes that they were works of art for art's sake. They may have had a magical or a religious function and as such were intimately related to the social structure of that time. This is also true of the art of all the succeeding civilizations of which we have historical evidence. If we examine the first records of the early civilizations of Sumer, Egypt or the Middle East, we always find artifacts that still appeal to our aesthetic sensibility—indeed, our knowledge of these societies is largely based on the evidence derived from surviving works of art.

All the way down the long perspective of history it is impossible to conceive of a society without art, or of an art without social significance, until we come to the modern epoch. Sparta is sometimes given as an exception, but this view depends on a narrow interpretation of art: Xenophon regarded the Spartan cosmos as in itself a work of art.[1] As for a tribe such as the Philistines, which by a strange chance has become identified with all that is insensitive and barbaric in society, it was probably as artistic as any other militant society of its time: it is said to have had a nice taste in feather head-dresses. It should be noted that Matthew Arnold, who gave general currency to Philistinism as a term of contempt, meant by it inaccessibility to ideas, and not specifically a lack of aesthetic sensibility, though he implied that only in so far as a society is permeated by ideas and vivified by them does it rise to the proper appreciation of art.[2] My own inclination is to reverse the statement: only in so far as a society is rendered sensitive by the arts do ideas become accessible to it.

We may next ask, how does it come about that modern societies have become insensitive to the arts. The hypothesis

1. Werner Jaeger, *Paideia*, Oxford, 1947, Vol. III, p. 161.
2. Matthew Arnold, in: *Lectures and Essays in Criticism*, edited by R. H. Super, University of Michigan Press, 1962, p. 120-1.

that at once suggests itself is that this fundamental change is, in some sense to be determined, a consequence of the sudden increase in the size of societies, a development that accompanies the industrialization of a country. It has always been a matter for wonder that the greatest epochs of art—Athens in the seventh and sixth centuries B.C., Western Europe in the twelfth and thirteenth centuries, the city-states of Italy in the fourteenth and fifteenth centuries—are associated with communities that, in comparison with the typical modern State, were minuscule. We tend to ignore this fact, to regard it as irrelevant, and even to assume that the biggest and most powerful nations must naturally, in due course, produce the greatest art. It is a conclusion for which history offers no support.

The most cursory consideration of the nature of the creative process in the arts will give us the explanation of this paradox. Whatever may be the nature of the relationship between art and society, the work of art itself is always the creation of an individual. It is true that there are arts, such as drama, the dance and ritual, that are complex by nature and depend on a group of individuals for their execution or presentation; nevertheless, the unity which gives force and singularity and effectiveness to any one example of these arts is the creative intuition of a particular dramatist, choreographer or architect. There are, of course, many examples of effective collaboration in the arts, but, to use one of Coleridge's neologisms, they are always 'adunitive': they consist of separate individual contributions, joined together like 'a quarter of an orange, a quarter of an apple, and the like of a lemon and a pomegranate' and made to look like 'one round diverse fruit'. Coleridge's metaphor is used to distinguish between the talents of Beaumont and Fletcher and the genius of Shakespeare. Similarly, I have yet to be convinced that any project realized by an 'architects co-operative', for example, can have the aesthetic value of a work conceived by an individual architect. Sentimental mediaevalists used to suggest that the Gothic cathedral was a communal creation, but this is to confuse building and design: all that was significant and original in any particular Gothic cathedral was 'the singular expression of a singular experience', and though architecture, if it is of any complexity, always involves the employment of subsidiary executants, builders and craftsmen, the aesthetic concept, that is to say the work conceived as an artistic unity, is always the product of an individual vision and sensibility.[1]

But the individual does not work in a vacuum. The whole complexity of our problem arises from that fact that the artist is in some sense dependent on the community, not merely in the obvious economic sense, but in a sense that is far subtler, and waiting for psychological analysis. I do not propose to attempt such an analysis: indeed, I doubt if even the science of social psychology is advanced enough to enable us to formulate a definite hypothesis on this subject. What is required is an analysis that would define two separate but interacting psychic entities: on the one hand the subjective ego of the artist, seeking to adjust itself to the external world of nature and society; on the other hand, society itself as an organism with its own laws of internal and external adjustment. Herein lies one of the basic paradoxes of human existence: art is the pattern evolved in a complex interplay of personal and societal processes of adjustment. It is only possible on the present occasion to give a brief description of this problematic situation.

Perhaps I should begin by indicating certain evasions of the problem. The first is the one that is found in most democratic countries, that is to say in all those that have become aware of the problem. An awareness of the problem arises in the following way and for the following reasons. It is realized that art as a social activity has characterized the great social systems of the past, from prehistoric and primitive civilizations to the great aristocratic, ecclesiastic and oligarchic societies of more recent times. This inevitable and apparently significant association of art and society is then seen to break down with the inception of the modern age—the age of industrialization,

1. Cf. Otto von Simson, *The Gothic Cathedral*, New York, 1965 (Bollingen Series, XLVIII). The phrase quoted comes from p. 62 of this work.

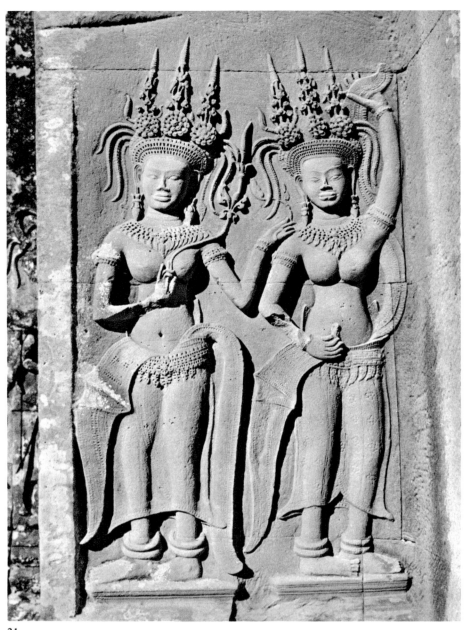

31

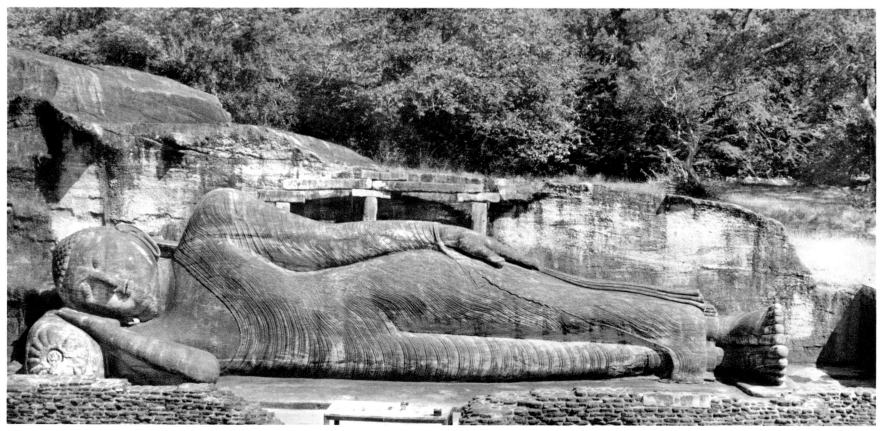

32

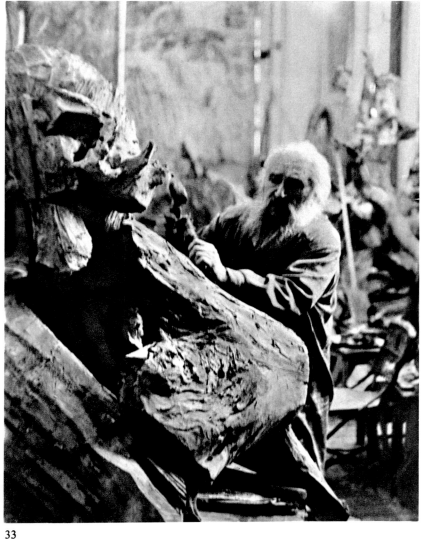

33

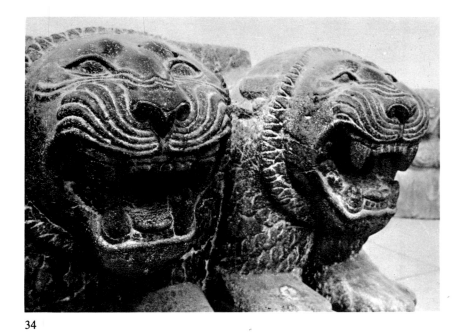

34

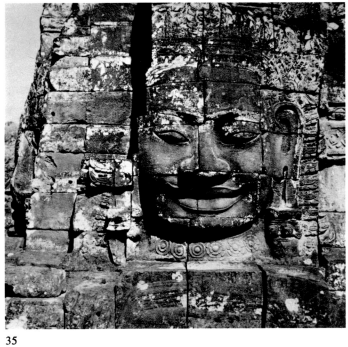

35

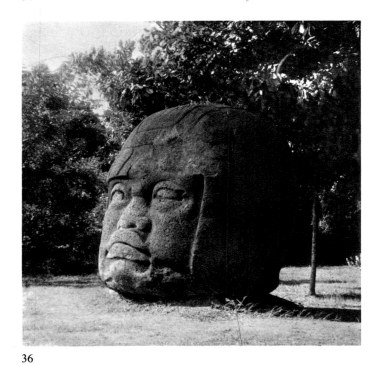

36

mass production, population explosion and parliamentary democracy. Two deductions are then possible. The first, which prevailed generally during the nineteenth century, assumes that art is a thing of the past, and that a civilization such as ours can dispense with it. The second deduction, which is more and more characteristic of our own time, denies this historicist assumption, asserts that what is wrong with our present civilization can be diagnosed, and proceeds to recommend various remedies.

I shall for the moment ignore the historicist point of view, for which Hegel was originally responsible, and examine some of the policies whose aim is to remedy the existing situation.

The most popular and in my opinion the most ineffective of these remedies is economic subsidy. It is pointed out, quite truly, that art in the past always had its patrons—the Church in the Middle Ages, the princes and city councils of the Renaissance, the merchants of the seventeenth and eighteenth centuries. This is a superficial generalization that would not survive a scientific analysis—there is no demonstrable connexion between the quality of art in any period and the quantity of patronage: patrons for the most part have been whimsical, inconsistent and sometimes positively tasteless or reactionary. But there is no need to examine this explanation of the present situation because the patronage at present enjoyed by the arts is probably greater in amount than at any previous time in European history. In the past fifty years vast sums have been expended on the purchase of Italian 'old masters' and Impressionist paintings, and equally large sums have been spent on the building of museums, theatres, opera houses, concert halls and so on, and on the subsidy of performances in such institutions. All to no effect on the basic problem, which is the creation of a vital democratic art to correspond to our democratic civilization. Our civilization, in its visual aspects, is chaotic; it is without a characteristic poetry, without a typical drama; its painting has sunk to a level of mindless incoherence and its architecture to 'economic' functionalism that projects its own 'brutalism' as an aesthetic virtue. There

are exceptions to these generalizations, but nowhere in the world today is there a *style* of art that springs spontaneously from the basic social and economic realities of our way of life.

The first question to ask and the most profoundly disturbing one is whether there is an incompatibility between those basic realities (our system of economic production) and the spontaneous production of works of art. Before answering that question it is perhaps necessary to affirm that there is no change in the potentiality of the human race for the production of works of art. Again I am evading Hegel's suggestion that art, 'on the side of its highest possibilities' (an important qualification), is a thing of the past. I proceed on the assumption that human nature, *in its potentialities*, does not change (or has not changed within measurable time). The world is full of frustrated artists, or rather of people whose creative instincts have been frustrated. Burckhardt, whom I intend to quote more than once in the course of this paper, pointed out that 'there may now exist great men for things that do not exist'. I refer not only to obvious geniuses who in spite of the times they live in give evidence of their genius in fragmented works of individualistic expressionism—the works of artists such as Picasso, Klee, Schoenberg, Stravinsky, Eliot—but also to all those potential artists who waste their talents in so-called commercial art (a contradiction in terms) and to all those sensitive children who give early proof of their potentialities and are then sacrificed like rams on the altars of industrial expediency. One of the most tragic injustices of our technological civilization is that the natural sensibility of men which in other ages found an outlet in basic crafts is now completely suppressed, or finds a pathetic outlet in some trivial 'hobby'.

I begin, therefore, by affirming with Burckhardt that 'the arts are a faculty of man, a power and a creation. Imagination, their vital, central impulse, has at all times been regarded as divine'. It is true that we must always distinguish (as Burckhardt does) between the doers and the seers, between the craftsmen and the visionaries. 'To give tangible form to that which

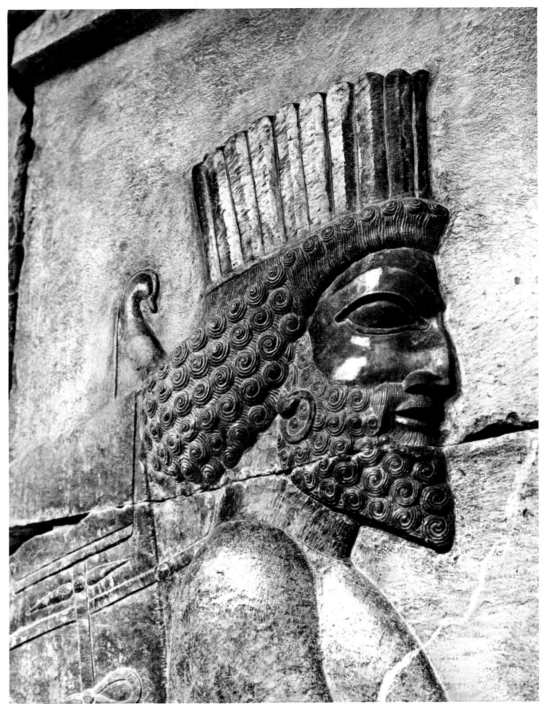

37

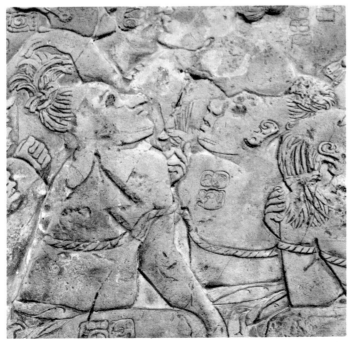

38

32

39

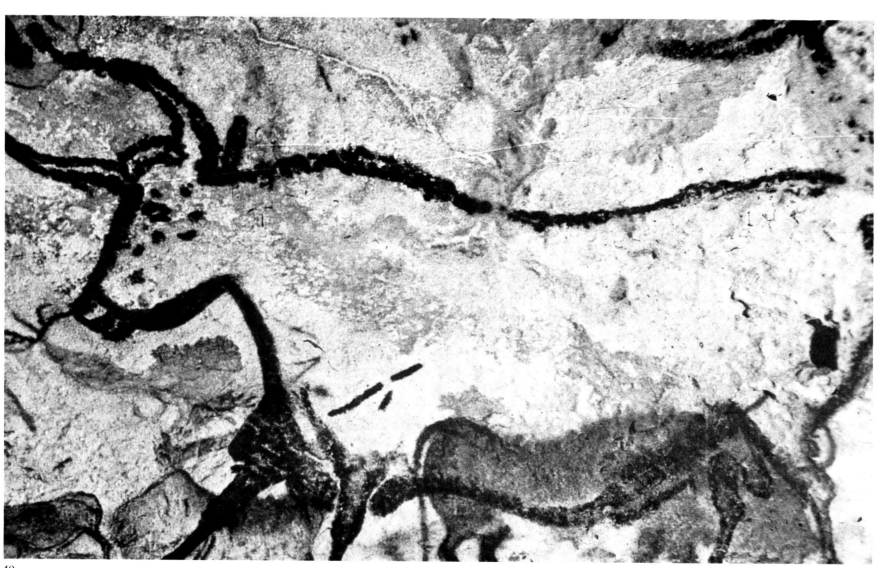

40

41

42

43

44

45

is inward, to represent it in such a way that we see it as the outward image of inward things—that is a most rare power. To re-create the external in external form—that is within the power of many.'[1]

We must examine our way of life—our social structure, our methods of production and distribution, the accumulation of capital and the incidence of taxation—to decide whether it is not in these factors that we should look for an explanation of our aesthetic impotence. To do this in detail would be a task for a book, not a brief essay, but I have written much on the subject in the past and would now only point briefly to two or three characteristics of our civilization which are patently inimical to the arts.

The first is the general phenomenon of alienation, which has been much written about since Hegel invented the term and Marx gave it political significance. The term is used to denote both a social and a psychological problem, but these are but two aspects of the same problem, the essence of which is the progressive divorce of human faculties from natural processes. Apart from the many social aspects of the problem (beginning with the division of labour and leading to the elimination of labour, or automation, and other consequences of the industrial revolution such as conurbation and congestion, disease and delinquency) there is a general effect, noticed by social philosophers such as Ruskin and Thoreau, but not greatly the concern of 'scientific' sociologists, which might be described as the atrophy of sensibility. If seeing and handling, touching and hearing, and all the refinements of sensation that developed historically in the conquest of nature and the manipulation of material substances are not educed and trained from birth to maturity the result is a being that hardly deserves to be called human: a dull-eyed, bored and listless automaton whose one desire is for violence in some form or other—violent action, violent sounds, distractions of any kind that can penetrate to its deadened nerves. Its preferred distractions are: the sports stadium, the pin-table alleys, the dance-hall, the passive 'viewing' of crime, farce and sadism on the television screen.

The second feature, the decline of religious worship, is doubtless the inevitable consequence of a growth of scientific rationalism, and the fact that scientific progress has not been accompanied by any equivalent progress in ethical standards is frequently regretted. But it is not so often observed that the same forces that have destroyed the mystery of holiness have destroyed the mystery of beauty. To quote Burckhardt again: '. . . from the beginning of time, we find the artists and poets in solemn and great relationship with religion and culture . . . they alone can interpret and give imperishable form to the mystery of beauty. Everything that passes by us in life, so swift, rare and unequal, is here gathered together in a world of poems, in pictures and great picture-cycles, in colour, stone and sound, to form a second, sublime world on earth. Indeed, in architecture and music we can only experience beauty through art; without art we should not know that it exists.'[2] But more than this: without art we should not know that truth exists, for truth is only made visible, apprehensible and acceptable in the work of art.

I am not suggesting that this process of rationalization is reversible: the mind never gives up its materialistic conquests, short of world catastrophe. I am merely pointing to the obvious fact that the scope of scientific knowledge is still limited. The nature of the cosmos and the origins and purpose of human life remain as mysteries, and this means that science has by no means replaced the symbolic functions of art, which are still necessary 'to overcome the resistance of the brutish world'.

Thirdly, and most diffidently, one must mention a characteristic of our way of life which however solidly based on our cherished ideals of democracy is inimical to art. I have already mentioned the obvious fact that works of art are produced by individuals. It follows from this that the values of art are essentially aristocratic: they are not determined by a general level

1. Jakob Burckhardt, *Reflections on History*, translated by M. D. Hottinger, London, 1943, p. 179.
2. Burckhardt, op. cit., p. 179.

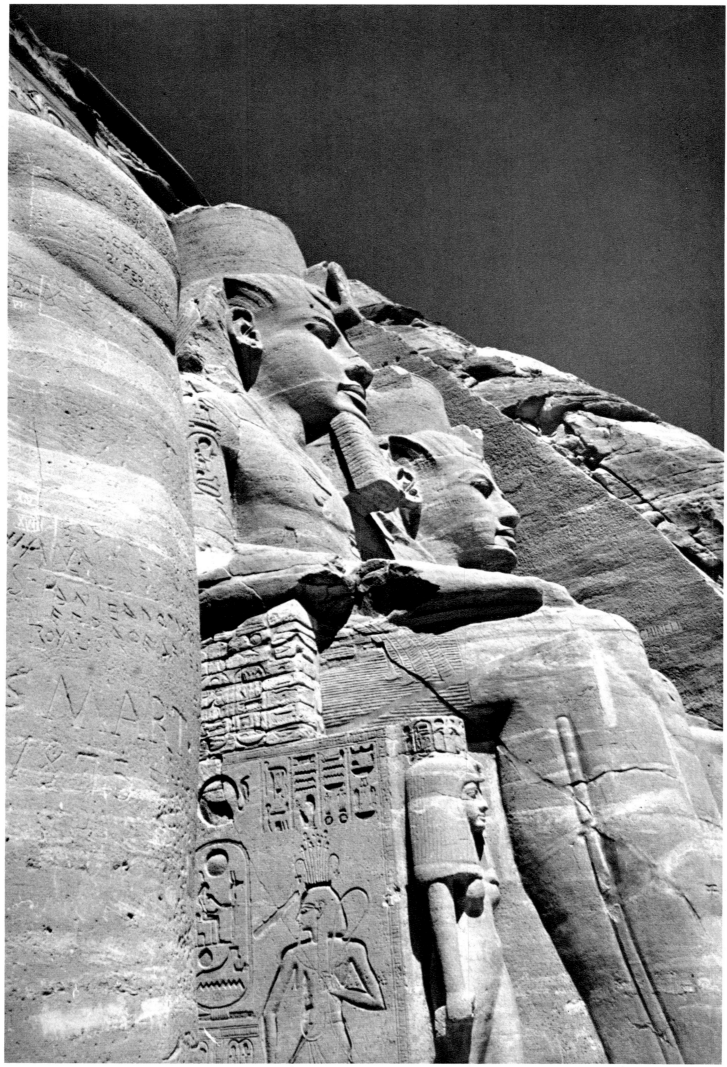

47

49

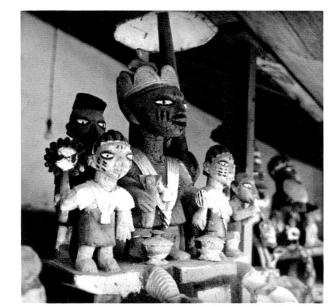

48

35

50

of aesthetic sensibility, but by the best aesthetic sensibility available at any particular time. This is a faculty possessed by relatively few people—the arbiters of taste, the critics and connoisseurs and, above all, artists themselves—and the level of taste is determined by their intercourse. Whatever we may think of Carlyle's or Burckhardt's theory of the role of the great man in history—and Burckhardt pointed out that there are categories of great men, some of them of doubtful benefit to humanity—and however much importance we may give to the 'grass roots' theory of art—a theory which I have frequently expounded and to which without paradox I remain faithful—nevertheless, the history of art is a graph traced between points which represent the appearance in history of a great artist. A Michelangelo or a Mozart may be the product of ascertainable forces, hereditary or social; but once he has created his works of art, the history of art departs from its previous course. I do not, of course, assume that the history of art is identical with the history of culture. Culture is not even the sum of all the arts, or of all the arts, customs, scientific and religious beliefs of a period. As T. S. Eliot once pointed out, all these parts into which a culture can be analysed act upon each other and a culture is something they create which is greater than the sum of their parts. Fully to understand one you have to understand all. Nevertheless 'there are of course higher cultures, and the higher cultures in general are distinguished by differentiation of function, so that you can speak of the less cultured and the more cultured strata of society, and finally, you speak of individuals as being exceptionally cultured. The culture of an artist or a philosopher is distinct from that of a mine worker or field labourer; the culture of a poet will be somewhat different from that of a politician; but in a healthy society these are all parts of the same culture; and the artist, the poet, the philosopher, the politician and the labourer will have a culture in common, which they do not share with other people of the same occupations in other countries.'[1]

Unfortunately for art a democratic society has its own categories of greatness which do not necessarily correspond to our definitions of culture. I do not refer so much to the heroes of war, politics or sport. These non-aesthetic categories are common to all ages. I confine my observations to the arts and there modern democracy has shown a total incapacity to distinguish between genius and talents. This is probably due to the strangeness or originality of genius—even in other ages, genius was not always immediately recognized at its true worth. But more recently technological advances in methods of communication have conspired with an innate envy of originality to produce that typical famous man of our time, the pander. Whether as a columnist or a television 'personality', this usurper appears before a public numbering millions and by anticipating their opinions and prejudices, flatters them into concurrence and adulation. To see—actually to see—their own commonplace thoughts and instinctive judgements voiced by an eloquent jack-in-the box not merely gives people the illusion that greatness is democratic, but also the greater illusion that truth need not be disturbing. For complacency (allied to complicity) is the ultimate ideal of a democratic way of life.

Art, on the other hand, is eternally disturbing, permanently revolutionary. It is so because the artist, in the degree of his greatness, always confronts the unknown, and what he brings back from that confrontation is a novelty, a new symbol, a new vision of life, the outer image of inward things. His importance to society is not that he voices received opinions, or gives clear expression to the confused feelings of the masses: that is the function of the politician, the journalist, the demagogue. The artist is what the Germans call *ein Rüttler*, an upsetter of the established order. The greatest enemy of art is the collective mind, in any of its many manifestations. The collective mind is like water that always seeks the lowest level of gravity: the artist struggles out of this morass, to seek a higher level of individual sensibility and perception. The signals he

1. T. S. Eliot, *Notes Towards the Definition of Culture*, London, 1948, p. 120.

sends back are often unintelligible to the multitude, but then come the philosophers and critics to interpret his message. On the basic works of one genius, a Homer, a Plato, a Dante, a Shakespeare, a Michelangelo, a Bach or Mozart we build not only outworks of interpretation and explication but also extensions and imitations, until the art of one individual pervades and gives name to an epoch. These concrete achievements in the plastic arts are the basis for what Hegel called 'reflective culture'. In admitting that the true function of art is 'to bring to consciousness the highest interests of mind', he was contradicting his previous statement that art is a thing of the past. For to 'bring to consciousness' is a process of reification, of concretization, that is or should be continuous in history. 'The imagination *creates*', as Hegel admitted; art does not deal in thoughts, but in 'the real external forms of what exists', with the raw materials of Nature. Writing in the 1820s, in the full flood of the Romantic movement, and before the effects of the industrial revolution had been felt, Hegel might well conclude that European art had come to the end of its task and had created more than the mind of the coming century could digest; but he was spared the experience of an age that can deny the very functions of imagination, genius and inspiration.

From whatever angle we approach this problem of the function of the arts in contemporary society, it is evident that their proper function is inhibited by the nature of that society. The Hegelian contradiction between art and idea loses its force and application in a society that has no use for either —either for 'the soul and its emotions' or for 'a concrete sensuous phenomenon', the two dialectical entities which in a progressive civilization are fused into unity by the vital energy that is life itself in its creative evolution.

It may be said that I have placed my priorities in the wrong order (actually I am denying that there are any priorities in the process). It has been generally assumed—at least in my own country where Matthew Arnold gave currency to the opinion— that 'the exercise of the creative power in the production of

great works of literature or art... is not at all epochs and under all conditions possible . . . the elements with which the creative power works are ideas; the best ideas . . . current at the time.'[1] Arnold limits his illustrations to literature, but his meaning is quite general. 'The grand work of literary genius is a work of synthesis and exposition, not of analysis or discovery; its gift lies in the faculty of being happily inspired by a certain intellectual and spiritual atmosphere, by a certain order of ideas, when it finds itself in them; of dealing divinely with these ideas, presenting them in the most effective and attractive combinations—making beautiful works with them, in short.'[2] This is the intellectualist heresy derived no doubt from Goethe and indirectly from Hegel. While it is true that in the creation of a master-work (in any of the arts) 'two powers must concur, the power of the man and the power of the moment', the essence of any work of art does not lie in synthesis and exposition, nor even in analysis and discovery, but in realization and manifestation. What is realized is an image—'we must render the image of what we see, forgetting everything that existed before us' (Cézanne). The artist, whether he is a poet or a painter, a musician or a potter, 'gives concrete shape to sensations and perceptions' (Cézanne again); and what he manifests is this shape, in colours, in words, in sounds. The rest is what Wittgenstein called 'the language game', and has nothing to do with art.

But that manifested shape is the node from which in due course ideas spring, and the more precise, the more vital the work of art, the more powerful will be the ideas it suggests. Then we can say with Arnold that 'the touch of truth is the touch of life, and there is a stir and growth everywhere'. But the first necessity is that the artist should render the image; if there are no images there are no ideas, and a civilization slowly but inevitably dies.

I believe that there is only one way of saving our civilization and that is by so reforming its constituent societies that,

1. Arnold, op. cit., p. 260.
2. ibid., p. 261.

37

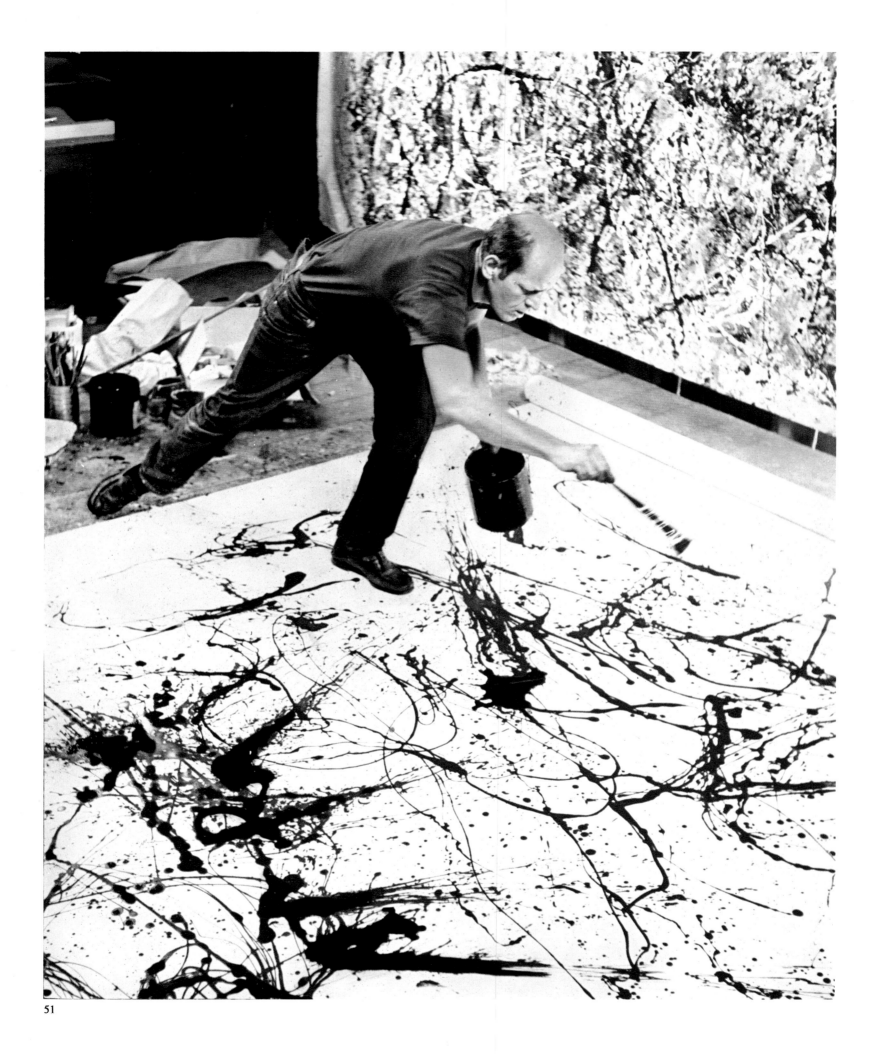

51

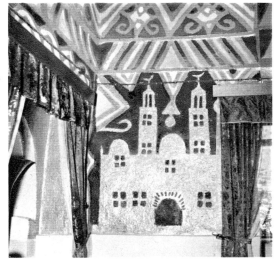

52

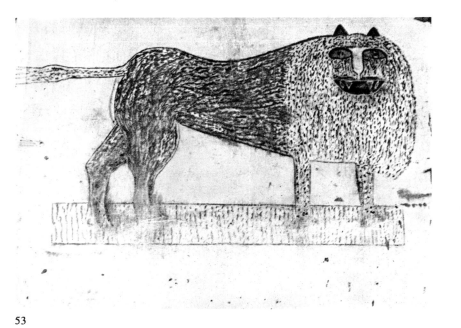

53

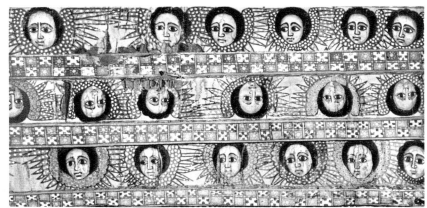

54

55

56

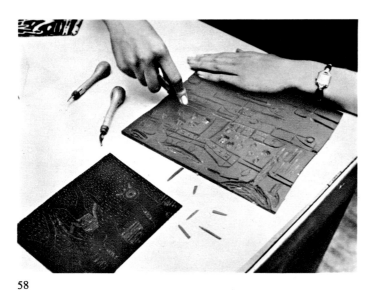

58

57

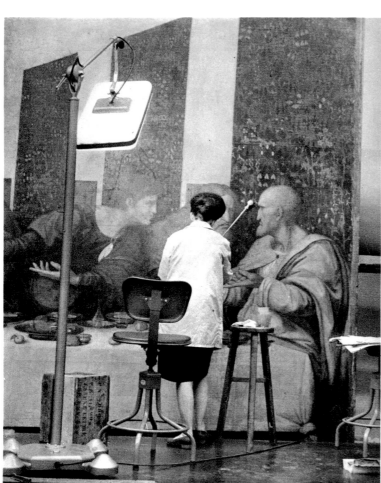

59

60

in the sense of the phrases already defined, the concrete sensuous phenomena of art are once more spontaneously manifested in our daily lives. I have called this reform 'education through art' and it now has advocates throughout the world. But what I have not sufficiently emphasized, and what is not sufficiently realized by many of my fellow-workers in this field, is the revolutionary nature of the remedy. An education through art is not necessarily anti-scientific, for science itself depends on the clear manifestation of concrete sensuous phenomena, and is necessarily impeded by 'the language game'. But an education through art does not fit human beings for the mindless and mechanical actions of modern industry; it does not reconcile them to a leisure devoid of constructive purpose; it does not leave them satisfied with passive entertainment. It aims to create 'stir and growth' everywhere, to substitute for conformity and imitation in each citizen an endowment of imaginative power 'in a kind perfectly unborrowed and his own' (Coleridge).

To believe that art is born in intimacy is not a quietist philosophy; there is no necessary association between art and inactivity. It is true that at the practical level there is a general contradiction between extravert activities and the calm needed for creative work of any kind. War and revolution destroy the constructive works of the artist. But at the same time we must admit with Burckhardt that 'passion is the mother of great things' and the artist is stimulated by great events, even although he takes no part in them and does not even celebrate them directly in his works. What matters is the general atmosphere of vitality 'when unsuspected forces awake in individuals and even heaven takes on a different hue'—or as Wordsworth expresses the sentiment in a famous passage of *The Prelude* inspired by the French Revolution:

> O pleasant exercise of hope and joy!
> For mighty were the auxiliars which then stood
> Upon our side, we who were strong in love!
> Bliss was it in that dawn to be alive,
> But to be young was very Heaven! O times,
> In which the meagre, stale, forbidding ways
> Of custom, law, and statute, took at once
> The attraction of a country in romance! . . .
> Not favoured spots alone, but the whole Earth
> The beauty wore of promise—that which sets . . .
> The budding rose above the rose full blown.[1]

Unfortunately the artist is not always destined to live in such a dawn or, having lived in it, not often destined to contemplate it in the tranquillity of some safe retreat.

There are few conclusions in this field which can claim scientific validity. Genius is a genetic chance and history a confused clamour, but life persists. It is a flame that rises and sinks, now flickers and now burns steadily, and the source of the oil that feeds it is invisible. But that source is always associated with the imagination, and a civilization that consistently denies or destroys the life of the imagination must inevitably sink into deeper and deeper barbarism.

1. Wordsworth, *The Prelude*, 1850, XI, 105-21.

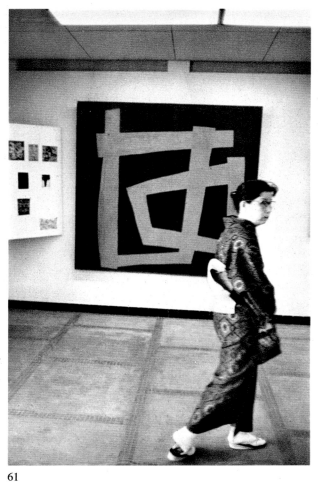

61

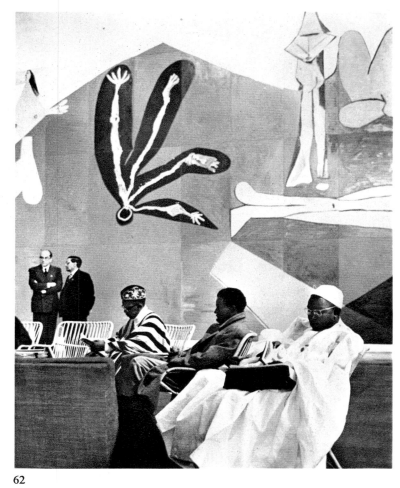

62

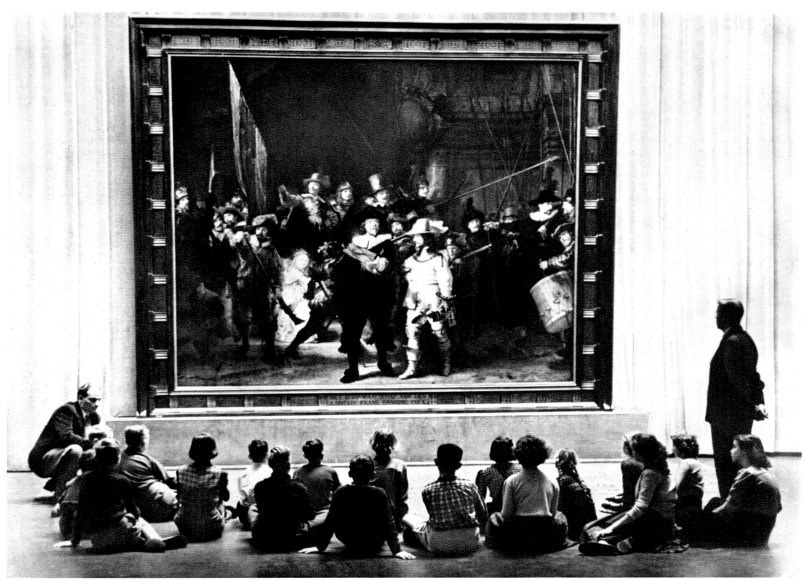

63

64

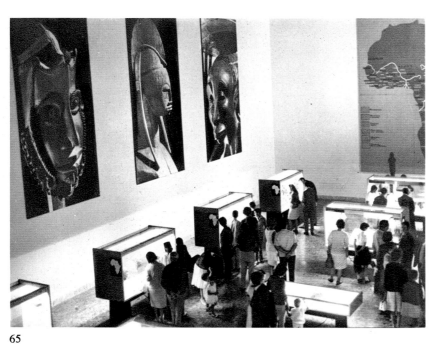

65

66

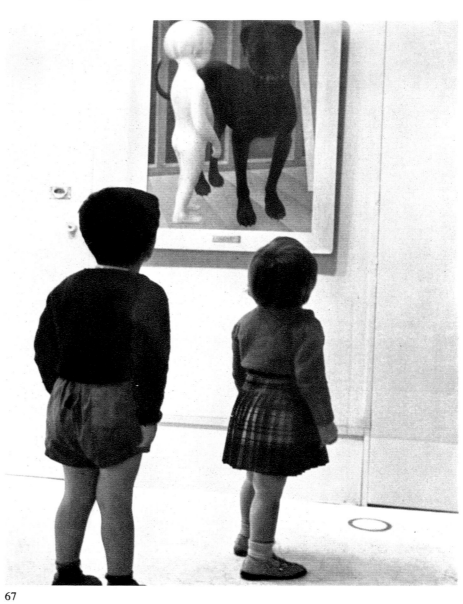

67

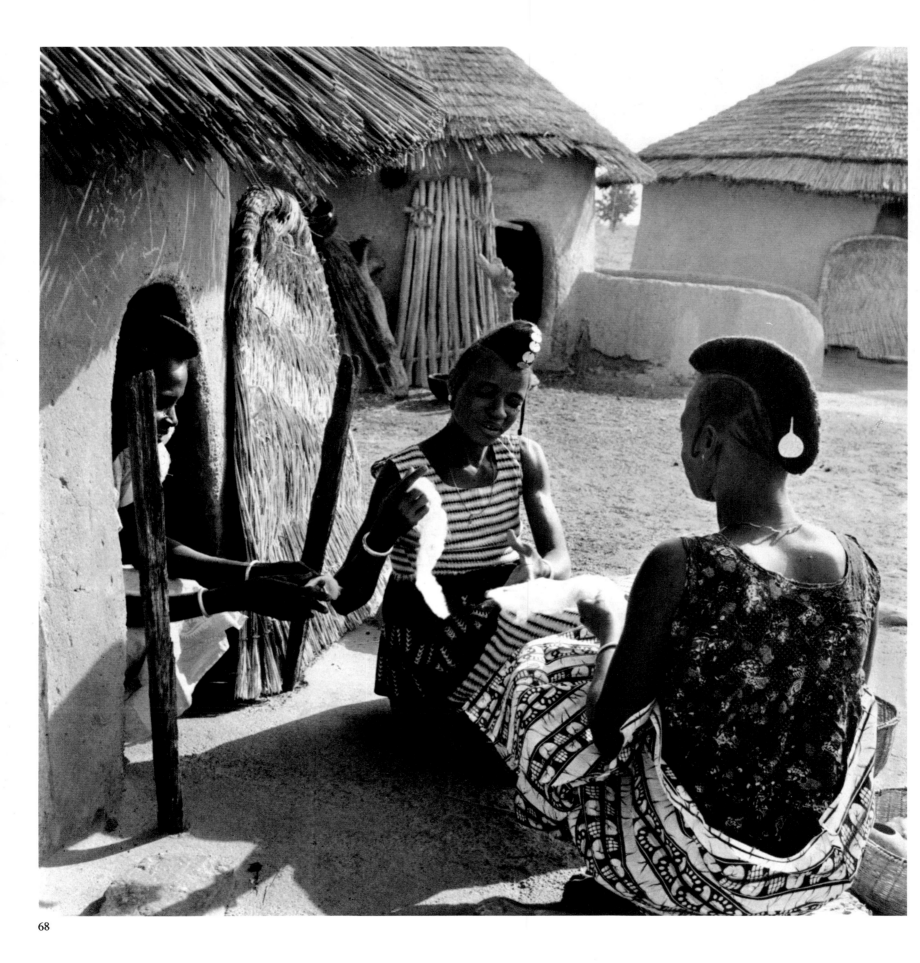

Chapter II

The crafts as an embodiment of the great folk tradition

Kamaladevi Chatthopadaya

Let me first of all clarify what I mean by craft as skilled labour in materials, not necessarily mere handwork that is simply manual dexterity as opposed to cultivation of the mind. Here I take craftsmanship as referring to a total operation involving the emotions, mind, body and the rhythm which such a co-ordination sets up. Nor is craft divorced from a degree of mechanism, because from earliest times man started evolving tools as an extension of his being and did not rest content with the unaided skill of his physique.

We must also recognize that craft is as much an expression of the human spirit in material form, which gives delight to mankind, as any of what are termed fine arts. In the craft world, however, there need be no hiatus between service-ability and aesthetics. One may say that in good craftsmanship the means and the ends are identical, for while the article is useful it will also be rich in appearance and good to look at.

Craft has always been a basic activity in human society, in fact it is considered more cohesive and permeating in human relationships than even language, for it can penetrate many barriers to communication. Particularly has this been true of the older societies such as those in Asia, South and Central America, Africa and countries like Greece or Spain, where certain aspects of the ancient handed-down cultures still continue to produce powerful impressions that almost seem ageless.

The growth of crafts in society was the sign of the cultivation of sensitivity and the stirring and mellowing of humanism. It stood for man's endeavour to bring elegance and grace into an otherwise harsh and drab human existence. In fact, man's elevation from the gross animal existence is marked by his yearning for something beyond the satisfaction of mere creature comforts and needs, which found natural expression in crafts. The most primitive people began to ornament their articles of everyday use, later their weapons, then their garments and their own person and surroundings. The rough and severe walls of their huts became canvases on which blossomed pictures. A death-dealing but very strategic item like the bow and arrow became embellished with decorations, water pots took on pleasing shapes and alluring designs were invented for mundane kitchen pans. Here we see the transformation of the mere functional into works of art, the common becoming the cherished, the joy-giving. Gradually the wall paintings, the ornamentation of the floor where one worshipped, performed ceremonies or even took food, the decoration on the doorstep and in front of the house, all became purposeful creations, almost ritualistic. No aspect of life was too insignificant or humble to lay claim to beauty or acquire sanctity as a symbol of good omen. The use of special articles for special occasions in the way of clothes, jewels, vessels, etc., all of which had to have a certain quality to ensure a high standard even in daily life and use, meant a continuous outflow of creativeness, a sustained spirit of animation and freshness dispelling staleness and monotony.

We find, for instance, that in many countries to give solemnity to certain things a convention was established by which they were made into ceremonials. The tea ceremony of Japan is a good example. It requires a special pavilion offering seclusion from the bustle of everyday life, in its own surroundings, and the use of its own vessels or cups, involving the manufacture of special pottery. Though the ideals sought were relaxation, contemplation of beauty and communion with nature, these alone were not regarded as giving complete fulfilment unless they were made part of one's intimate daily life, hence the introduction of the tea ceremony. Where the earth is dry and burns under voluptuous rays as in deserts, where life is grim and severe and resources poor, the people seem to compensate with riotous colour and exuberant forms, creating a sense of luxuriance and plenitude through their crafts. There is a breathless eagerness created in the atmosphere, rapturous vivaciousness in the articles that are used, a springtime dazzle in garments and even in the harness and trappings of domestic animals. Yet all this mingles with a sense of repose and stillness as comes at twilight over the weary earth. The whirlwind of the sandstorm is tempered by

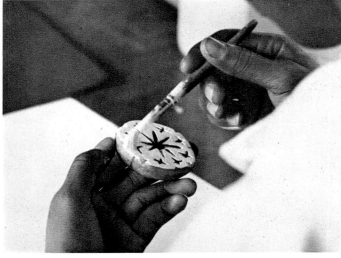

69

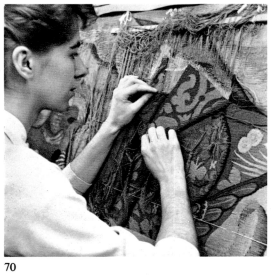

70

71

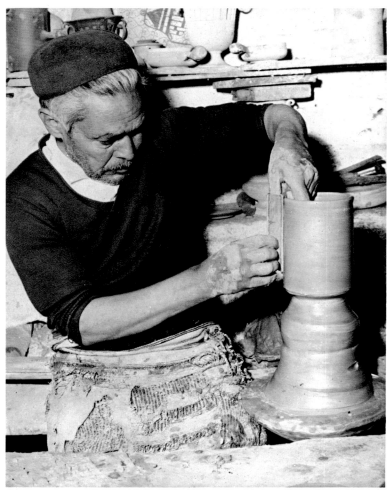

72

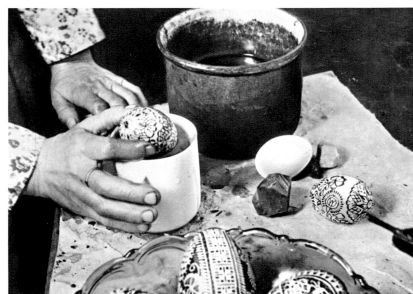

73

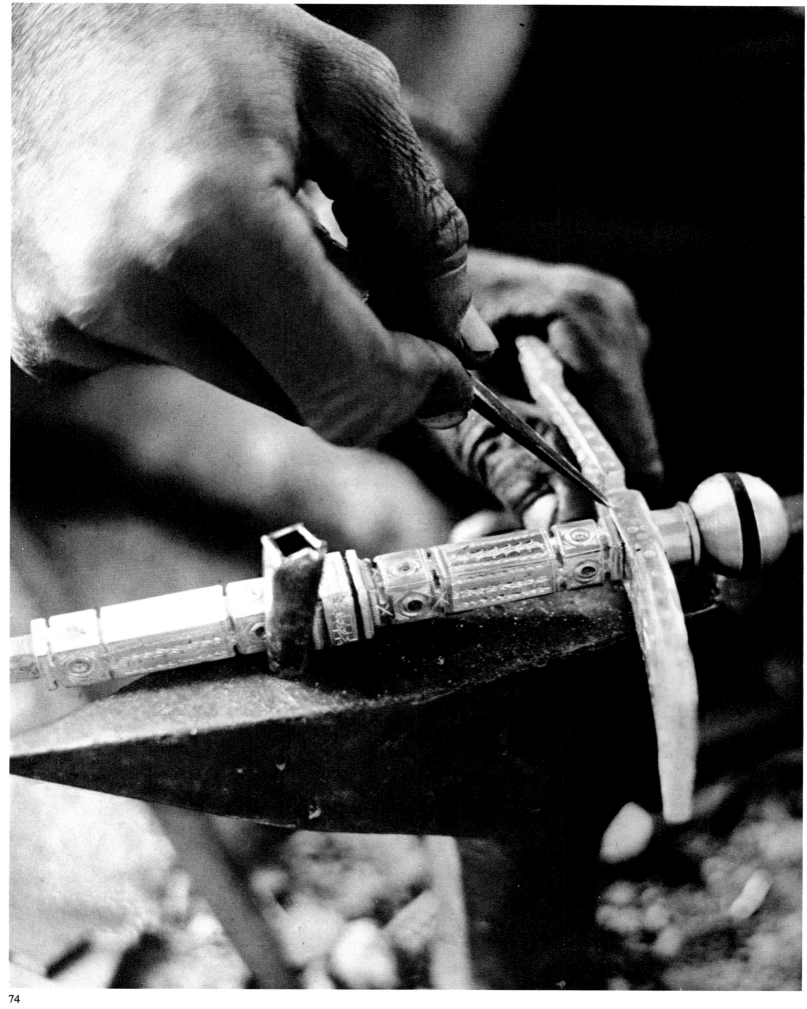

74

a kind of midnight calm. For what takes form in crafts are feelings actually experienced, not just conjured up in imagination. For such depth or vitality cannot be introduced into a craft form unless it flows from within as an inner reality. Craftsmanship, it must be remembered, is not a matter of mechanical reproduction. It is creation that is not divorced from production, where the designer and the producer are one—unlike studio designing which is removed from the actual object that is to be made. In fact one of the allures of the crafts lies in that as it were magical involvement of the artisan's personality with the product from its inception to its final application.

One may say that there is no such thing as craft for craft's sake. It is not an exercise of the intellect, which finds a form in a secluded studio to become the proud possession of an individual or institution. It arises from the deeper hunger of humanity, its functions are socialized for its use and distributed through the family and even the entire community. Craft is not preoccupied with subjective feeling and thought, but with objectification.

It would need a thesis by itself to explain man's innate need for beauty, the why and wherefore of the pleasure and satisfaction experienced through stimulus and response generated by the sight or touch of certain forms, the emotions stirred within us by colours and rhythmic lines that even in concrete objects seem to flow while they stand stolidly rooted to the ground. Beauty in objects around us provides visual comfort, equilibrium and relaxation. In craft we have the identification of the self with the object—not just a sentimental sympathy—because craft is really an extension of oneself, growing out of one's physical and psychological need.

Crafts create an instinctive appreciation of beauty rather than a self-conscious striving after it. They call for as subtle an understanding of composition as any work of art; the combined use of form and curves to advantage; the avoidance of odd or awkward empty spaces by filling them up appropriately to contrast with the more ornamental parts; subtle emphasis on lesser parts to make them stand out more clearly; and also blending and highlighting the lustre and mellowness of light and shade.

Folk craft tries to express something more than the visible appearance, to bring out an element which seems to lurk in the depths of a more significant reality than facile reproduction. This is a characteristic of all the old cultures, frequently dismissed as 'fantasies' and attributed to a lack of knowledge of perspective and chiaroscuro. The fact is overlooked that oriental crafts, for example, were the expression of a will, the fulfilment of a purpose, with none of the nebulous vagueness that comes of subservience to a passing mood.

The craftsman seeks rhythm in his life, colour in his composition and harmony in his form in order to perfect an object which has a function and at the same time provides visual pleasure. Here the material and expression move and balance within the magnetic field of the operation.

Crafts have been the indigenous creation of the ordinary people, a part of the flow of events of the common life, not cut off from the main stream. They grew up in the peace and seclusion of the countryside, where the community evolved a culture of its own out of the steady flow of its own life and of the nature around it. The community acted as a single personality because of its communal activities, in response to common occasions and landmarks that stood out in the flux of time, and the change of seasons. Out of a million coloured strands of traditions and memories filled with song and verse, legends and myths, fables and local romances, from the core and substance of their daily existence and out of nature's own rich storehouse, was woven a refulgent creative and forceful culture. This was the issue of an unhurried rhythm of life and a spell of serenity, as contrasted with the bustle of the present machine age. Its products had a vitality and character of their own in that they were the direct expression of the craftsman, with a careful emphasis on functional beauty. Yet at the same time a very significant factor was the anonymity of the producer, in striking contrast to the present age of signatures and

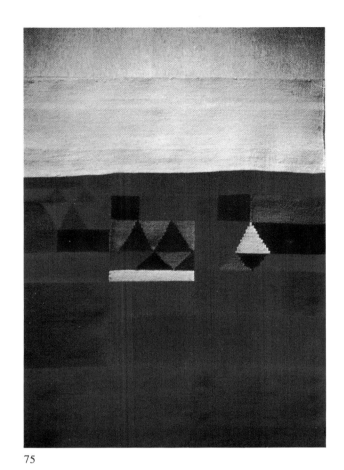

75

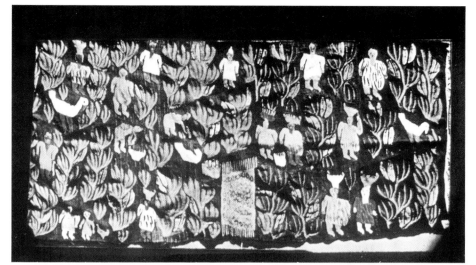

76

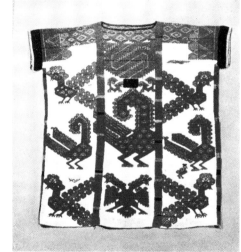

77

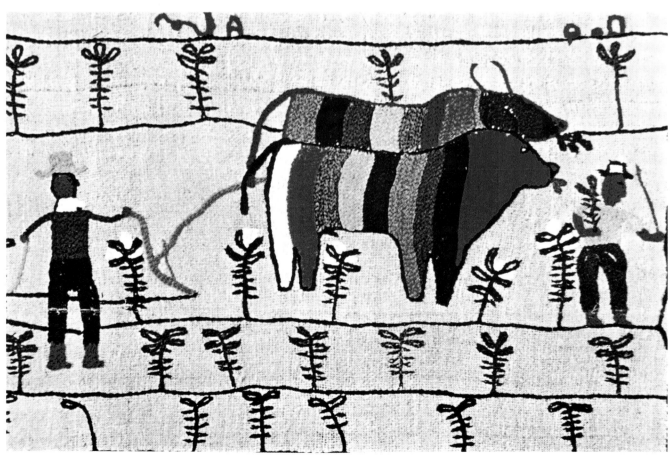

78

79

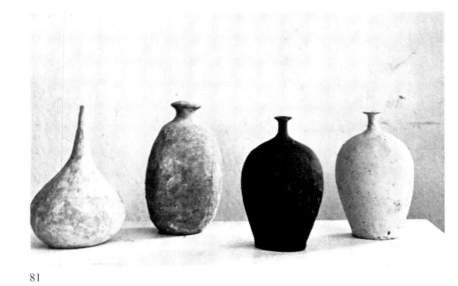

81

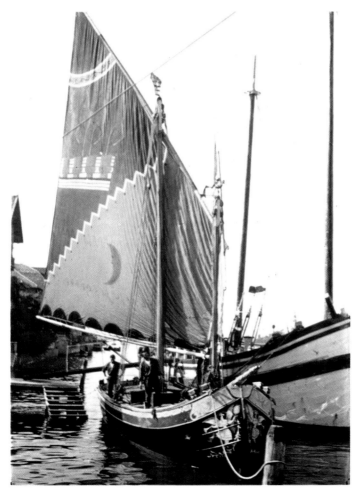

80

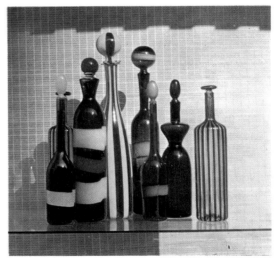

82

publicity. Evidently the name did not add to the value of the article and beauty was accepted as an end in itself, and service to the community a source of complete satisfaction. What was of great significance in this context was the status assigned to and security provided for the craftsmen, to preserve and provide continuity to the crafts and save them from the gnawings of anxiety and the paralysis of insecurity. A craft-oriented society was based on personal relationships, not contracts and competition.

Crafts are imbued with a certain idealism not normally associated with an industrial pursuit. Craft work is not just the plying of a trade but rather a social act. The human touch does something to the fragments which are brought together in a craft where they seem to mingle and cling together drawn by the magnetism of love, seeking one another, to give birth to a new life in a fresh form—unlike the tumult and pressuring exercised by a powerful machine where the pieces seem helpless and lost. Thus traditional decorative motives can lend colour and mellowness to our current existence, otherwise stern and grim, with its many privations and denials.

The ancient books of the East say that when the hands of a craftsman are engaged in his craft, the act is always a ceremonial. Tools are but an extension of the personality of the craftsman to reach beyond the range of human limitations. The craftsman thus combines within his being the functions of both the conceiver and the executor. He symbolizes to his society the outward manifestation of the creative purpose and the unbroken link in the tradition that embraces both the producer and the consumer within the social fabric.

Two significant characteristics of crafts are that aesthetics and function are integrated, and ornamentation and decoration are not divorced from utility. And even where craftsmanship is based on tradition, the dangers of stagnation are minimized by freeing each productive act from imitative intention and linking it with the stream of life, making it a dynamic manifestation of man's endeavour to express universal human emotions and interests.

Even though craftsmanship has always been considered hereditary, passed on from generation to generation, inheritance of actual skills was not assumed. The emphasis on the contrary was on proper education and the right environment for the growing generation. The young craftsman learnt in the family workshop as an apprentice the techniques in their entirety in direct relation to basic production and problems, primarily by practice. In fact he was just as much engaged in learning metaphysics and the true value of things, in short, in acquiring a culture. There was no isolation of the school from the larger life. For in this setting the child learnt little tasks as part of the daily routine, picking up skills even as he did other components of his way of life. The problems were real, not make-believe, as the aim of education was understood to be the unfolding of the personality to make for a fuller life.

For the quality of inspiration which transmutes skills and competence can hardly be taught. It has to be cultivated by experience. This makes for a very special relationship between the teacher and the pupil, an intimacy binding the two. The latter looks up to the former as the source from which knowledge is imbibed, great truths learnt and interpreted. The teacher educates the pupil as much through his own personal conduct as through studies, and is expected to enjoy the same respect and regard for the pupil as he would for his own progeny and family. The sharing of problems and varied experience was a real contribution to the enrichment and formation of the pupil's personality.

In a craft society the master craftsman is also a social leader and an important entity in the community. The teacher keeps nothing worth while back as a trade secret from the pupil. This form of institution makes craftsmanship a living thing, giving prestige and value to sound standards. The teacher spurs the pupil on to surpass himself and takes genuine pride in conceding superiority to the student.

In a society which accepts crafts and still finds an honoured place for them, there is a free exchange of ideas between fine

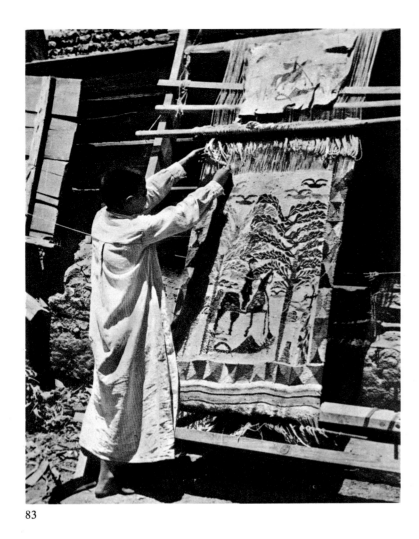

83

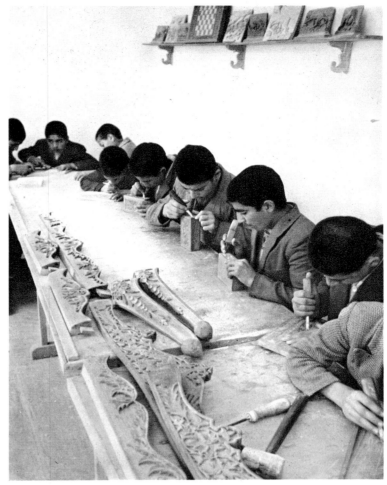

84

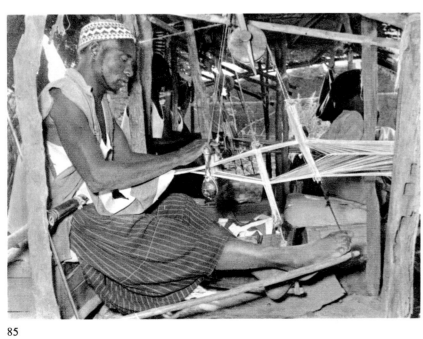

85

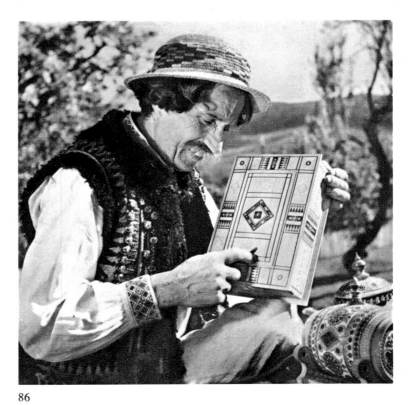

86

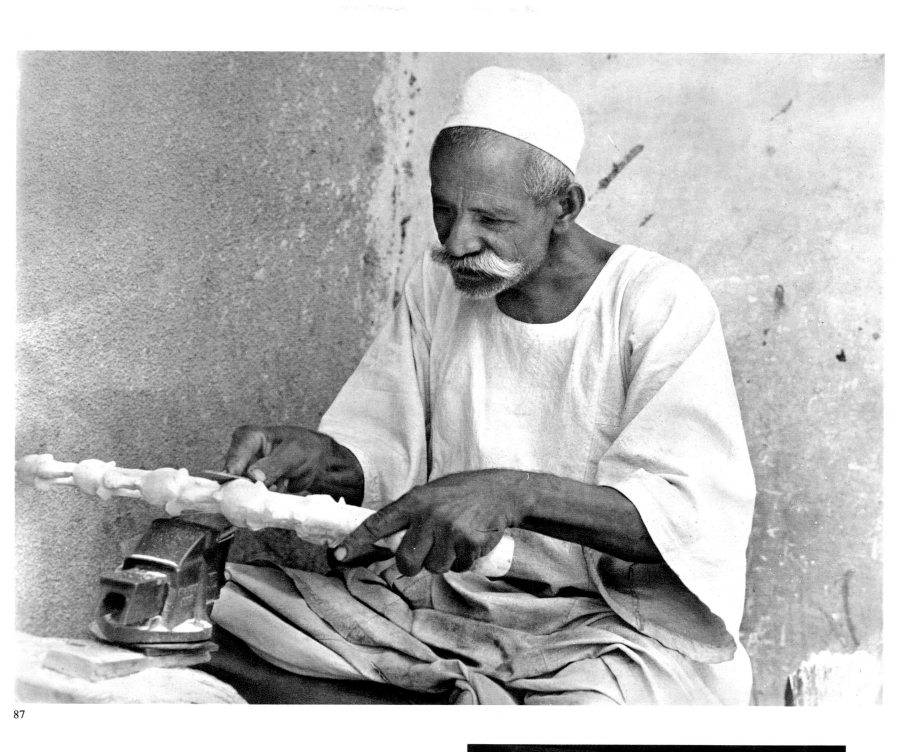

87

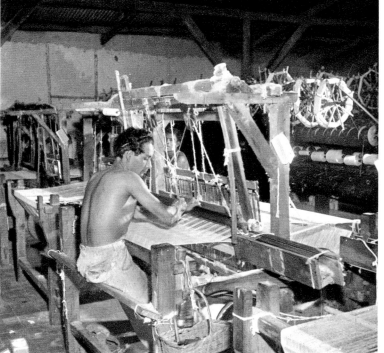

88

arts and the crafts, each accepting cues from the other. Similarly the man of taste is rated as equally gifted and with the same sensibility as the man who creates. So appreciation is in a sense on a par with creation, because it is felt that the man of sensitivity participates with almost the same excitement and exhilaration when he appreciates as when he creates. This concept is an important and integral part of the craft world. Moreover, the insistence on good taste ensures a consistently high standard for all arts and crafts. Even the common terracotta shows a vigour of muscle and at the same time a fluidity of line to as if prove that the earth is not static but has a dynamic rhythm realized in a flux through a continuous process. Craft means cultivation of an intimacy with human life and creation, a sympathy for all living things and the realization of the fundamental unity of all aspects of life though diverse in form.

A society dominated by mechanical industrialization tends to exalt efficiency over creative gifts, though the latter are rarer and more precious from the human point of view. Thus administrative staff enjoy better status, higher salaries and are generally considered more important than expert craftsmen.

It must be remembered that over-emphasis on techniques that accelerate speed and swell the quantum of volume but are divorced from imagination and intellect can result in the loss of that exaltation which stimulates creative activity in craft production. Similarly the pivotal importance accorded to *facts* in education may draw away all inspiration and leave life too flat to awaken any sense of wonder in the young. Such over-emphasis can be just as hard to shake off as the superstitions of the imagination.

We once believed that a full personality is fostered by ideals in relation to which the course of life is set and plotted through the observance of certain disciplines. It may be that ideals have fewer chances of survival in an atomic age. Moreover, the ever-increasing invention of sensitive machines and instruments places less and less premium, in a way, on man. The trend now is to give pre-eminence to the machine. In a world where life is being increasingly geared to predominantly physical targets that have to be achieved through highly complicated mechanical processes, the role of man must inevitably necessarily pale and shrink. He has therefore to be compensated by artifices. The modern concept of the build-up of the personality flows largely from a machine-dominated age. Personality build-up today is made into a kind of a cult. Wide publicity is given to tips and practical hints towards this end: wear the right kind of clothes, have the right make-up for the complexion, use the right type of perfume for the evening. Surely, these do not help in the blossoming of a personality.

The more frequent use of automatic machines curtails the demands on man. Less and less of him is called into action. Geared to automation, human beings must increasingly conform to machines: individual opportunities for choice and decision narrow and, in the ultimate, leave the way open for the replacement of man by machine. Large units constantly expand into larger ones and the concentration of machines becomes still heavier. In this gigantic grind, the human personality may well be undermined if it is not balanced by an accompanying pattern of production, as in the crafts.

One is gradually becoming aware of a lowering of quality standards in the current age, compared with the craft age. People's taste is determined more by other opinions, called 'fashions', than by the intrinsic value or merit of a product. Similarly the solidity or endurance of a product becomes a less important consideration.

Craftsmanship on the other hand is more a tribute to the high function of the human being, who is not just a physical frame, but is endowed with creative talents. Society needs constant reminders of this and of the corrective and balancing force which crafts so naturally provide. The alternative, for the majority of people, may all too easily be a form of escapism, a flight from the monotony and the stifling pressure of mass production. In such an atmosphere people tend to become preoccupied with careers rather than a sense of mission

or service. At the same time they are readily attracted by anything that is new and, because of its novelty, exciting, with little discrimination or concern for proper values.

We must not forget that while science may open up the fourth-dimensional world, and technology the wide firmament, the individual in technological society seems to get compressed into an as it were single dimension. The responsibility he exercises is trivial, his power of decision nil. Only a small part of him operates. Craftsmanship, on the contrary, involves the entire person, relating the mind and the material to a certain function for a specific purpose. While the tempo of the craft age gave the illusion of timelessness, the current age rushes on at the astronaut's speed. It is largely against this back-drop that we have to view the value of crafts and their relation to contemporary society.

Crafts have a special role and significance in the creation of a home—home to mean all that part of one's environment that is personal and intimate as distinct from temporary and utilitarian. When the machine usurps the essentially human part of performance, it cannot but reflect on the intimate environment. In the furnishing of the home a direct association with the original and authentic registers a personal impress on us, as with an original painting, a manuscript, a relic, things that a reproduction cannot equal no matter how perfect it may be. Here one senses all the difference between the work of a master and a machine. Crafts form part of the daily environment and fit in naturally and gracefully in the arrangement of the home.

In upholding crafts one does not necessarily by implication reject machines or make an impassioned plea for a return to hand production. There is, in fact, a basic relationship between small tools and large machines. Where we take the wrong turning is in failing to make the proper appraisal of and acceptance of the role of each in its own sphere, which would still leave the community to make a choice. There would then be no danger of man being bullied by the machine. Tradition respects the natural limits of craftsmanship and the harmony that is established between the craftsman, the materials he uses and his tools. The pride the craftsman derives from his creation and the delight in the perfection of his finished product sustain him. It is this knowledge enshrined in the crafts that give them an abiding place in our social set-up.

The very fact that even in this growing forest of machines with its triggery tempo, far from being smothered, crafts are once more coming into world focus, is evidence enough that within us pulsates an innate yearning to use our hands and to feel the surface of individually created objects. Crafts embody certain qualities and a depth of experience arising out of direct expression which is very different from studio work. Craft work is an acknowledged form of therapy for those who are mentally unsettled and nervously upset: it is a source of rhythm and stability in living. Even hard labour done rhythmically becomes more bearable. The problem before us is therefore not man versus machine but rather how to promote a harmony and cohesion between the two, a regulating of each in its own appropriate field.

The need for saving and developing crafts is felt to be vital even by those who follow or are caught up in other pursuits. For it enables them to maintain contact with those aspects of our culture that are characterized by crafts, and to absorb some of their elegance and grace. Crafts are particularly important with young people for the qualities they help to develop. For inherent in the craft tradition are abundant reserves of sustenance and delight. As long as crafts continue as living and compelling witnesses of these cultural resources, art will remain intimately connected with the daily usages of man. Crafts also have a special vitality as a direct human answer to direct human needs. As has been said, the demand in eating calls as much for satisfaction from the right kind of spoon as from the food to be eaten. Crafts have therefore an intimate kinship with and understanding of the human needs its products serve, which induces an intuitive sense going *with* rather than *against* the grain of life, absent in the assembly-line pattern. In craftsmanship man is in full control and can make his own decision at every point. In large machine

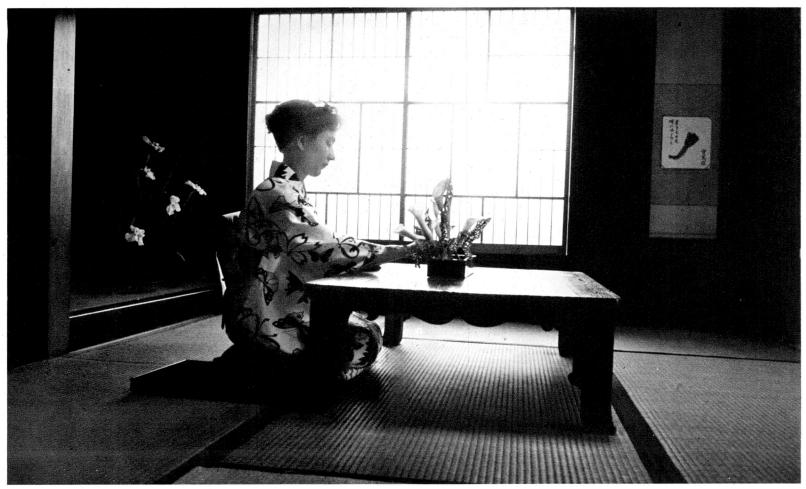

89

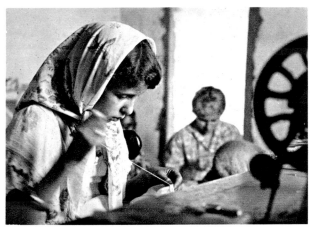

90

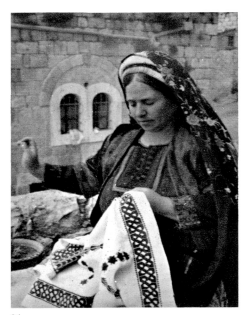

91

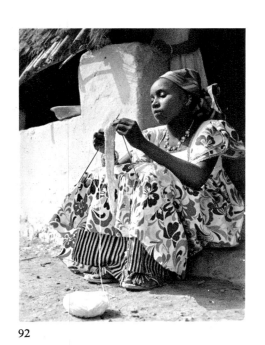

92

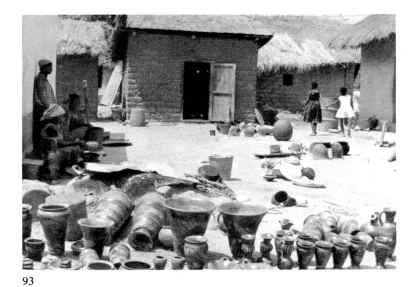

93

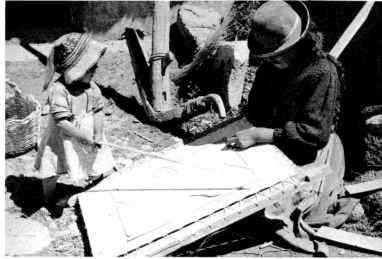

94

95

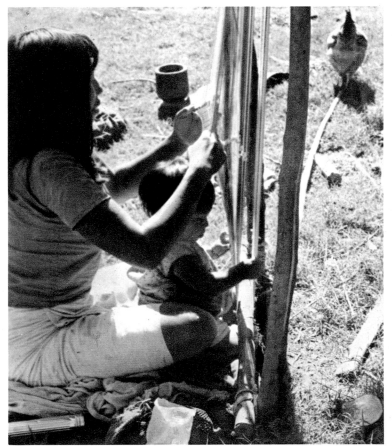

96

97

establishments the workman is likely to be subjected to the deadness of outward uniformity and the gnawing pressures of his inner self seeking release. The very fact that in the modern highly sophisticated period a compelling need is felt to reach back into the remote past, with its naïvety and simplicity, to try to flood our being with its springlike freshness, is a clear demonstration of this sustaining role of crafts. Under social pressures, the essence of things gets overlaid by more superficial layers of modes and manners. It has been truly said that the virtue of a plant is in its seed and its form in its first shoot. Craft is not a disinterested extraneous function complementary to life but divorced from the inner being of the community. Rather it is an intensification of life, a stirring of the pulse, a quickening of the heart, a releasing of the muscle, in short a compelling and natural mode of expression.

Crafts are not stylized imitations of nature but actually help to harmonize life with nature. In a way, they teach us what to look for and how to see. Craft forms have roots in the soil as well as in the imagination of the craftsman. They become a direct and sincere expression of the character and life of the people, and therefore speak a language all their own. As the saying goes, music is more intelligible to the musician than speech.

In the present age where crafts are exposed to many dangers, a particular responsibility devolves on craft lovers. It is significantly said that the disintegration of a craft-oriented society is reflected in the disintegration of its crafts. Crafts need not, of course, be bound up exclusively with tradition. For life is on the move and patterns of living change with habits and customs. New relationships are evolved with the current flow of life and new traditions created. But there are certain values indispensable to mankind which crafts preserve, and those craftsmen and craft lovers who draw on this perennial spring of inspiration and experience its unchanging sense of fulfilment have a precious charge to keep.

New exchanges are taking place in many spheres and fresh breezes are wafted across that touch and transform worn-out and weary spirits. The long centuries of political and economic rule of some regions by others are giving way to a growing realization of a common brotherhood and destiny of mankind. The less industrially developed areas have retained more of the craft heritage along with their other traditions. As they emerge from the old suppressions and come to life, these things slip into proper perspective. The result is a growing realization of the significance of their contribution to the world of culture. The people of the former ruling countries too are waking up to a greater discernment and appreciation of the gifts and qualities the newly freed have to offer. Today, much of the old obtuseness and casualness on the part of the more industrialized peoples towards the less industrialized nations is giving place to a more intelligent and sensitive understanding of the old cultures and traditional values, and a recognition of the need for and significance of mutual understanding and appreciation and exchange. There is also a realization that the tissues of an older way of life are not to be swept away like so many cobwebs, for to a sympathetic mankind they reveal untold charms and subtle and restrained overtones of abiding value and vibrant meaning. Anand Kumaraswamy, the great interpreter of oriental arts and crafts, says that 'years ago, under pre-industrial conditions, the public had perforce to accept good art, good design, good colouring, because nothing worse was hardly available'. Now mass production under advanced mechanization places the ignorant and the aesthetically untutored at the mercy of those who seek larger margins of profit. The time for a choice has come. Good taste and greater opportunity to live in intimacy with beauty should not be the privilege of the few, but the common inheritance of all. This is what the crafts have to teach and offer us. The two paths have already crossed. Western science is no longer regarded as just a mechanism but has acquired also an element of philosophy.

The role of crafts in the economy of a developing country has become a subject of world-wide significance. Economists all over the globe have directed their vision and experience to

this study. And indeed it is clear that a sentimental regard for traditionalism alone will not take us very far in our effort to give these ancient activities a modern vitality and meaning. The modern demand is for beauty as a supplement to usefulness. Then again, the concept of usefulness itself has changed because of the transformation of our modes of thought, of living habits and environment. Nor is there any longer the same fastidiousness for the purity of material or the authenticity of form. With the advent of cheap alloys, even for jewellery, artificial silk and synthetic materials like plastic, the emphasis has definitely shifted to cheapness. Similarly, the insistence on durability has been replaced by a demand for greater variety. Modern taste is restless and prepared to renew and replace articles more easily and more frequently.

It is therefore in the very nature of the craft industry that great sensitivity and delicate handling, infinite patience and tireless perseverance will be needed before crafts can play an appropriate role in contemporary society. The public must bear with this great heritage of mankind in its period of mutation, and remember that even though its birth and flowering belonged to another age, another atmosphere, a totally different pattern of living and tempo, it nevertheless has something significant and important to bring to the modern context. There is nothing spectacular about crafts. You do not find them in imposing structures humming with life and lit by million candle-power lights. Thay have mostly to be unearthed in twilit corners and humble cottages. Even though millions are engaged in crafts all over the world, they are never found in large concentrations. Their tools are modest and unostentatious. The importance of crafts cannot therefore be measured through super structures or streamlined machines. They speak of an age when dignity lay in silence and beauty in subtlety.

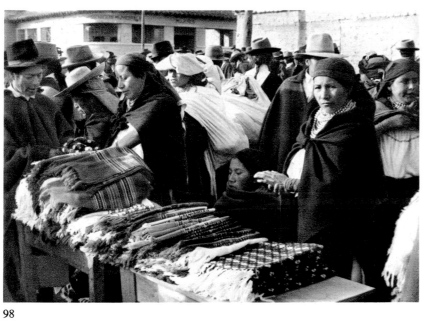

98

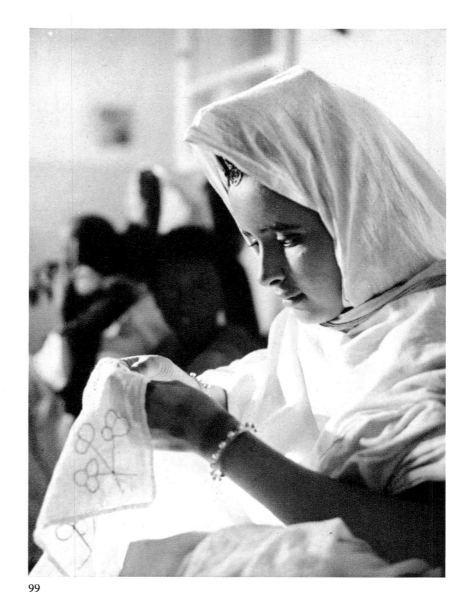

99

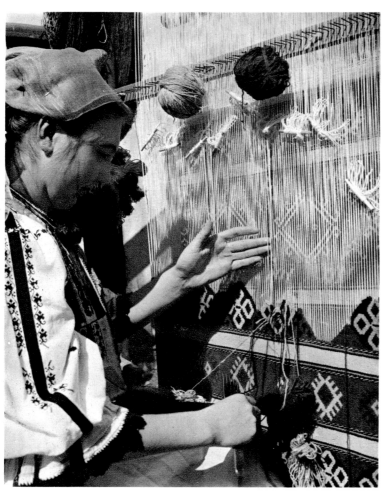

100

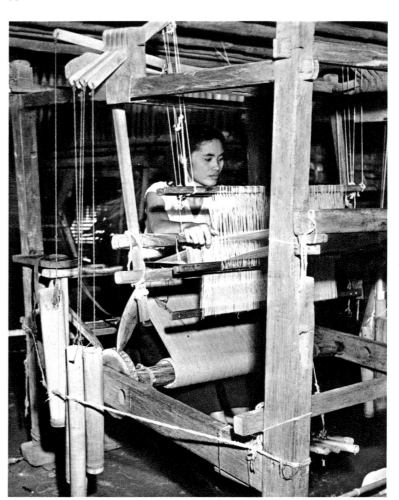

101

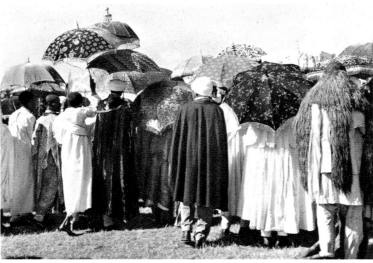

102

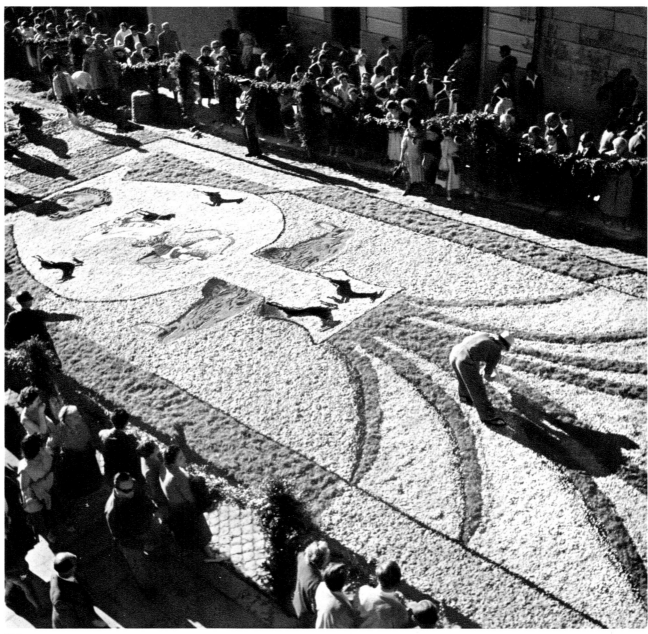

103

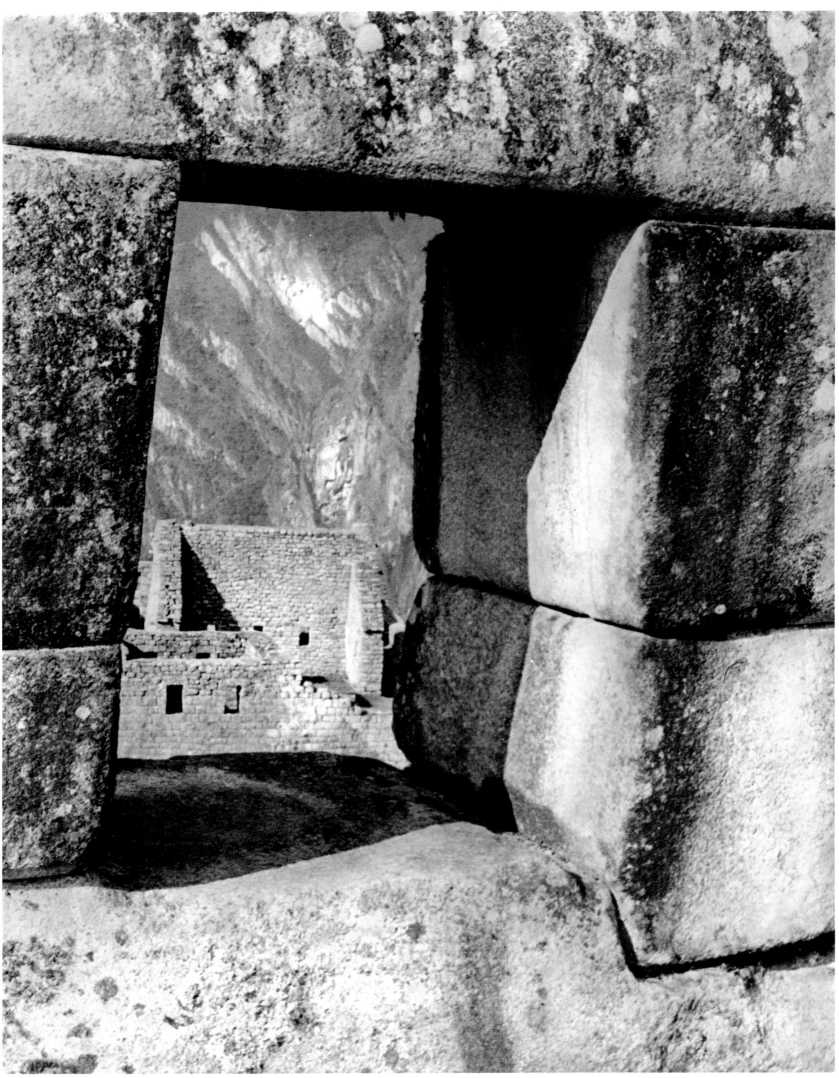

Chapter III

Architecture
and the human requirements of our age

Pier Luigi Nervi

Over the last few decades all intellectual pursuits of a characteristically artistic nature have been undergoing increasingly rapid and revolutionary changes in respect of both ends and means. The time, therefore, could hardly have been better chosen to stop for a moment and take a new look at the situation, attempting—if this is possible—to see what the results of this headlong development have been and in what directions it is now tending. I shall try to put forward some ideas on architecture, which has been defined as 'the art and science of constructing buildings adequate in terms of durability, beauty and economy to fulfil the specific functions for which they are intended'. I feel it necessary to stress these points because architecture is often made to include town planning (the art and the technique of organizing, not of building), as well as research on questions of form without direct bearing on the actual design and construction of buildings. An architectural work has meaning, and can be assessed, discussed and examined, only when it has become a real building, and can thus be judged in terms of functional adequacy, solidity, durability, economic justification and true aesthetic effect.

Never, I believe it could be said, in the whole history of building, has any period been so interesting and so wide-ranging in architectural discussion and theory as these past few decades. But inevitably, what this largely academic concern turns upon and involves is not so much architecture itself, exemplified in actual buildings, as the misleading image, one might almost say, the simulacrum of it propagated in pictorial form, in cultural and professional milieux, through the press, through competitions for new buildings, through the vast number of architectural reviews in circulation and through specialized teaching.

The result is that a great deal in architectural development and its new trends is judged, criticized and adopted from designs that attempt the impossible: to show on paper, necessarily always on a greatly reduced scale, something which in reality will be a large and complex organism that will be seen, and appreciated or criticized (as of right), by those who have

to live in it or see it as they move around it, and that is primarily called upon to be stable, durable and reasonably cheap. It is too often forgotten that plans are very difficult to read. Each architect has his own personal technique of draughtsmanship whereby he contrives to get an idea on to paper, refining it at each successive step of a lengthy study, so that when he looks up from his drawing-board, he can form a reasonably accurate mental picture of the entity which he has been trying to represent and which is to take shape as a real building in the future.

Even more grave and harmful than the value increasingly attached to the architectural design on *paper*, in publications, in schools and in the criteria applied in architectural competitions, is the resulting contemporary tendency to disregard the true essence of architecture, its fundamental values and the relevant constructional, functional and economic considerations.

Architecture during the next decade will probably have to adapt itself to two well-defined requirements: on one hand, the need for large, public, multi-storey buildings for office purposes or housing in urban centres; and on the other, a growing demand for residential buildings which, it is easy to foresee, for obvious technical and economic reasons will increasingly involve total or partial prefabrication. Both of these imply dispensing progressively with all those forms of decoration with which it was customary to embellish buildings of all kinds from the earliest times up to the first few decades of this century. This does not mean that there will be any lack of new forms of aesthetic satisfaction, deriving from structural forms, the relations of mass and space, contrasting or imposing dimensions, the beauty of surfaces and materials.

But all these are things which elude graphic representation, whereas it is quite possible, by the simple use of light and shade or perspective, to give an almost photographic impression of capitals, cornices, entablatures or the actual texture of a wall in brick or stone. But can one possibly convey the impressiveness of a building hundreds of metres high, the reflections from a glass wall, the beauty of metal surfaces, or the

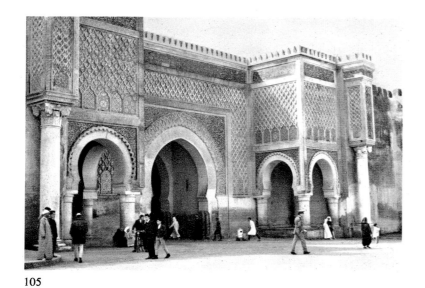

105

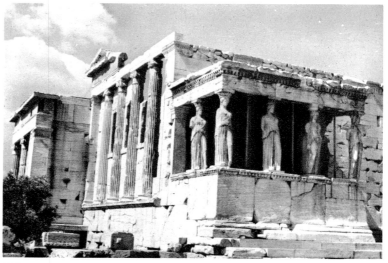

106

107

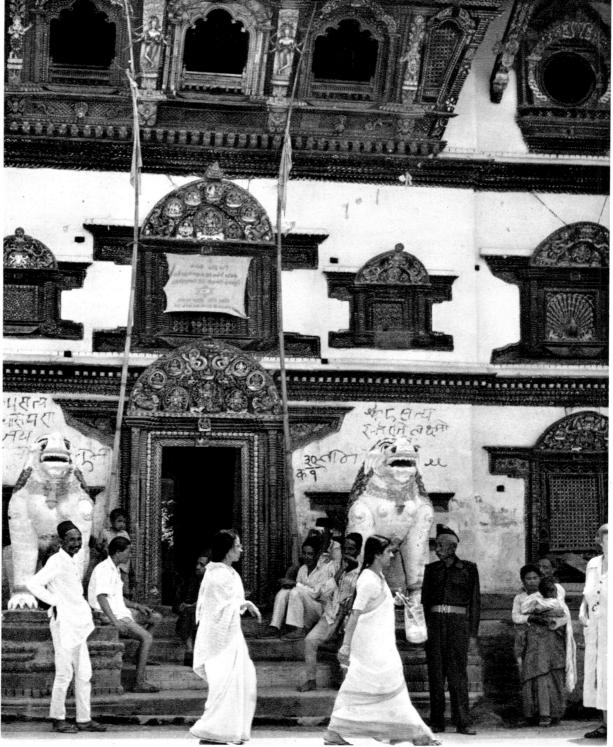

108

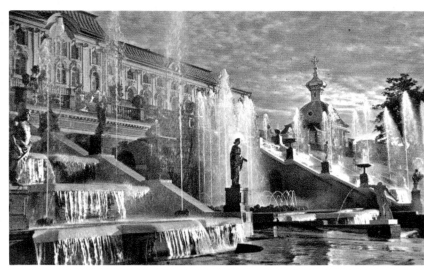

109

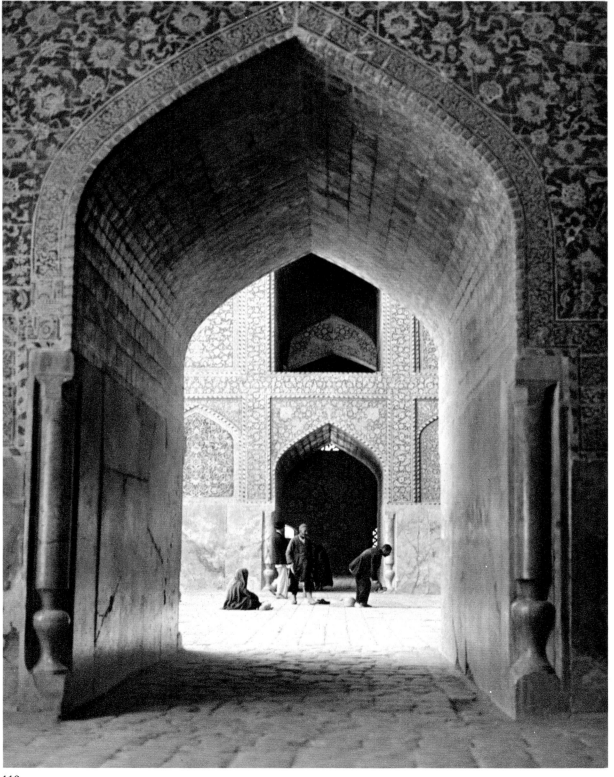

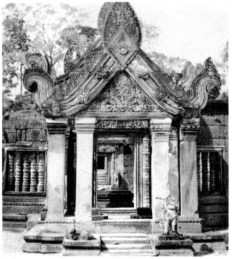

111

110

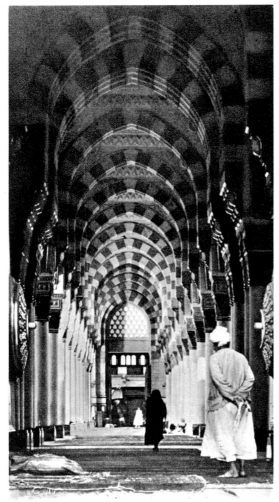

112

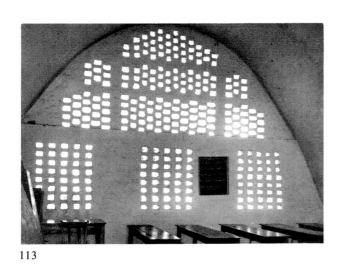

113

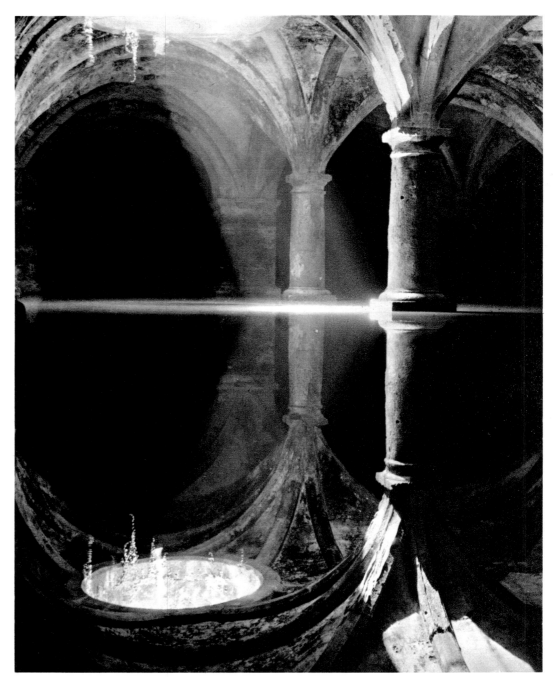

114

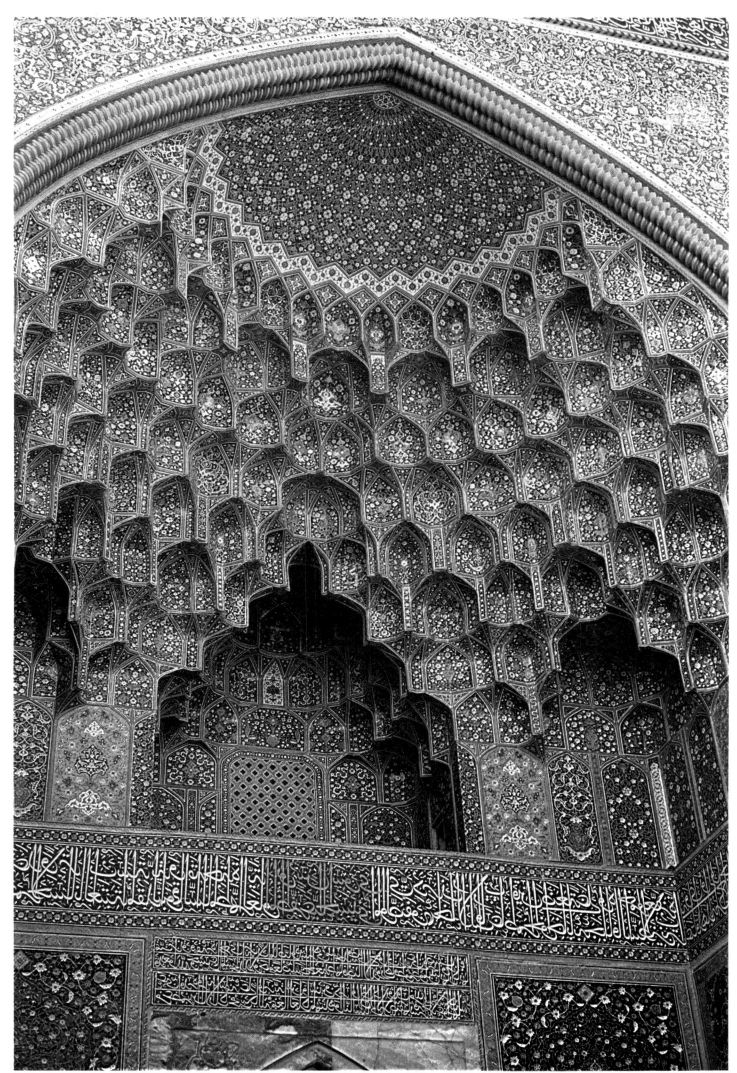

115

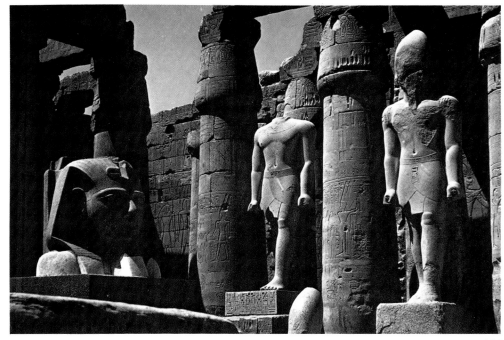

116

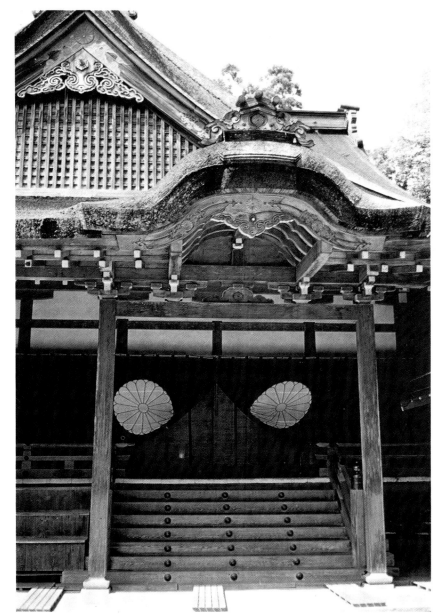

117

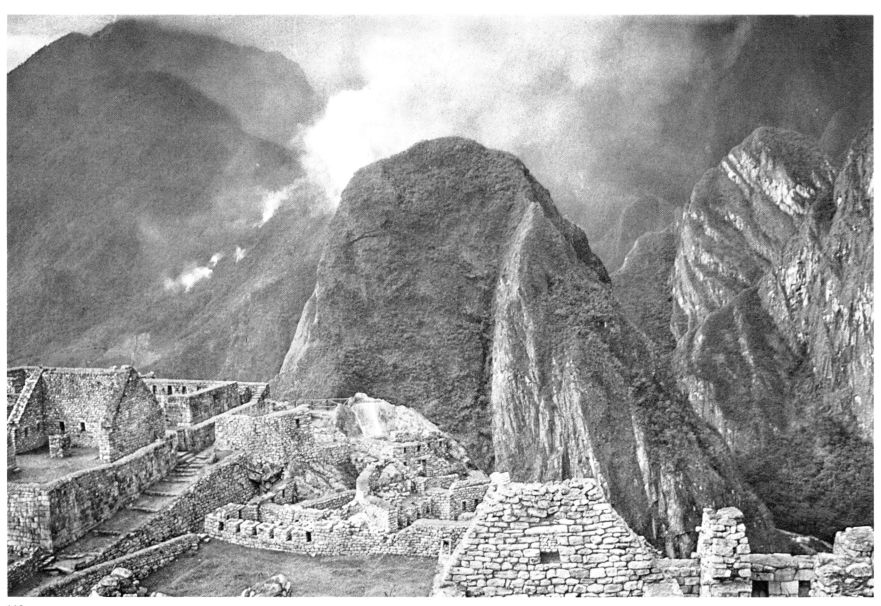

118

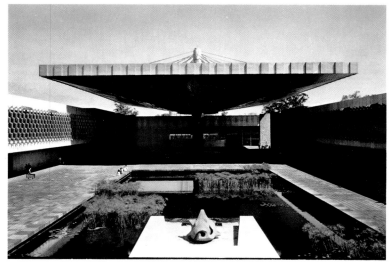

119

120

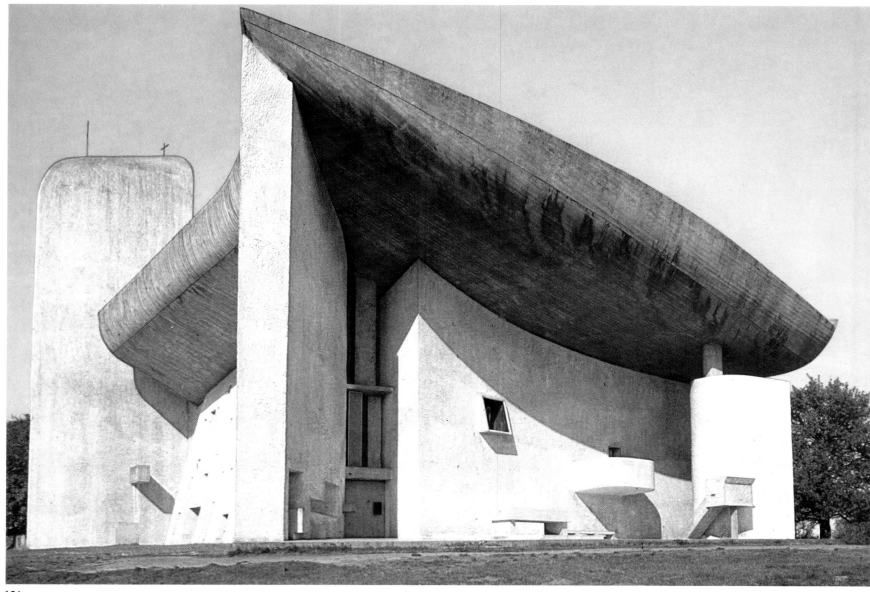

121

geometrical perfection of their form? The interpretation of architectural drawings will thus become more and more difficult, and their usefulness as a legible image of the future edifice more and more questionable.

There is another aspect of architecture which is destined—one might almost say doomed—to influence building in both the immediate and more distant future. The conquest of height, the only real constructional revolution in architecture in the past fifty years, imposes formal restraints and imperatives that are bound to become ever more demanding. It is no longer possible to conceive of buildings upwards of 100 or 200 metres in height merely as 'forms', embellished with the decorative elements that have been used, with variations of style, for thousands of years, for these would represent an intolerable increase in weight and a considerable aggravation of the already troublesome wind factor.

Again, when we come to the question of prefabrication and the very welcome trend towards standardization of building units, we see how economic considerations and more particularly the gradual disappearance of such skills as plastering, stone-cutting and finishing, call for a new spirit of inventiveness. Here there is fertile ground for research in the wealth of materials now available: metal, glass or enamelled surfaces whose mechanical precision and purity of colour can themselves become beautifying elements, but which because of their very beauty elude all attempts at previous representation on the drawing-board.

Indeed, it seems to me that one of the most serious dangers of the present time lies in a certain purely formal approach, quite unconcerned with the actual realities of building, in which can be discerned the desire, if not the compulsion, to give free play to the designing imagination that is now denied the outlet of decoration. Many architectural designs published in the specialized reviews make no secret of the feverish search for new forms, the majority of which bear no relation to any sort of structural feasibility. They are still-born, and yet they are hailed as examples of a daring modernity which, on closer examination, reveals, beneath its various forms of expression, the ornamental fantasies of a neo-decorativism repudiated in certain outward aspects but adhered to in substance.

Architecture is construction and as such it cannot evade obedience to all the objective limitations imposed by the materials it uses and to those laws, not made by men, which govern their equilibrium. Yet I firmly believe that implicit in this obedience are to be found the real seriousness and that independence of passing fashion that have always characterized true architecture, whether imposed by the specific qualities of the marble in the Greek temples or the massive brick-work of the Romans, the delicacy of Gothic, or the great structural possibilities of the materials and techniques of today that take up so marvellously well the daunting challenge of the problems of contemporary social and technical development.

It is obviously out of the question to suggest that representation by drawings, either in teaching or in general architectural practice, should be proscribed absolutely. One may nevertheless insist upon the fact that every design should always and in all respects be related to practical building in the sense that it should always be a faithful representation of something that from one day to the next could become an actual structural reality. In other words, all architects' drawings should be critically examined, not only from the point of view of form, but as practical structural propositions, and rejected as useless and unsuitable if they fail, in any single respect, to satisfy the essential requirements of solidity, durability and economic feasibility. This is a particularly important consideration both in teaching and training and in the adjudication of architectural competitions.

All this underlines the danger of a gradual drift towards a kind of pictorial architecture influenced by a (presumptuous) quest for formal innovation similar to that which, in the untrammelled freedom enjoyed by the other arts, has revolutionized painting, sculpture and music.

The actual requirements of building fix certain clear and imperative limits to architectural practice which save it from

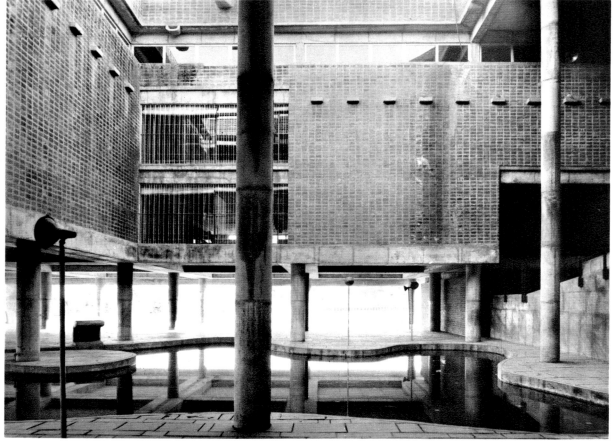

122

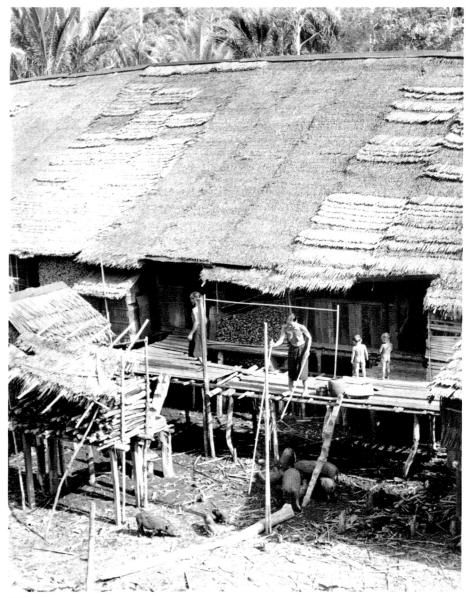

123

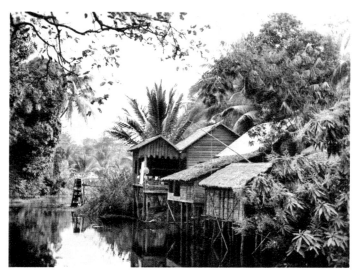

124

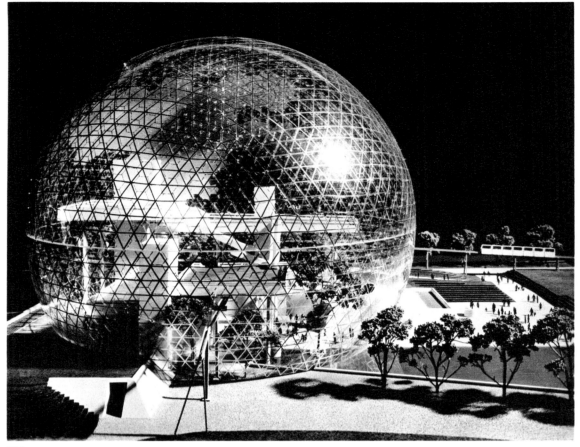

125

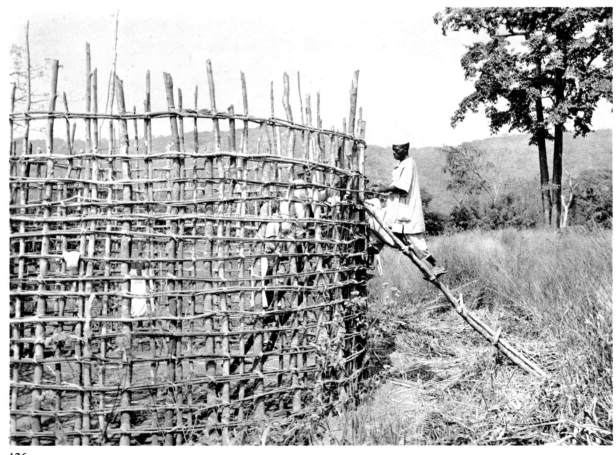

126

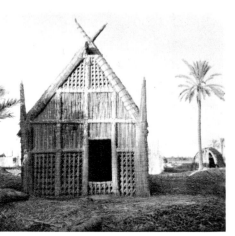

127

the worst excesses of passing fashion. Which is just as well since buildings are, by definition, built to last and will certainly outlast the fashions in which they were conceived and which, once discarded, will become intolerable. This is not to say that architectural forms and aesthetics should not and do not change with the times—this they always have done—but simply that in both the manner and the magnitude of such change there should be a greater dignity and sense of proportion, responding not to fashion but to the very essence of the culture, technology and spirit of the age.

The contact of the builder's art with reality, the respect it is obliged to pay to the laws of the physical world and the consequent restraint upon irresponsible flights of fancy, the fact that its works are lasting and transmitted from one generation to the next and, short of actual destruction, plain for all to see—all these things impose a greater responsibility on architecture than on the other arts, a responsibility to which all its practitioners must be profoundly sensitive.

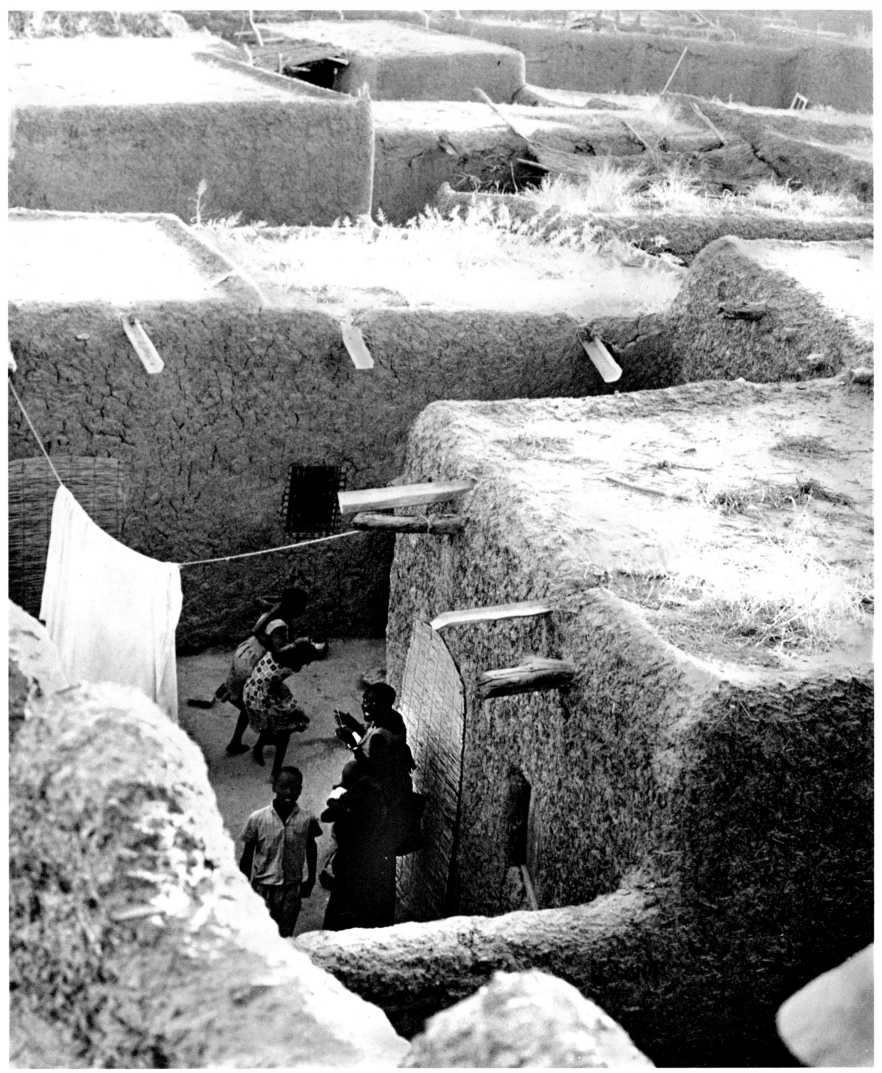

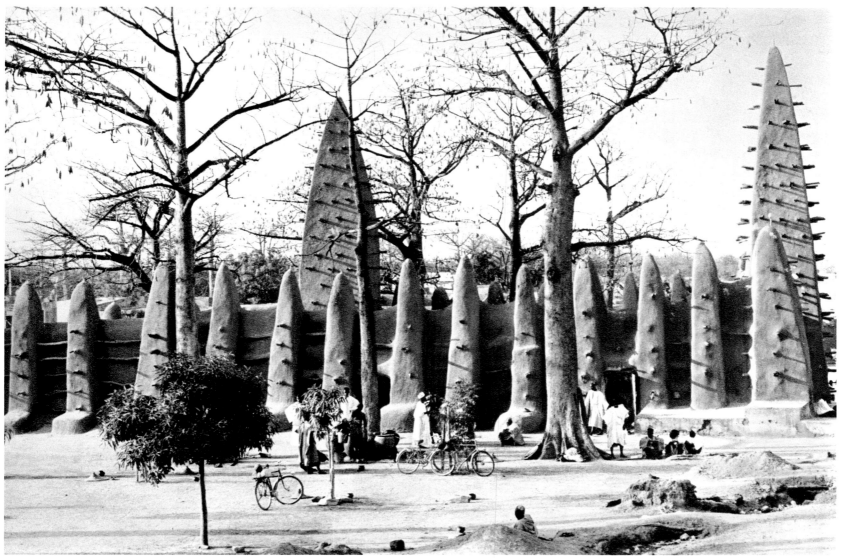

129

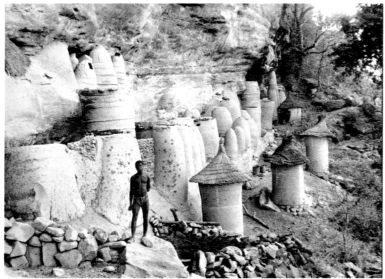

130

70

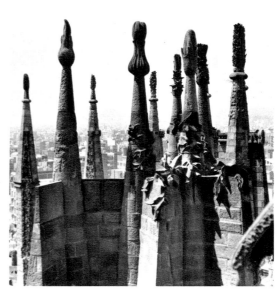

131

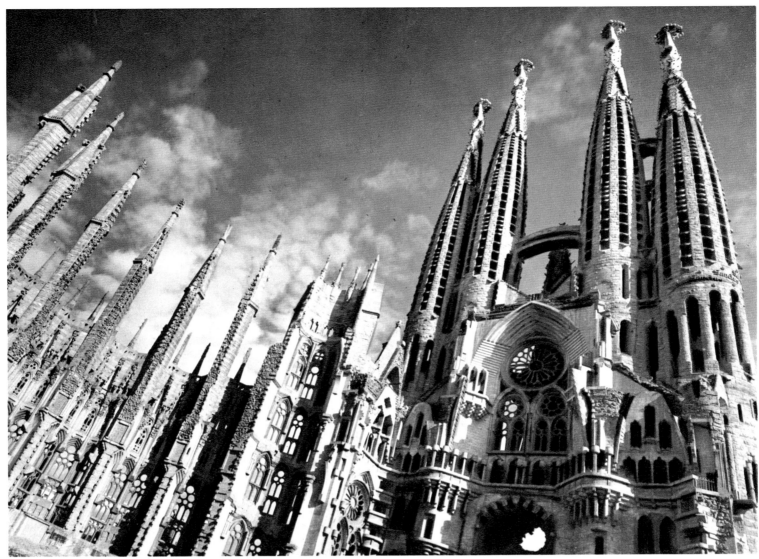

132

133

134

135

136

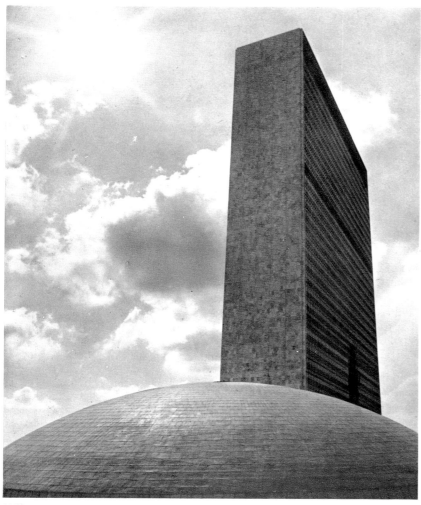

137

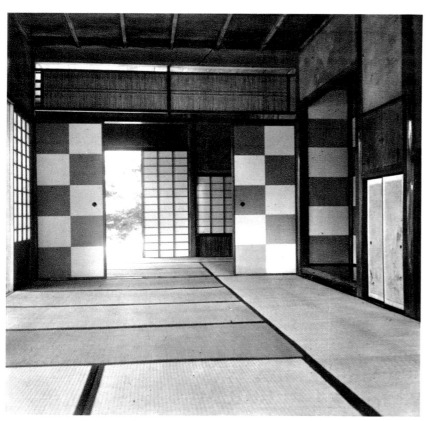

138

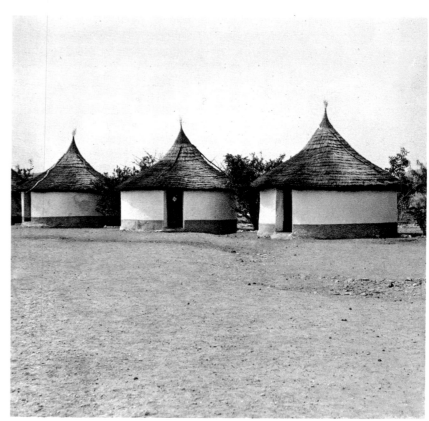

139

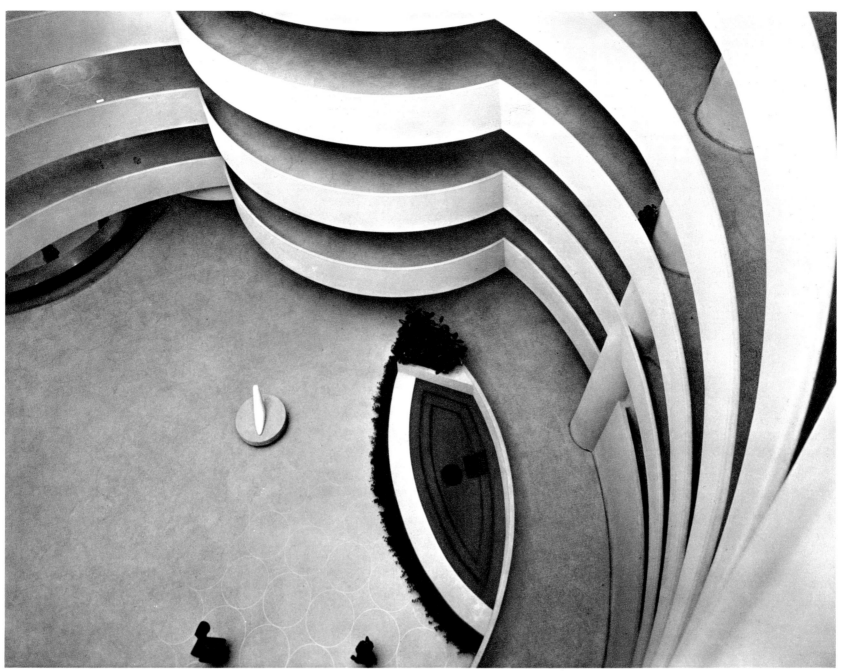

140

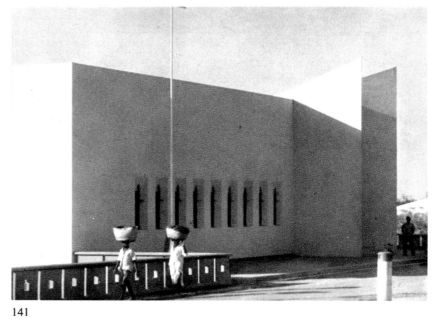

141

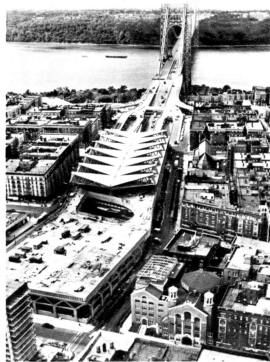

142

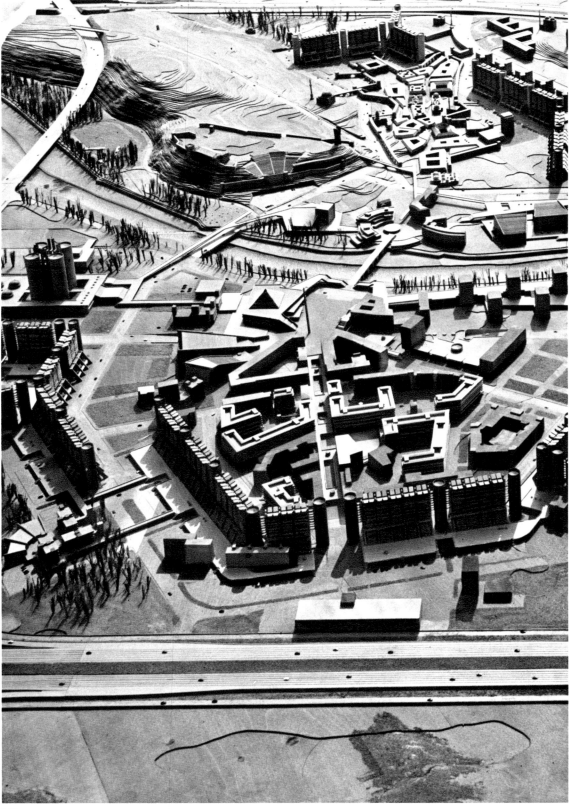

144

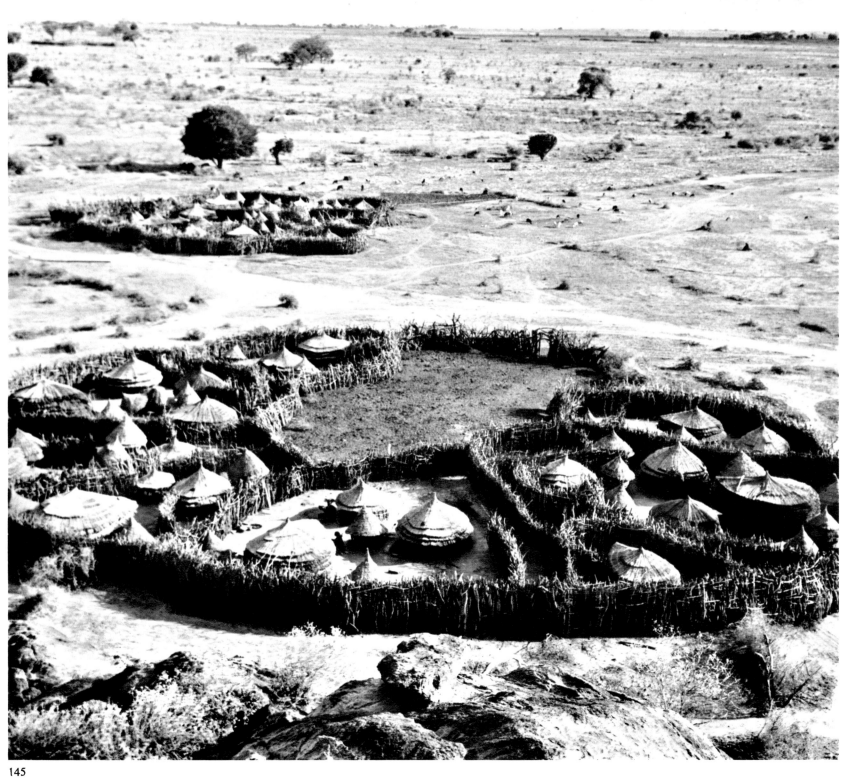

145

146

Chapter IV

The contribution of industrial design to twentieth-century aesthetics

Basilio Uribe

It is generally agreed that there are certain objects which are distinguished from the generality of things by their aesthetic qualities. Such objects are recognized as being the products of artistic activity, whatever the particular meaning we attach to the word art. If we look more closely into the features that distinguish these products we shall see that each is unique of its kind. Further, we shall perceive that they were not made to serve any specific purpose or use. Indeed we may be sure that in so far as they do fulfil some practical function, they do not conform to the canons of art.

Neither of these notions is new. The idea that a work of art must be unique is one that originated many centuries ago, probably at least seven, when the distinction was first drawn between craft and art, between proximate and ultimate qualities, previously undifferentiated in the notion of craftsmanship. And the belief in the non-utility of art doubtless originated at the same time, slowly and hesitantly, and for much the same reasons, since anything which is transcendental by definition serves no practical purpose. It is clear from contemporary accounts that many centuries passed before artists succeeded in gaining recognition as a specific category; though the difference in the importance attached at that time to a portrait—this was the age of the iconographic notion of the portrait—and a shoe cannot have passed unnoticed. Only the traditional prestige of the crafts could perpetuate the confusion and argue that skill was a necessity to the crafts, just as the spirit needed a body and the intelligence a brain, but nothing more. It is only recently, however, that these two conceptions appear to have finally gained general acceptance. They came to be taken for granted, over the last hundred years or so, first by art theorists and critics and then, to an increasing extent, by the public at large; they are now so firmly rooted that they are coming to constitute the implicit basis for all informed public art appreciation.

But the fact that a general consensus of opinion has been reached now enables us, for the first time, to scrutinize what is thus commonly accepted with that rigour which only becomes possible when all opposition has disappeared. We are now in a position, if we are clear-headed enough, to entertain the doubts that all commonplaces naturally arouse and consider whether the above hypotheses are correct, and if so, in what way and to what point.

The admission that art serves no utilitarian purpose raises the question whether the so-called creator of art is not in reality its servant, and whether the creative attitude of the artist is not in fact a cult paid to art. No one who has witnessed the seriousness, the devotion often, which the artist brings to the object he is creating and realized how, in these moments, he constitutes with the object of his creation an indivisible unity such as escapes the understanding of philosophers and art critics, will dispute the truth of this statement. There can be no doubt that the artist in the act of creation—as opposed to the man as he appears in everyday life—is bound to his art by certain very special ties which, in genuine cases, strange though this may seem, are of a religious nature. The fact that the unknown God dazzles him with an unaccustomed facet of his being does not alter the nature of the bond.

When applied to some aspects of the artistic scene, such a claim may appear extravagantly unreal. For here the dead leaves not only conceal the fruits, but are also visible from much farther off. Many so-called artistic activities are no more than peripheral and have nothing to do with the true substance of art. Nor indeed does the too obvious indifference, cynicism or absence of moral values of the man who, through diffidence or lack of discernment, obscures the nature of such artistic phenomena as he may occasionally be concerned with.

If the foregoing is correct, and art *is* an activity of an authentically transcendental kind, then there are conceivable reasons for contending that each individual work of art must be unique. If not, there is no point in believing that anything which is finite and foreseeable could possibly be unique; since only those things can be unique which cannot be wholly foreseen or planned—otherwise they would of necessity have to submit to the will of their creator. Works of art cannot be

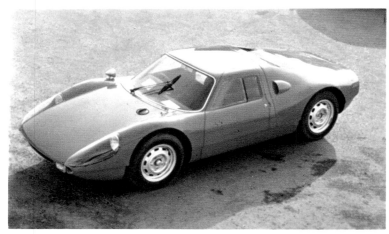

147

148

149

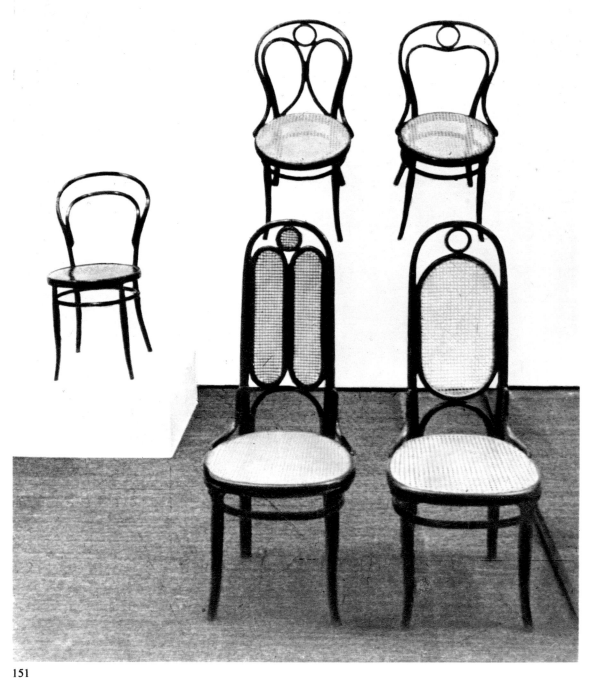

150

151

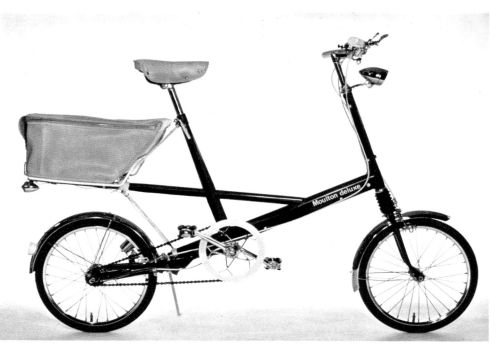

152

created with mathematics—at least in so far as the interplay of mathematical elements is something that can be cognitively grasped and fully explored.

It is customary to speak of twentieth-century aesthetics in the same way as we might speak, for instance, of fourteenth-century aesthetics, although in fact it is evident that, in our century, the whole question has assumed different dimensions. If absolute time indeed exists, we are not aware of it; we apprehend it only in relation to space. As long as man journeyed on foot or on horseback and the world could not be encompassed, there was a sense in which one could talk about the sensitivity and perceptivity of a century as a whole, but things have now changed. Now that the impact of events is no longer confined to the region in which they occur, but is felt simultaneously over the whole face of the globe, now that traditional frontiers have been swept away by artificial satellites circling the earth every sixty minutes, now that computers can solve in a moment equations that once would have taken more than a lifetime to work out, what is the sense of talking about the aesthetics of a period whose extent can only be defined in relation to the space that can be traversed in that time? There is no one aesthetic pattern, no one way of understanding and appreciating the twentieth century: the first fifty years of the century saw many such patterns, there have been countless others in the fifteen years or so that have elapsed between then and now, and many more will emerge in the years to come. The aesthetic theories of yesterday are already out of date, those of today are born obsolete, those of tomorrow will cease to apply even before they emerge. Any visitor to an exhibition of contemporary art cannot help feeling, *ad nauseam*, that no real novelty ever sees the light, only that a new triteness is being born. As though emerging from its Shangri-La, the countenance of eternal youth disintegrates and falls to ashes directly it reaches the everyday world. The fundamental problem of present-day art is that it fails to create an art that is truly of its time; there is only old art. And it seems inconceivable that any artist, however great, can reflect more than the briefest instant of our age. A Picasso has already become an impossibility.

'To sum up', says R. G. Collingwood, in his excellent book *The Principles of Art* (1938), 'aesthetic theory is the theory not of beauty, but of art.'

The emotion which seizes us when we are confronted with a natural landscape is different from that we experience when the scenery includes objects made by man. Before the untouched landscape, we feel a little as on the first day of creation, in the presence of a world which is not yet ours, of which at most we form part, but which overwhelms and immeasurably overflows us. We may perhaps feel that we are in communion with it, but that union is indefinable and awful. Pascal, observing the stars, expressed such a feeling: '*Le silence éternel de ces espaces m'effraye.*' And Rilke was probably referring to something similar when, in one of the *Duino Elegies*, he speaks of beauty as the first degree of the terrible which scorns to annihilate us.

In the second case, however, there are familiar references to reassure us: houses, bridges, the wall, the church or the aqueduct are, or could have been, something made by our own hands. The world has become our garden to a greater or lesser extent. Whatever uncertainty lurked in our minds has disappeared; we are no longer ill at ease, nor are we at the mercy of the hidden forces of the dark or the unknown.

These two emotions are distinguished inasmuch as, whatever their semiology, the former continues to be deep and uncontrollable, whereas the latter is less violent and incidental, more permanent and constant, more akin to our reason. The emotion inspired by a virgin landscape is conveyed direct, without mediation or restriction. The second is also an emotion, but it is an emotion which is experienced only from the point at which the work of man is seen to be present, thus being in a sense an emotion linked to another emotion; and it is this situation which appears to constitute the point of departure of the aesthetic emotion. If this is so, it will naturally be experienced in its greatest intensity in the presence of a work of art.

153

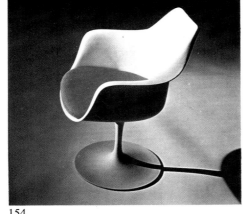

154

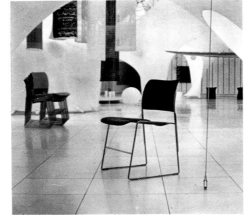

155

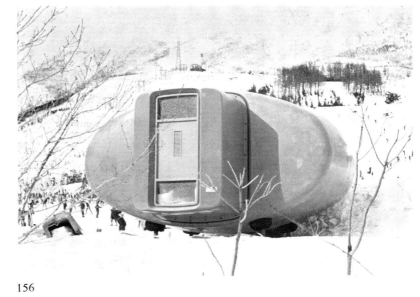

156

157

158

159

160

162

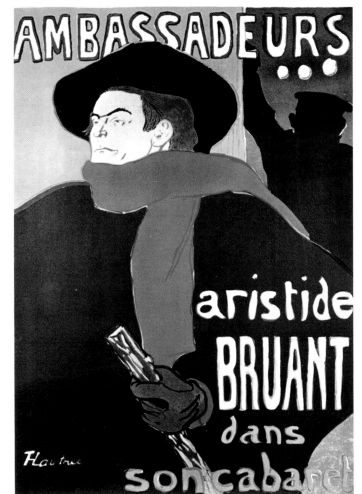

163

164

165

166

167

168

169

170

171

Collingwood attributed secondary importance to what we are in the habit of calling works of art; in his theory, he considered them by-products of art as such, which in his opinion was a purely mental activity. This is not the view we take here: there are no such by-products. Works of art are the only certainties in art. The artist's activity in its most characteristic manifestation cannot take place independently of the work of art itself. There is no pre-existing mental image which materializes and assumes a form, but a penetration, through matter, into the total intuition that motivates the artist; a discernment of his intention which he himself discovers little by little, and which moves simultaneously with the object he is making towards the ultimate that is never attained. In every creative activity there is a vigilant and critical attitude, implicit or explicit, which keeps watch while the artist is at work: 'the dreams of reason engender monsters', wrote Goya on one of his etchings. Sometimes, it will be operative during those periods, long or short, when the artist is contemplating what he has already done, and also before he sets to work; but in any case, the idea the artist has of what will eventually be made is quite remote, and in practice it is always modified while he is actually at work. Critical enlightenment, at best, only points out what is not wanted, thus rendering the search for its own unknown and yet exacting destiny easier to the artistic intuition.

Generally speaking, the best-known art critics of today, when writing on this subject, use the two words, art and aesthetics, far more loosely than we have been doing here. The word aesthetics is very often used to refer to such partial concepts as order, equilibrium or harmony, which fall far short of its full meaning. If we speak of aesthetic emotion as of a state of mind, which is amplified by a specific object that serves as its resonator to a plenitude far beyond the inherent potentiality of the object itself, we shall be speaking of aesthetics in its fullest acceptation. This suggests that we have returned to Collingwood's position, which is valid, though only in part; for what is described here is not the aesthetic or artistic activity of the artist as such, but that of the beholder. Nor do we thereby refuse to admit the existence of a certain virtue inherent in the object itself and responsible for the fact that in this particular object, and in no other, the state of resonance or sympathetic vibration can attain its maximum degree. Although the aesthetic response of the beholder may be experienced in different ways, it is invariably perceived as a sense of absolute totality embracing him who experiences within it. This being so, what is referred to above as the resonator is, in fact, the work of art in the full sense of the term.

There are, on the other hand, other states of mind which do not transcend the objects which cause them, in which the observer and the observed retain the habitual relationships of their habitual environment. Here the capacity of resonance is far from that experienced with the work of art, though this does not imply that such states of mind have not crossed the threshold of aesthetic perception. Aesthetic perception and its concomitant emotion are only experienced in the presence of the works of man—this is a necessary condition. But this perception may be experienced without discernment and it would not be proper to call it aesthetic experience as such. Its threshold corresponds to a further elaboration of the same kind of experience, which is what certain 'resonators' give rise to when, as we observe them, a relationship that may be static, peaceful or calm but always favourable is established, this being attributed, from an external viewpoint, to the order, the balance or the harmony of the object. Of these three, harmony is unquestionably the minimum level which can be said to correspond to aesthetic experience.

The use of these concepts in this way is, however, a fact. If we have insisted on it to the point of devoting more than a third of this article to a description of differing reactions to works of art and harmonious objects, before coming to the subject proper, it is because the purpose of industrial design has nothing to do with art itself, but a great deal to do with harmony.

The notion of harmony is a structural one. It is the result of relating the parts of something to one another, and each

172

173

174

175

176

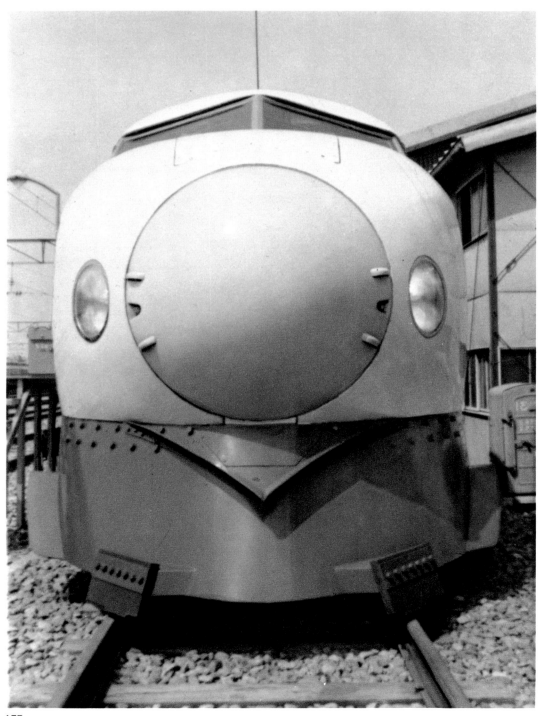

177

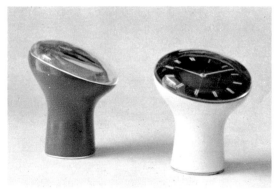

178

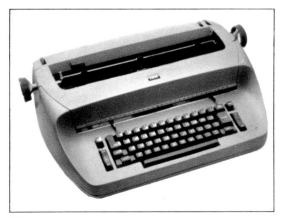

179

part to the whole in such a way that they all accept, sustain and exalt one another. Almost always, when we speak or read of the aesthetics of something, we are thinking in reality of the way in which that something is to be inserted in a whole or in a medium greater than itself, and of the mutually satisfying relationships of formal action and reaction. That they should evoke a harmonious reaction is obviously a primary requirement for useful objects just as it is not a requirement for those which serve no useful purpose. We could not bear to be surrounded by articles of daily use such as tools, utensils, pieces of furniture and so on which get on our nerves. Art, on the contrary, in this respect is supremely free. Goya's *Saturn Devouring his Children*, Rembrandt's *The Slaughtered Ox* or Valdés Leal's *Open Graves* ignore their surroundings and ignore us, even though they may subjugate us.

This, however, is not enough to avoid confusion. Over and over again, industrial design is referred to as an artistic activity. Thus, for instance, Gillo Dorfles: 'If we agree that no clear distinction can now be drawn between applied art and pure art, if we agree that modern architecture, including prefabricated architecture, is art, then we must agree, if only partially, that the industrial object is art.'

The problem could be stated the other way round: what obliges us to consider architecture as art? The architect has never, at any time in history, been regarded as an artist. In what seems to have been the period of his greatest favour, in classical Greece, he acted as organizer and co-ordinator, in a sense it was he who established the laws concerning the spatial organization of the city, it was he who built the city and brought his civilizing influence to bear; it was he who built what had to be built in the way it had to be built. He was never considered a creative artist; not because the Greeks lacked such a notion, as they lacked the notion of art, but because they applied it exclusively to the work of the poet whose name—and this is nothing new—signifies one who creates, which is what the visual artist has come to be considered with time.

Designers frequently object to their profession being associated with that of the architect. This attitude arises from a misunderstanding, but one which is perfectly comprehensible since, unless we explain what we mean by architect, we think at once of an architect in the *beaux-arts* sense. They are thus guilty of the same oversimplification with respect to the true architect as they themselves are subjected to when they are equated with the 'stylists' of industrial products, make-up specialists or hairdressers of the mass beauty industry, 'art directors', the practitioners of applied art or of any of those activities which Mumford, in *Art and Technics*, designated equivocally as industrial design and which he justly declared to be one of the perversions of contemporary culture.

But it will be clear to the impartial observer that both the industrial designer and the architect alike are called upon to deal with pragmatic problems and to produce formal solutions expressed in material terms in three-dimensional space on a scale commensurate with their own proportions and capacities as human beings. This is an extreme simplification and it must not be assumed that architects may act as designers as of right. There is much more to be said concerning ambient space, which is the architect's domain, and the internal and parietal space of industrial objects, which is the designer's domain. And also, of course, concerning the overlapping of these two approaches to the problem of space. And also again concerning the meaning of mobility in the world of the designer and immobility in that of the architect. All this may be summed up by saying that design implies a new way of approaching things, but if the basic consideration of approach is the same for the designer and the architect, the resemblance ends there. Design must be learnt as a new discipline, taught by new methods, and informed by new environmental realities springing from the new sense of industry that is increasingly pervading the modern world. The history of mankind, it has been said, may be divided into three periods: humanization, which took millions of years; agriculturalization, which began a hundred-odd centuries ago; and industrialization, the period on which man

is now embarking. Industrial design belongs not so much to an existing reality as to the shape of things to come.

The task of the industrial designer, whose concern is with the mass-made products of industry, is to develop harmonious formal structures which provide adequate solutions to problems of production, economics and utility.

This function is an eminently social one, and the designer is all the more conscious of it in that he himself is a user among the many users of the products of industry. This differentiates him clearly from the visual artist who is not a user of other works of art and never can be because of the very nature of such works. The social attitude of the artist is expressed socially according to the personal inclination of the individual. That of the designer, however, is expressed in terms of a double involvement in society, both as a user and as a creator of products manufactured for its use. Such a relationship is a living and complex one—to take an example, objects of current utility are bought and sold in large quantities, are used by people in widely scattered areas and in varying economic circumstances, reflect back on the designer himself, and so on—which is always a characteristic of a focal point in any culture. And this involvement of the designer in the environment, which he himself influences and to whose influence he is subjected, is a situation which does not affect the artist to anything like the same extent, either because of his tendency to isolate himself in order to avoid the useless wear and tear caused by friction with a surrounding climate of misunderstanding, or because he chooses to shut himself away in order to pursue the pure and ever fugitive essence of art. In saying this, however, we ought to make it quite clear that when a work of art is marked by social involvement the resulting repercussions are such as would never be caused by any object of everyday use. The useful object, therefore, must be conceived of as a disseminator rather than a creator of aesthetic culture. But at the same time it must be remembered that its significance goes beyond the confines of aesthetics to enter the greater sphere of influence upon, and consequently exposure

to, its environment. It is in fact, to a very large extent, a technical product, that is, by definition, the outcome of certain scientific findings for which technique offers a suitable field of operation and technology the ways and means of material realization and social appropriation. For, contrary to what happens in the field of art, science cannot communicate with society directly but only through its practical, and usually factory-produced, applications. It is, of course, an economic product as well, a real means of distributive justice, though it is seldom consciously considered as such by the enterprise which produces it. And, at the same time, virtually, it is a complement to man, an extension of his natural capacities, if we think of man as an ergonomic machine.

Of these or the various other points of view from which we could consider the manufactured object, the one that concerns us here is the role it has assumed with the growth of industrialization. Mass produced in increasingly larger quantities, it has itself become a means of mass communication. And since durable consumer goods and manufactured articles of industrial origin constitute practically the whole morphological horizon of everyday life, they have come to exert a decisive influence—much more decisive in fact than that of any of the other media of mass communication, since durable goods and products of this kind go on repeating the same practically invariable message throughout the whole of their useful life, a feat unequalled by the big periodicals or by television or by radio. In every respect man consists very largely of the things he has consumed, and this is no exception. The degree of development of a people's acquisitive culture will always depend on the environment created by the objects produced by local industry. Its average level of formal education, its sense of material values, its idea of quality and of what is required to improve it, will all be the outcome of this landscape of objects for which, in the last analysis, industrialists must be held responsible, though designers are not altogether unconcerned with it either. The breakfast cup of our childhood days, the clock that used to hang on the kitchen cupboard, the sharpener

we used to sharpen our pencils with, the typewriter or the drawing-board of our first job, calculating machines, computers, traffic lights, automobiles and all the other paraphernalia of the domestic garden or the urban jungle constitute the inescapable horizons and the inevitable landmarks of our formal world. Our capacity for the appreciation of the forms of art or of any other aspect of culture depends upon the general cultural background that such objects have made it possible for us to acquire. Thus industrial design is not an artistic phenomenon in itself but its social impact is of fundamental importance to art since it can improve the cultural standards necessary to aesthetic appreciation.

One must not, of course, oversimplify to the point of equating the crude reality of the industrial object as it exists today with the ultimate desiderata of industrial design. As long as this reality *continues to exist*, with all its content of everyday reality, of absurdity and contradiction, industrial design will continue to be, and in a sense it will always *tend to be*. If science is no more than a first approximation to the real, technique, which is the knowledge of knowledge—not of reality but of how to use the knowledge of science—is simply a second approximation. The objects of industrial design belong to the world of technique, whether of technique as a way of using scientific knowledge or of technique as a way of using artistic knowledge. Technique is here given its traditional meaning of a manner of operating of a science or an art. But this traditional concept is rapidly undergoing a change similar to that which has overtaken the concept of art, and it is now pressing on in hot pursuit of the categorization to which it has been subjected, thus polarizing perhaps what was once the magic of the primitive world. But whether this is so or not, industrial design tends to be equated with the industrial object, as long as we understand by industrial design the discipline whereby industrial objects can be adequately produced, and this tendency will continue until the day when science and art, on coinciding with reality, cease to exist—an assumption which for the moment seems rather much to hope for. We can therefore expect to see

an industrial design, followed by another, and then another.

Industrial design, then, tends towards the industrial object; but if we assume that asymptotically—inasmuch as the discipline is necessary to the creation of the object—the two must coincide, it will be interesting to see just where the industrial object stands at the present moment, considering it also as a tendency rather than as an already crystallized reality.

Many of the elements of what is now called op-art, that is, a type of geometrically elaborated art in which composition is governed by optical considerations, have long been subjects of study in certain schools of design. This is considered an essential part of the courses of such schools, since all industrial design fulfils a function of visual communication, sometimes almost exclusively so. To these pure exercises are added various applied activities, such as the integration of colour in a given form, to which a concrete purpose is ascribed. This gradual progression from the abstract to the concrete is comparable to the way the processes of science acquire more useful contours as they are translated into technical or applied terms. Thus it is no exaggeration to claim that so-called geometrical art—and today, in particular, op-art, with its emphasis on visual texture—tends to govern, control or determine the nature of the industrial object in so far as the object is exposed to its influence. Indeed we have already had a specifically op style, and many lighting devices, advertising signs, radio cabinets, commercial packages, to mention no more, owe their existence to the kind of exercise we have been talking about.

Then, at the opposite extreme to the patient, iterative and carefully studied order that underlies this intellectual and aristocratically oriented tendency in art, there is the dionysiac exuberance of pop-art, which uses the industrial object to blow up the whole catalogue of traditional forms in art—including geometrism—to destroy the object itself, to couple it with others to form distinct new units, or simply to show the folly of our industrial civilization by lifting it out of its accustomed environment.

This, of course, as Ecclesiastes would have said, is nothing

new. What we are attempting to make clear here is the part played by the industrial object as a kind of pointer indicating the swing of the artistic balance. On the one hand there is a whole artistic trend which helps to shape the contemporary design of the object, and this goes back much farther than the applied art stage, to the period, before actual creation takes place, when the designer himself is undergoing his training— and even then it is not as art but as an exercise in the analysis of visual problems which the trend has characterized in a particular way by the practical use it has made of them. On the other hand, there is another trend which seizes upon the object as created by industry in order to incorporate it, either transformed or not, into the new iconography. In other words, while in the first instance we have what could be considered a normative action, in the second we observe the digestion of the industrial object by art. And this is what happened over forty years ago in the early days of the theory of design, from which industrial design with all its vices and its virtues was to spring. In 1922 an extraordinary Constructivist-Dadaist congress met at Weimar at the invitation of Theo Van Doesburg, Moholy-Nagy and others. If these two are mentioned particularly it is because they both had a hand in the 'basic course' of the Bauhaus. Van Doesburg was the man brought in to replace Johannes Itten and Moholy-Nagy was one of the most influential figures in the birth of the theory of design. It appears that in fact the only one who knew that the Dadaists were to take part was Van Doesburg, he being, according to Moholy-Nagy, at the same time a visual Constructivist and a Dadaist poet. 'At that time we did not realize that Doesburg himself was both a Constructivist and a Dadaist writing Dada poems under the pen name of I. K. Bonset.'[1] Was Van Doesburg already conscious at that time of the role of the industrial object as an intermediary between one trend and the other? If he was—which is by no means certain—he certainly did not manage to bring about a harmonious understanding between Constructivists and Dadaists, and the Weimar congress, as described by Moholy-Nagy, turned into a purely Dadaist performance.

While some Constructivists like Tatlin and Rodchenko viewed the industrial object as an object of cultural significance and tended in their own activity to abandon the field of art for that of industrial design, the Dadaists exaggerated the significance of the industrial object, elevating it to the status of art. There is clearly a close connexion between Duchamp's ready-made objects and the op-art objects of today. This inflated view of the industrial object was not so much a valuation of the object itself as an explosive attack on accepted artistic tradition.

However this may be, the important point here is to note that the role of arbiter or indicator in this polarization of art between geometry and destruction had already been publicly assumed by the industrial object.

The people who turned out to be really responsible for the teaching of industrial design have been tied to the evolution that artistic trends have undergone during their respective periods of currency. Even when the value of the *Grundlehre*, or basic course, of the Bauhaus is subject to discussion, what remains indisputable is the fact that it has constituted and in many respects continues to constitute the most influential contribution to the teaching of design. In one way or another, from Stockholm to California, the basic course still represents the bones and a good deal of the meat of the designer's education. This means, in effect, that whether by serving as an example to be followed or an irritant to be reacted against, the *Grundlehre* has been the axis about which the whole of industrial design teaching has turned. And this course, which was presumably the invention of Johannes Itten but which resembled a palimpsest on whose identical parchment each successive teacher rubbed out the existing text and wrote his own, developed under the influence of Paul Klee, Wassily Kandinsky and Laszlo Moholy-Nagy, acquiring its final characteristics with Josef Albers. Of these, Moholy-Nagy and Albers at least exercised a decisive influence on the basic course. It is difficult

1. Paul Theobald, *Vision in Motion*, Chicago, 1947, p. 315.

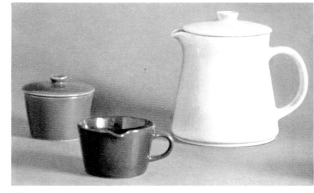

180

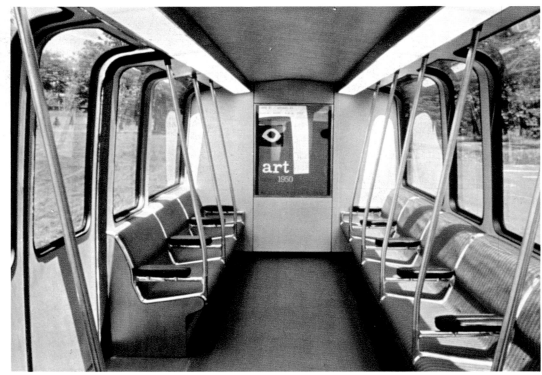

181

182

183

to determine just how much of their previous theories and beliefs went into the course, thus assuming definitive form, and on the other hand how much of what was discovered and experienced in the course itself influenced their own art and enlarged it. But it is clear enough that this double influence did exist and that it enriched both the teaching of design and the general heritage of art. In a way, Albers' painting evolved more and more towards a sublimation of the exercises of the basic course, the most notable example of this being his *Homage to the Square*. And something similar may be said of Moholy-Nagy, bearing in mind however that his field was that of theory and experimentation rather than that of full realization. But this is something which is clearly characteristic of a great deal of contemporary art: its instantaneous quality and easy transition from one working hypothesis to another. In Moholy-Nagy's case this was exemplified in a field derived from two others—light and movement. It is not too much to say that Albers and Moholy-Nagy, between the two of them, cover much of the panorama of contemporary art.

Conclusion

The purpose of these notes has been to draw attention to the following points:

1. The art object does not exist as an entity in itself, but only as a 'resonator'. Within its limits this 'resonator' has a real existence of its own and constitutes the work of art—not as a mental by-product, to use Collingwood's term, but as the recipient of a certain emotional transference capable of producing the full state of aesthetic excitement in the beholder.

2. There exist other minor resonators incapable of producing this vibratory plenitude. At this level, industrial design has a structural role to play in the establishment of harmonious relations with the various environments concerned—economic, technical, cultural and functional.

3. Industrial design does not belong to the domain of art, though it is of fundamental aesthetic importance as a culture-spreader, a role which art fails to fulfil completely in contemporary society.

 Industrial design can be interpreted as being a medium of mass communication.

4. If industrial design is considered as an asymptote of the industrial object, the conclusions drawn with regard to the relation between the visual arts and the industrial object will apply to it also. The industrial object is the end-product of a whole visual trend, constructivist in the early days of design teaching, geometrizing throughout, including the op period of today. It is also the point of departure of another trend which gives it preference over the traditional or romantic concept of art (Dadaist about 1920 and neo-Dadaist today).

 The domestic, office, factory or city landscape is the actual or potential field of industrial design. This landscape is nourished by one of these artistic trends and devoured by the other.

5. Certain of the people who assisted in the birth and development of the notions of design and industrial design were or are visual artists whose art was enriched by contact with this teaching and provided new avenues for artistic development.

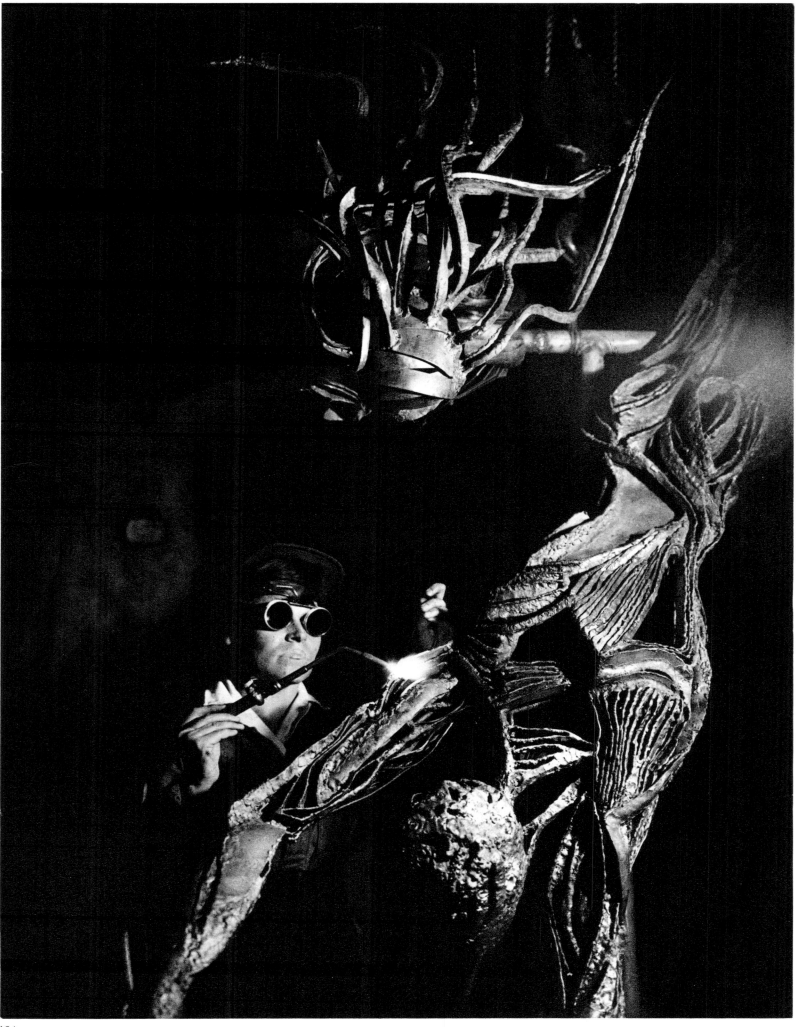

Chapter V

The artist-scientist-inventor

R. Buckminster Fuller

Really great artists are scientists and the really great scientists are artists and both are inventors. I call them artist-scientist-inventors.

I think that all humans are born artist-scientist-inventors but that life progressively squelches the individual's drives and capabilities. As a consequence, by the time most humans mature they have lost one, two or all three of those fundamental self-starters. When I speak of an artist *or* a scientist *or* an inventor, I speak of circumstance-pruned individuals. Pruning can and does force specialization, which can be spectacular, but as with spectacular fruits the result is rarely as rich in taste and food value as the plain average 'good' variety.

During the last half century I have personally found, on the part of the rank and file academic (*ergo* pruned) scientists, an enormous antipathy, a refusal to ascribe importance or even validity, to the phenomenon *intuition*. The academicians have had an over-exclusive fixation on their otherwise fundamentally sound physical experiments.

Some 'educators' have declared intuition to be invalid because it was metaphysical. Thus, they also misidentified metaphysics as being magic. Magic is non-demonstrable by experimental techniques, *ergo* there is no magic with which to identify metaphysics. Metaphysics embraces all the experimentally demonstrable, weightless phenomena such as mathematics and all of thought. Metaphysics is as real as physics and far more durable. The physical is for ever transforming while the metaphysical is for ever clarifyingly resolved towards imperishable simplicity and stability.

When we review what we know about some of the great scientists and their moments of great discovery we find the word intuition appearing constantly in their personal notes. Professor Northrup at Yale University and Alfred Garrett in *Flash of Genius* have each made studies of the personal letters, diaries and family records of a representative group of scientists who are acknowledged by all the world to be 'great' because they made fundamental contributions to knowledge which have greatly augmented the human intellect's advantage over the physical environment. Both examined all the available literature emanating from the 'greats' at the period just before, at the time of and immediately after they made their discoveries. This disclosed the intimate thoughts of the 'greats' when they did not know they were going to make their scientific discoveries or have them acknowledged or made useful.

Northrup found several thought and action patterns common to all the 'greats'. All put intuition above everything else as responsible for their unexpected discoveries. Next most important was what they did within a split second after they had their intuition; and thirdly how they acted progressively in pursuance of their first intuitive insights and again after their split-second 'capturing' acts. All people have intuitions, but it is apparently how they act on them immediately that makes the difference between 'everyday' lives and the 'greats'.

Nothing could be more descriptive of both the great artist and why he does what he does than the great scientist's description of himself. The great scientists and great artists are not only subjective and pure but also are objective and responsible inventors.

I try to avoid the use of words having only mystical connotations. I am not against mystery, but I feel that there are areas where that which seems superficially to be magical or mysterious when subjected to scientific experiment, usually discloses physical principles to be operating logically despite man's ignorance.

Why the universe? is a completely mysterious question and always will be. You will not get any answer to 'Why I?' The big whys will probably never get answered.

Hows can be answered. Intuition to me is a how. I can identify what I mean by intuition as follows: humanity tends to think of its life as being preponderantly conscious and of its subconscious as playing only a minor part. Now, however, behavioural science's electrode probing of the brain and the instrumental documentation of reflex behaviours together show that we are 99.9999 per cent subconsciously operative and only 0.0001 per cent consciously operative. As proof to yourself of

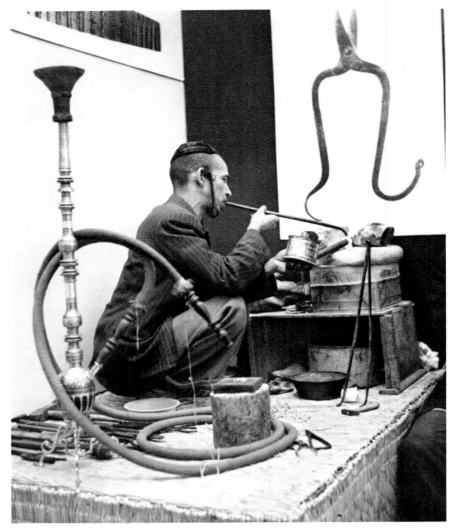

185

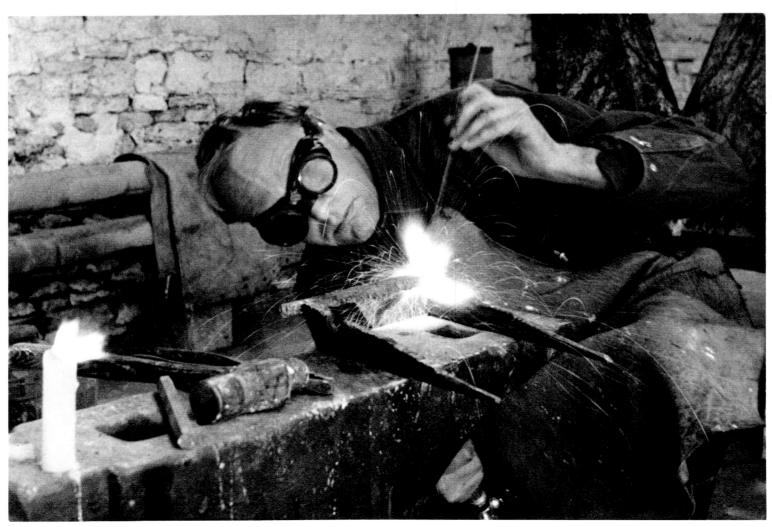

186

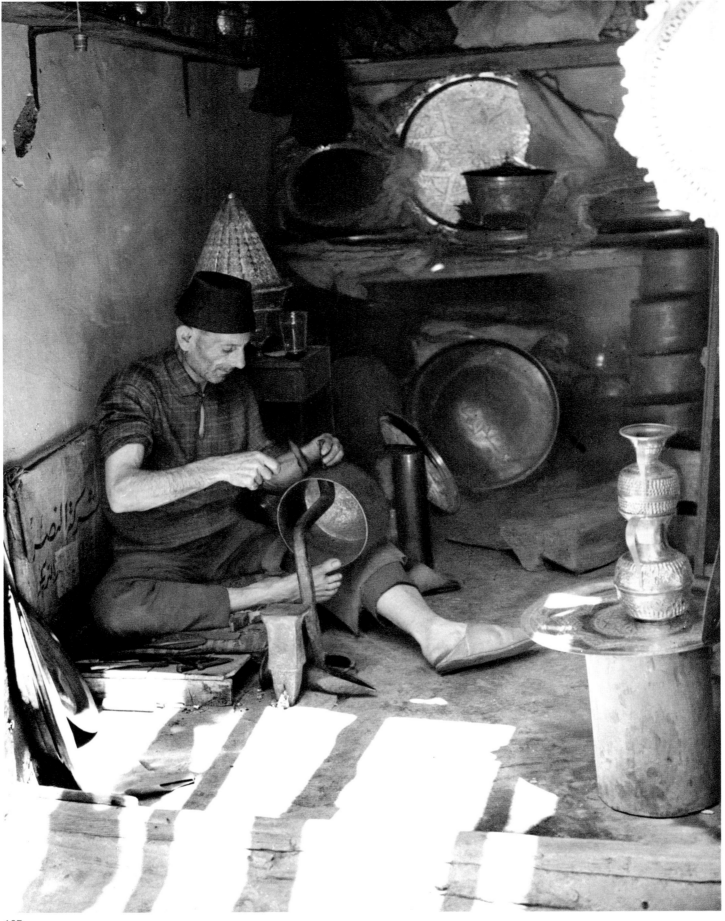

187

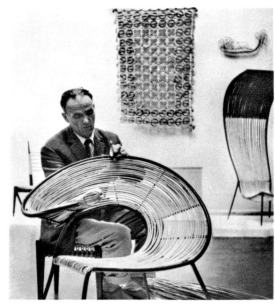

188

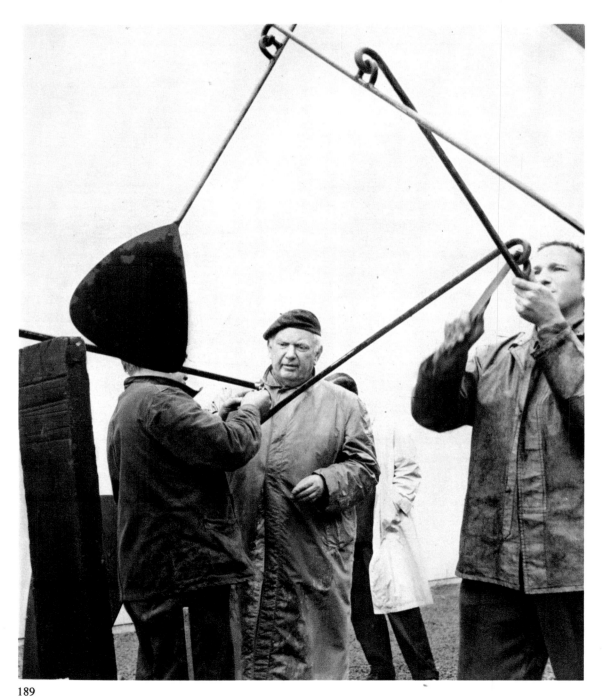

189

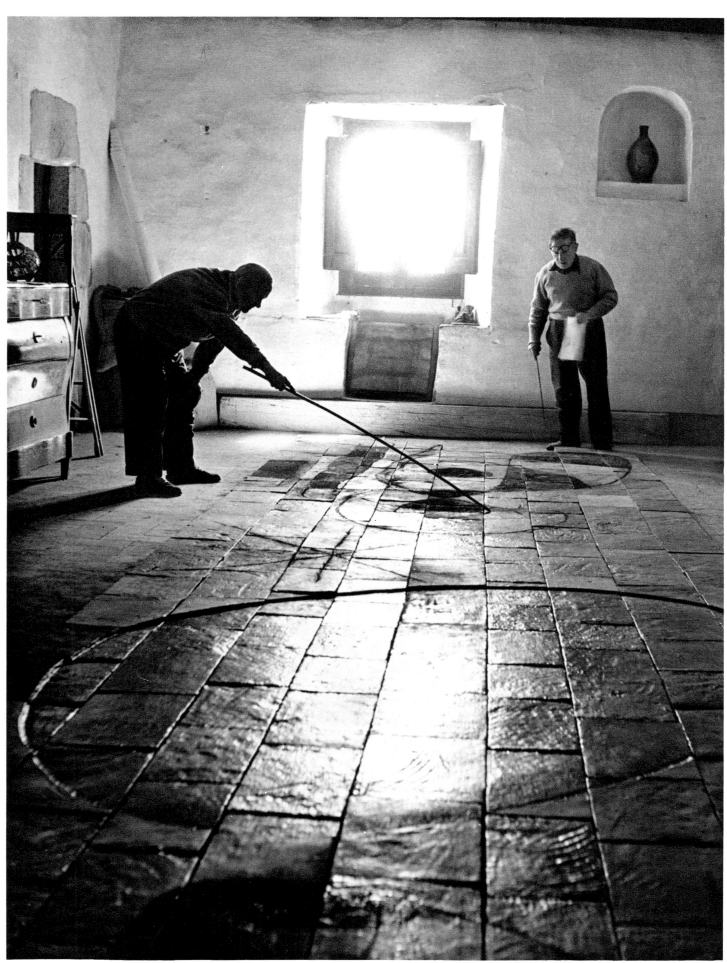

this ratio of subconsciously operative action of the brain, note that each of your millions of hairs is being individually pushed out through your head in well-defined shapes and colours without your conscious control or knowledge of why you have hair. When wounded, your beautiful submicroscopic scaffolding cell crews go to work to repair your locally damaged parts in ways you do not understand. When you eat you do not pay conscious attention to how much of the food is going to be assigned to skin functionings, how much is going to be blood and consciously differentiate out the chemical compounds to be dispatched to your many separate glands and myriad hormone factories. There are approximately two quadrillion times two quadrillion atoms operating in superb co-ordination in your brain. You were not even consciously aware of that let alone being consciously responsible for their co-ordinate effectiveness. Thus we begin to realize the fantastic exquisiteness of the complex functioning of our subconscious selves.

Man is unaware of his tongue until he bites it, unaware of his eye until he gets a cinder in it. When he 'feels well' he is aware only of himself as a whole being. To be sick is to be aware of subconsciously misbehaving parts of self. If humans had to go to a supermarket and buy their individual organic parts and assemble them personally, no humans would exist.

By intuition I mean the semi-conscious shuttle operating over the threshold between conscious and subconscious. I will give you an example. I hold out my arms in front of me with my index fingers vertically erect. I swing my horizontally extended arms away from each other one towards the right and one to the left. I discover by trying that I can still see my two index fingers, both at once, even when they are way out at right angles to my forward sight. I learn that my sight is analogous to a 180-degree wide-angle lens capability whereas I had previously thought of it as being only a forwardly focusing, narrow-angle zoom lens. I thus learn that while I think I am, consciously, only looking forward, my subconscious is keeping track of the sideways events and will often intrude to warn me of lateral developments. The warning comes as an intuition from the actual but unattended side viewing controlled by the subconsciously operative brain which detects familar conditions of danger, etc.

Approximately all humanity is born equal, in the matter of physiological equipment: two eyes, one nose, two ears, two feet. The number of cells in the brain is approximately the same in all people and all people have intuitions.

A child is an active package of intuition. Active intuition is what we speak of as spontaneous. Children are bundles of spontaneously articulate intuitions. They are born 100 per cent subconsciously operative. These intuitions seem so natural that the individual grows to maturity unaware that the conscious and subconscious are separate affairs. But most humans in early life have been discouraged in the use of their intuition. Children find out in a hurry that they get into trouble by following their intuition.

As we learn more in the behavioural sciences we find that the individual's real education is entirely dependent on his own self-discipline, chromosomically initiated, and intuitively inspired. He stands erect, walks and talks only when his chromosomic ticker-tape tells his brain to inaugurate those innate controls and not when his parents think they teach him to do those acts. If the brain refuses to so inaugurate there is nothing the parents can do to bring the child to do so. Most schooling only copes with the damage already done before school age to the children's spontaneous brain co-ordinating capabilities or to their innate drives to comprehend and to be understood. Advanced education, if successful, is a process of self-disciplined unlearning of all the anti-knowledge administered to its young by a superstition- and erroneous-opinion-ridden-'mature' society.

Children, as best I can digest the experimental data, are all born with the equipment and capabilities of what is called 'genius'. They become sub-genius or de-geniused by virtue of the progressive frustrations of so-called 'growing *up*' (there being neither 'up' nor 'down' directions in the universe!).

I would like to go more specifically into the experimental

191

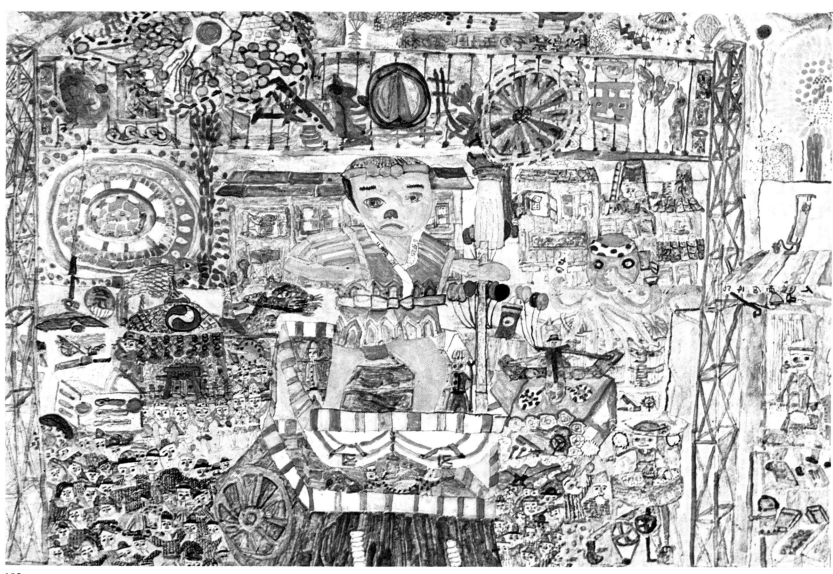

192

193

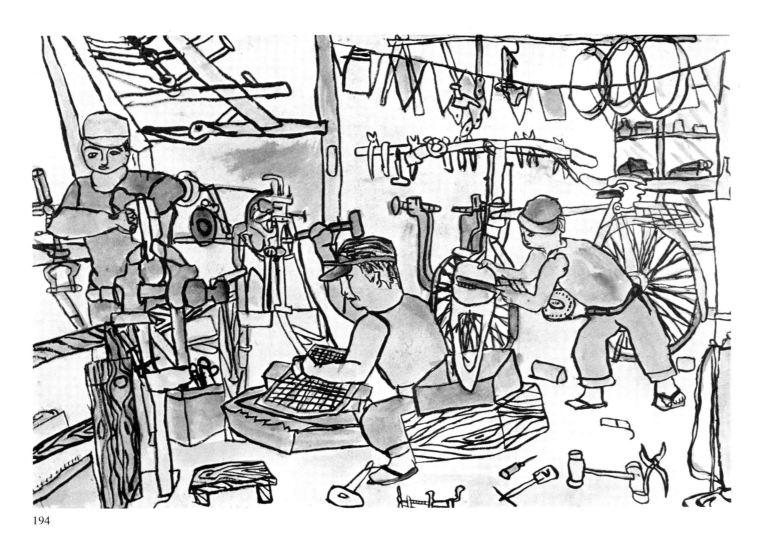

194

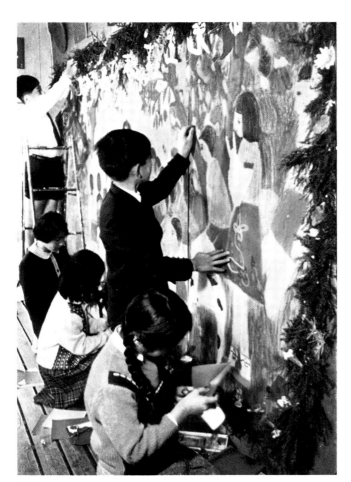

195

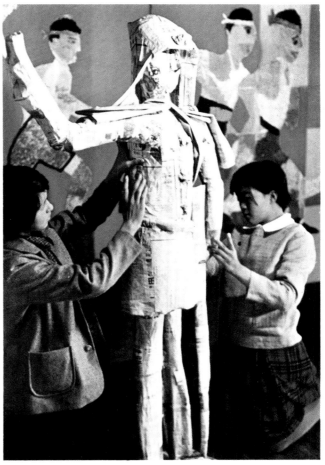

196

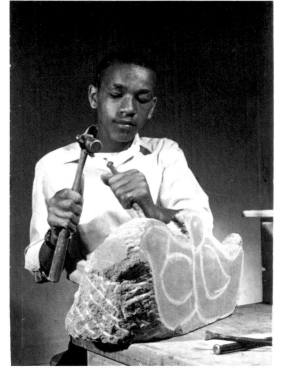

197

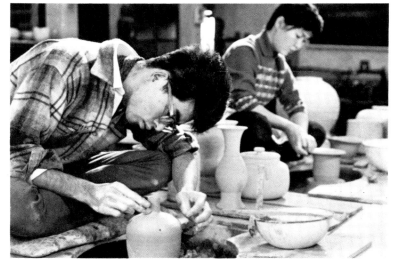

198

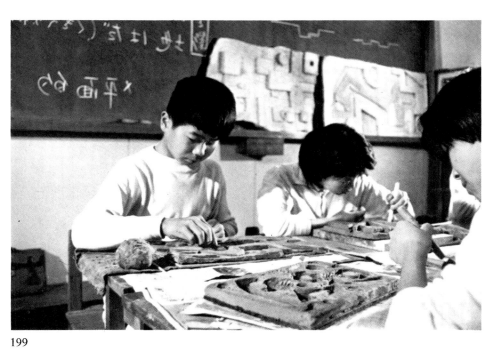

199

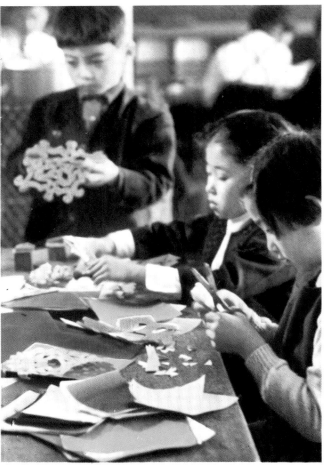

200

201

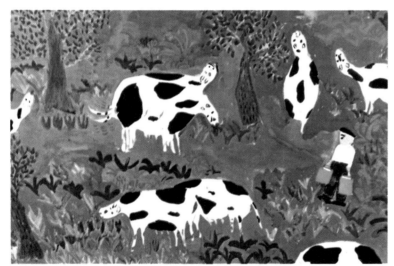

202

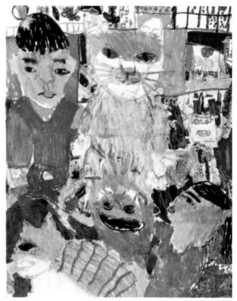

203

204

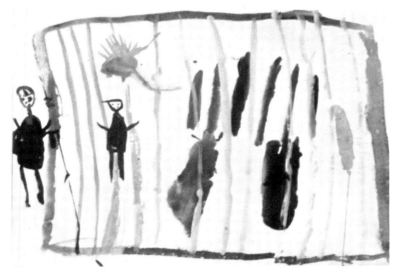

205

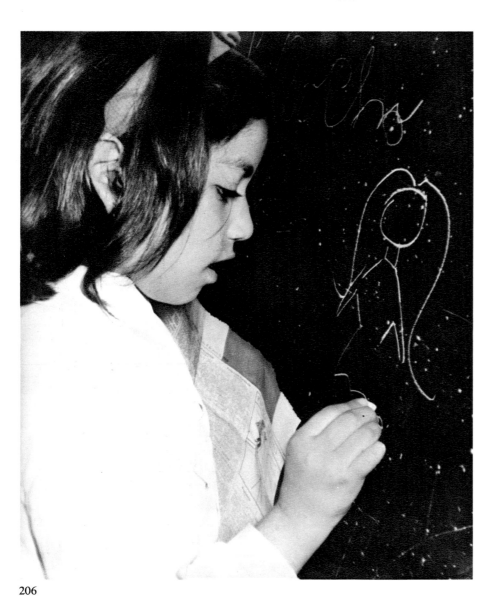

206

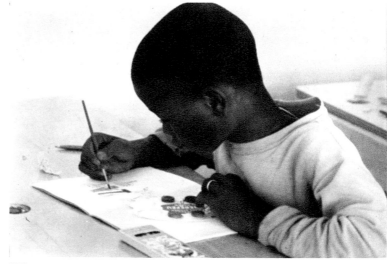

207

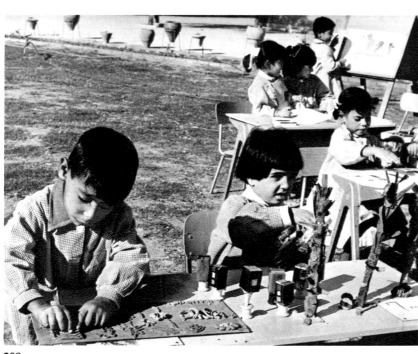

208

209

disclosure of the threshold functioning of intuition—as operating between the subconscious organic processes and conscious deliberations. I learned long ago that when I do not have an alarm-clock and there is nobody to wake me, and I am very tired, and have for instance just time for three hours and fifteen minutes sleep—all I have to do is think before going to sleep of what 'three hours, fifteen minutes' usually feels like in one or two specific experiences. Upon so doing I always sleep deeply for exactly that amount of time. Many people report the same experience. It is not unique to me. An enormous number of events is cycling in fantastically exact co-ordination within us—heart-beats, etc.—which though unconsciously co-ordinate, are accurately geared into the solar system's complex set of relative frequency rates. This commitment of ourselves to sleep is a superb case of the conscious co-ordination of man crossing the threshold to the subconscious and returning again to the conscious.

Aesthetics and intuition are the same but the first is the subjective and the second is the objective phase of the conscious-subconscious, threshold-crossing, communication system. So accurate and swift is the aesthetic communication phase of man's conscious-to-subconscious-to-conscious feedback system that within a split second a male human can calibrate the slenderness ratio of a female human's legs to within an accuracy of one thirty-secondth of an inch at fifty paces distance without effort and almost without knowing that he has done so. A multitude of such aesthetical subconscious activities bear powerfully on humanity's conscious deliberations without their awareness of those factors.

The grown-up artist-scientist-inventor is one who has not lost his original intuitive co-ordinating power and individual initiative to cope with any and all situations. The artist-scientist-inventor is the kind of man who realizes that when humans repeat tasks time and again the tasks could be handled by extra-corporeal equipment. He must therefore invent. For instance, some hundreds of thousands of years ago the artist-scientist-inventor saw that man had been cupping his hands for endless years to pick up water and realized that by making a vessel of hollowed stone or wood or a tightly woven basket or clay bowl or sewn skin, this repetitive job could be done much more successfully. Next he saw that he could make a large vessel, an enormous 'pair of cupped hands' and could carry the water with him. Thus his intuition and imagination gave humanity many more hours of life, freed from desperate seeking for water, to be invested in more profitable searches.

The artist-scientist-inventor was born with human history. My daughter is a dancer. When she was studying the dance, she wanted to find out something about the function of it. She had a feeling that dance started with the fundamental drives in life. She observed the dancing of birds and insects. She found that when living creatures were uncertain about anything they tended to stay very still, fantastically still. If they were to go into motion it would be risky and they would only do it for two reasons, two powerful drives: one would be hunger and the other would be the procreative urge. These two drives could overcome their fear. She then thought about how the dance began within the human community. There might have been this one human being, a long time ago, isolated from his tribe—perhaps he was way up on a mountain peak overlooking his village. He was hungry and looking for food, for himself and for his tribe. He was very still for several days and then he found food. He needed to communicate to the tribe from this distance about the food. He needed to signal that he had found a source of food. Thus, he made quite large motions from the mountain top to be seen by his tribe in the village below. Perhaps this is how dance was born. It would seem that the origin of dance was communicative in function. There are two fundamental patterns of man's living: the hunting people and the agrarian people. The agrarian people are more to the south than the hunters. In general, dance around the world is broken into these two groups where the people who talked about animals (the northern hunters) would use their legs and move the lower bodies, and the people in agrarian areas (southern regions) would imitate leaves moving, branches swaying,

by moving their arms and the upper parts of the body to a greater extent, such as can be found in the dances of South-East Asia.

I feel that the dance might very well have originated in the way my daughter imagined. Other art forms probably followed the same pattern. Somebody in that early tribe looking at the dance began to make a picture of it, on wood, on shells, on the cave walls. Then someone else realized that the dance-signal could be carried much greater distances if the gestures were scratched on small objects and transported to a neighbouring village. With time, these drawings became more and more formalized until they became pictographs and finally alphabets.

The motions of the dance, which originated as communication devices, became obsolete as signals after a while, but people wanted to continue to dance, so they rationalized their desire, saying that they were doing it for their salvation, and thus it became (along with other art forms) part of the religion, ritual, custom, part of the way of life of the community.

The artist-scientist-inventors are the men who have gradually and now almost completely transformed the environment of man, by virtue of whose activity about half of all the problems to be solved to make 100 per cent of humanity physically and economically successful have already been solved.

As already noted, most of the universally born artist-scientist-inventors have one, two or all three of their innate capability valves shut off in childhood. The original artist-scientist-inventor may retain his artist's or his scientist's critical faculties, or only his inventiveness.

World science has come to concede during the last decade that it is now feasible, within the scope of known technology, to support all of humanity at ever higher standards of living than any humans have ever known. In view of that scientific information, I intuit that artist-scientist-inventors who have reached maturity without critical impairment of their original faculties will now become responsible for initiating and industrializing the remainder of technology-advancing inventions,

for realizing the comprehensive physical and economic success of world man, and that with universal abundance, the warring, official and unofficial, will subside to innocuous magnitude. With that artist-scientist-inventors' accomplishment, humanity may, for the first time in history, come to know the meaning of peace.

I then come to the artist-scientist-inventor majoring strictly as an artist, a sculptor, a painter, to whom it seems just as important to turn things sometimes into anti-order array for the purpose of giving humans his indirectly constructive criticisms regarding what they ought to know about themselves and their universe.

Intuitions, aesthetics and the function of man in the universe are insistently and inherently evolutionary. Heisenberg's theory of indeterminism states: 'The act of measuring alters the measured.' T. S. Eliot anticipated Heisenberg by writing: 'The act of reviewing history alters history.' Still earlier Ezra Pound wrote: 'The act of thinking alters thought.' There is no instant universe. There is no exactitude of truth. The artist-scientist-inventor can only reduce the magnitude of error.

In the beginning of the twentieth century some artist-scientist-inventor artists saw that some of the otherwise meritorious cultural customs which we have inherited are at this moment in history treacherous in their narcotic romanticism because they prevent humanity from recognizing and participating consciously in its own evolution. Human life is born utterly helpless and must be fostered by others and by a favourable environment. As it grows older it usually becomes more responsible for its own and others' success. At this moment in history heretofore preponderantly innocent and ignorant humanity, operative only with subconscious success, is being required by universal evolution, and led by the artist-scientist-inventors, to participate in increasingly conscious degree in humanity's evolutionary transition from a very local parasite on the planet earth to an energy-conserving intellectually effective universe man.

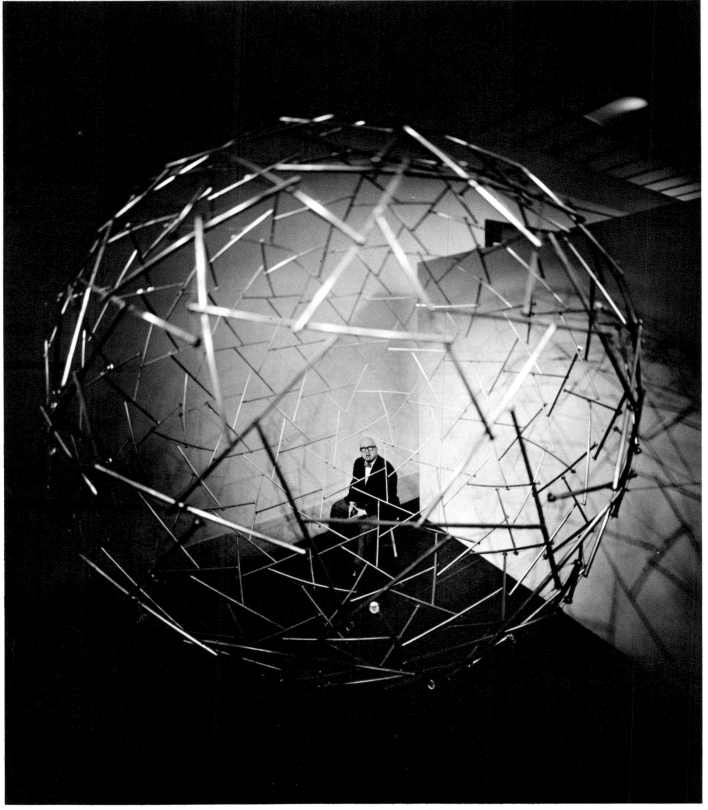

211

212

Chapter VI

Literature considered as a means of expression

André Maurois

All men and women experience powerful emotions that they cannot always clearly define, go through periods of anxiety or passion and as a result they are conscious of an acute need to express themselves. First, because they do not really understand what is going on within themselves, because their imagination seems to keep them in torment, stirring up those physical forms of turmoil and disorder that are made manifest by insomnia, palpitations, sometimes even madness. And, in the second place because every human being wishes to be understood, because emotions which cannot be communicated prey upon and poison the mind. It would be a relief to talk about them freely with friends, but often the subject is so intimate, the inner repression so violent, that any confidence seems impossible. Some religions have sought a remedy for this in confession. Psychoanalysis meets a similar kind of need. But literature remains the most powerful and the most universal medium of self-expression.

The author, novelist, dramatist or poet obviously finds in literature a vehicle through which he can express himself. Taking shelter behind the characters he creates, protected by them, and using their voices to make his confession, he manages to say what he would never have dared to admit. Think, for example, of Tolstoy. He is assailed by scruples; he criticizes the way of life of his own social class; he is tortured by a burning sensuality of which he disapproves. He may be able to purify himself through action, and he tries to do so by forcing himself to perform manual labour or by teaching peasant children; but he is conscious that there is something artificial about this. On the other hand, he creates characters like Levin, Pierre Bezukhov, or Prince Andrew, each of them a partial image of himself; then the flood-gates are opened, his true thoughts pour forth in torrents and Tolstoy finds release.

Again, think of the young Balzac. He was an unhappy child; he believed, rightly or wrongly, that his mother did not love him; he arrived in Paris thirsting for fame, confident of his own genius, but with no money and no patrons. For ten years he suffered trouble and frustration. Could he describe his

troubles to his friends? Such an admission would have been too much for his pride and for his sensitivity. Instead, he creates the character of Rastignac who, like himself, challenges the great city and sets out to make its conquest; he writes *Les Illusions Perdues* in which Lucien de Rubempré, a man of considerable importance in his own province, experiences in Paris all the humiliations suffered by his creator. And, of course, neither Rastignac nor Rubempré are exactly Balzac. Their adventures are different from his, more heart-rending, more dramatic. Yet, in depicting these characters, he was able to give expression to underlying emotions which he shared with them, and thus to purge himself of his passions.

One last example: Dickens, haunted all his life by memories of a hard childhood. His father was imprisoned for debt, and young Dickens, with his keen intelligence, was obliged, in order to maintain his family, to label bottles, in a window, under the critical or mocking eyes of passers-by. Even more than resentment, this gave rise in him to a tender pity for children, for women and for the poor; an ardent desire to see these unfortunates saved and loved at last as they ought to be; it enabled him to gain an intimate knowledge of the poor people's London, shrouded in fog and mystery. All these things by which Dickens' spirit was oppressed needed to find an outlet in conscious expression. From them sprang David Copperfield, Oliver Twist, Little Nell and many other ill-treated or luckless children; from them, too, sprang the delightful dreams of the Christmas tales in which goodness and the warmth of human fellowship triumph over selfishness. Dickens was literally saved by his own writing.

The same might be said of Proust, Hemingway, Dostoevsky —in short, of all the great writers and dramatists. Pirandello told me himself that his dramatic works derived entirely from his misfortunes. 'A writer', said Valéry, 'makes up as best he can for some wrong inflicted by Fate.' It might be objected that not all writers have had to suffer wrongs inflicted by Fate; that some of them have been happy and healthy; that Victor Hugo, for example, was still in his youth when he won fame

Madame de Cambremer jeta un regard sévère à son mari; elle n'aurait pas voulu qu'il s'humiliât ainsi devant Brichot. Elle fut plus mécontente encore quand à chaque expression "tête fêlée" qu'employait son mari, Cottard qui se connaissait le fort et le faible forçage qu'il leur avait laborieusement appris, démontrait au marquis, lequel confessait sa bêtise, qu'elle ne voulait rien dire "Pourquoi dit-elle... Pour qui ... cette chose ... que la chose soit plus belle ... cette chose ... quoi tonnerre de Brest?" Mais alors la défense de M. de Cambremer était prise par Brichot qui expliquait l'origine de chaque locution, mais M. de Cambremer était plutôt occupée à examiner les

78

454

... le de confondre, mais je ne sais ce qu'est votre question dit M. de Cambremer. "Le texte dit: Est-ce que ...

... souffrait que madame Verdurin ignorât qu'ils avaient failli ne pas se voir. "Allons voyons, dit Cottard à son mari pour l'encourager, raconte ton voyage." "En effet, elle sort de l'ordinaire dit le docteur ... et il apparaît dans vos renseignements mon cher! Et Brichot qui nous attendait à la gare!" ... mais êtes plutôt bizarroïde de ...

... à la gare!" Et le marquis dit l'universitaire se jeta ... de lui ce qui lui restait de regard et de sourire de ... tous mis ... que ... avec ... côté à ... quelque ... Si vous êtes allé à Grain court c'est que vous avez rencontré ...

péripéli... ! "Voulez-vous vous taire, si non je ... vous attendait dit le Professeur. La femme à plus ... il est jaloux "Ah, Brichot s'écrie ... l'équilibre de plaisanterie de Brichot s'y allait la gaîté habituelle il est toujours le même d'écrire ... t-il bien qu'il a ... dit! ... à ... où l'universitaire avait jamais été polisson. Et pour ... ajouter à ces paroles consacrées ... résister à ... la ... il fit mine de ne pouvoir ... la foule ... l'universitaire ... ne charge pas ce ... la coutume Ski, et se ... chaque ... l'universitaire devait ... triste et ... corrige à ces mots, il ajoute: Toujours un petit œil pour les femmes ... voyez-vous dit M. de Cambremer ce que c'est de voyager un savant ... voilà quinze ans que je chasse dans la forêt de Chantepie de jamais ...

... que Chantepie veut dire la pie qui chante! Crochotte? ajoute-t-elle pour ... Monsieur ... qui ... naguère ... elle faisait partie à ... forestière ... "Voilez-moi donc un peu de ce violoniste, il m'intéresse, j'aime beaucoup ...

... ne s'ouvrait que moyennant une honnête rétribution ...

214

and love; that sometimes an author, far from creating a character who resembles himself, produces a hero who is totally different from his begetter. To this I would reply that some secrets of the soul are well hidden; that some men presumed by their fellows to be happy are aware of the anguish within themselves; and lastly, that any writer acknowledged as a master and acclaimed by the crowd must have begun as a shy adolescent with misgivings about himself and about life. Turgenev, in the eyes of Dostoevsky, was a happy man, even too happy. And yet what inner anguish he experienced, to be assuaged only by creation. Goethe was the most balanced of men, and yet it was only by killing Werther that he saved himself from suicide. As for the hero who differs from his creator, he often represents an unknown aspect of the author. In his saga *Jean-Christophe*, Romain Rolland divides himself into two, creating Jean-Christophe from his strength and Olivier from his weakness.

In any case, an author does not express himself solely by depicting characters who resemble himself. He experiences violent feelings with regard to persons other than himself. Sometimes the feeling is love, and Balzac paid his debt, as it were, to Mme de Berny by writing *Le Lys dans la Vallée* in which she was to discover an idealized image of herself. In *L'Education Sentimentale*, Flaubert took pleasure in re-creating, under the name of Mme Arnoux, Mme Schlesinger whom he loved all his life. Almost every poet has sung the praises of a Laura or a Beatrice; Shelley's poems tell successively of his admiration for Mary Godwin, Emilia Viviani and Jane Williams.

On the other hand, it may be hate or aversion of which a writer has to purge himself. This he can do by drawing a ridiculous or repulsive picture of people he cannot abide in real life. Somerset Maugham himself admitted, in a preface to *Cakes and Ale*, written after the death of Hugh Walpole, that he had worked off a long-standing resentment against him in the character of Alroy Kear. Proust, irritated by an old snob who feigned simplicity and concealed his social foibles in flowery language, avenged himself by imagining the ridiculous Legrandin.

Above all, literature enables the writer to express a general attitude towards life and mankind. This, too, is a release. When Sartre, in *La Nausée*, describes the people he calls *les salauds*, he is getting rid of mental toxins. When Tolstoy, in *The Death of Ivan Ilyich*, depicts the habits of mind of the Russian *bourgeoisie*—conventional manners, meanness, selfishness—when he shames all these hypocrisies before the harsh reality of death, it is himself he is purifying. Thus, for the creator, literature offers a prodigious means of expression.

And what of the reader? The proof that literature also meets a vital need of the reader lies in the fact that for thousands of years men and women have hungered and thirsted after these substitute worlds offered first in spoken poetry and then in books. All peoples have had their sacred texts, at first recited and then written down. Homer's poetry united and delighted the Greeks. Ecclesiastes and the Book of Job were expressions of human revolt. Every country has had its epics, its mysteries, its fables, and later its novels. Today pocket editions and public libraries make it easier for the masses to satisfy their need for literature and we can see how all classes of society experience that need irresistibly. To what does the feeling of the literary creator correspond in the consumer of literature?

Here the reply is more complex. The reader's problem is in part the same as that of the author. 'Hypocritical reader, my fellow-creature, my brother', said Baudelaire. 'Literature is the meeting-place of two souls in tune with each other' (Charles du Bos). Like the creator, the reader has his inner problems, his frustrations, his scruples; he has not, as the writer has, the safety valve of creation. Of course, there is still the safety valve of action. A young man desires a woman; he can seek to please her. But it often happens that in fact he can do nothing about it. The young man may not be able to find the woman he desires in the environment in which he lives. Or, if he thinks he has met the ideal woman, he knows very well that he is too shy to court her. What is his remedy? To abandon action for representation, the real world for a substitute world. What

recourse is left to the poor lover who is forced to admit the mediocrity of his amours? If he is a Greek in the age of Homer, he falls in love with Helen or Venus; if he is a man of our time, he turns to Mme de Rénal of *Le Rouge et le Noir*, Natasha of *War and Peace*, or Marcel Proust's Albertine. Many lives are dull and empty. Literature fills them and gives them vitality.

Just as the novelist creates a hero in his own image, so the reader seeks in the novel a hero with whom he can identify himself. How many men have known difficult years of apprenticeship! They find them mirrored in the apprenticeships of Wilhelm Meister, Julien Sorel or Rastignac. How many women have suffered through not being understood by their husbands, or through not having found the love they had hoped for in their girlhood! They see a sister in Madame Bovary or Madame de Mortsauf. It is reassuring to find that other people, people we like, have gone through the same troubles, the same sadnesses and the same regrets. We are not abnormal, we think, nor are we the sole victims, since a man of genius has described feelings similar to our own. By making us feel we are not exceptions, literature manages to break the spell. It restores us to our place in the human community from which we thought ourselves excluded, by showing us that those greater than ourselves have suffered the same ills and have overcome them by giving them expression. Literature humbles our pride by reducing us to the ranks, but we feel no humiliation on that account, but rather exaltation.

The real romance in life lies in the difference between a young man's picture of the world, his ideas of women, of love, of how to succeed, of the obstacles before him, and the true picture which he will discover slowly through experience. The awakening from illusion to reality is often very painful. It surprises and alarms the young man experiencing it for the first time. What consolation it is for him to find his ignorance, his naïveté, his imprudence and his failures in Balzac's *Illusions Perdues*! Lucien de Rubempré is a very handsome, gifted young man, loved by many women. Yet he is doomed to failure. Why? Because he lacks courage, magnanimity, unselfish devotion to his art, and because he yields to every temptation. The reader may become attached to him because he is not unlikeable; what is more important, he can learn a great deal from him. Lucien helps him to give expression to his emotions and his desires, and, through the example of his own misfortunes, to overcome them.

There are many instances where a whole country experiences an emotion—enthusiasm or horror—and desires to find some inspired expression for it. The poet can provide it. Imagine what the publication of a book like Victor Hugo's *Les Châtiments* meant to the French at a time when, after a *coup d'état*, they were grieving for their lost freedom. During the 1914-18 war Rupert Brooke in England, Alan Seager in America, and Charles Péguy in France spoke the words which a whole nation was waiting to hear. The success in France and throughout the world of Camus' *L'Étranger* may be attributed to the fact that it gave expression to a revolt common to many young people of his generation and spoke to them of it in a manner that was not entirely destructive. Neither total rejection, nor total approval. The only way to speak to everyone is to speak of those things that are common to all—sunshine, need for fulfilment, desire, the struggle against death. So the emotions of all will find expression.

Why does literature fulfil this function better than life? Could we not observe lost illusions, loves and hates in reality just as well as in fiction? I think not. The superiority of literature over reality lies in the fact that a work of art allows what real life almost always forbids, that is, objective contemplation. True, we men and women of this frenzied age have, like the heroes of our novels, lived through war and peace; we have experienced love, jealousy and pity; but in what conditions? Doomed to immediate action, a prey to anger, fear or anxiety, we have lived our life without really understanding it. We have been constantly goaded on by the necessity for choice or action.

'I should like to stop awhile; I should like to reflect; I

l'enfant, voyant l'aïeule à filer occupée,
Pour faire une quenouille à sa grande poupée.
l'aïeule s'assoupit un peu ; c'est le moment.
l'enfant vient par derrière et tire doucement
un brin de la quenouille où le fuseau tournait,
qu'il farfouine triomphant,
Et puis elle s'enfuit, emportant avec joie
la belle laine d'or que le vieux sapin jaunit,
Aurais qu'on pourrait prendre un oiseau pour un nid.
—

Caudecoste - 25 août 1843

Contemplations.

215

216

217

should like to enjoy that face, to analyse that feeling', we think. 'No', says Life, 'keep on. Further, faster!' It is only poets, novelists and philosophers who can free us from this harassing pursuit. *The Longest Day*, on the Normandy beaches, was an infernal chaos, a charge into the jaws of death, in which each man, in the roar and rattle of machine-guns, artillery and the drone of aircraft, saw nothing but the deluge of steel and blood about him. On the screen that terrible day becomes a scene that we can observe in tranquillity and lucidity.

To the reader of *La Chartreuse de Parme* or *Les Hommes de Bonne Volonté*, Waterloo or Verdun presents no danger and calls for no decision. Literary emotion is essentially impartial. The really great writers have never forced our judgement—this would have simply put us back under the yoke of necessity—but they have always buttressed their work with stable values —goodness, love, friendship.They lead the reader to experience feelings which strengthen him; they have the gift of imparting absorbing interest to the banalities of daily life. By showing that the small dramas of life are no less important than great ones, indeed that the small dramas are great, Balzac, Chekhov and Pirandello bring new assurance to those leading apparently humdrum lives. They wrote for everyone and they were read by everyone. The French people, without distinction of class, read Victor Hugo just as the English people read Dickens. The classical theatre of the ancients stirred the emotions of all the citizens of Athens or Rome. Everyone understood, everyone recognized himself. Great literature purified men and made them, I believe, better.

And it did so even when describing such distressing feelings as contempt or hatred. For we know full well that men are not saints; we know they are capable of killing, sometimes by violent means, sometimes by long, agonizing tortures of mind or heart. But whereas in real life we should find the sight of such horrors unbearable, we happily go to the theatre to see *King Lear*, *Othello*, *Macbeth*, or *Timon of Athens*. And yet what is King Lear but a picture of the folly of old men, the ingratitude of children, the injustice of fate? Only, in the theatre,

these common misfortunes become objects placed at a distance. And so the spectator takes his seat quite calmly, with neither apprehension nor terror. The curtain, Harlequin's cloak, the raised stage, separate him from the action. Even more so if the play tells of illustrious misfortunes, known in advance, such as those of Phaedra or Oedipus, Julius Caesar or Mary Stuart.

But that is not all. Literature makes intelligible for us emotions which are not understood in real life. We spend our whole lives alongside parents, children, husbands or wives whom we scarcely know. Sometimes we imagine we do know them and suddenly their behaviour in a crisis reveals that our judgement of them was completely mistaken. We do not even know ourselves. Reality is shrouded in mist and eludes our grasp. I turn to analyse the reflection of some emotion on a well-loved face, but already that reflection has vanished like a ripple on the waters. Our own emotions are as changing as an April sky. But a well-constructed novel offers us characters who, though sometimes mysterious, are nevertheless always more intelligible than those of the real world, because they have been created by the mind of a man.

This high degree of intelligibility of the emotions in literature is achieved without any need for reasoning. Beauty is intelligible without thought. We are moved at the sight of a cathedral; it does not impose a theology upon us; it signifies, by its mere presence, something great, mysterious, divine. The same holds for the great works of literature. They give a permanent form to our errant emotions. Reverie without an object is a disturbing occupation, as we discover in hours of insomnia. The novelist and the poet give it purpose and form. In this transient world, it is a delight to find characters on whom we can fix our attention, like Anna Karenina, Madame Bovary or Daniel Deronda. We can return to them over and over again and let our gaze rest upon them. This is the whole subject of Proust's great novel: 'Life as it flows by is merely time lost and nothing can be saved except in the form of eternity, which is also the form of art.' From Achilles and Patroclus to Don

Quixote and Sancho, from Andromache to Eugénie Grandet, literature creates eternal emotions, truer and more firmly delineated than those of life.

We may. even add that literature teaches men emotions which they would never have known without it. Compare the feeling of love as it was in the age of Homer with what it became in the time of the Princesse de Clèves. Animal desire has been transformed into a tender attachment. Mind and heart have come to play as great a part in love as the body. This romantic love evolved in the Middle Ages from the tales of chivalry where the cult of the Lady was exalted, from Arab poetry, from the poems of the minstrels and the troubadours, and from the cycles of Celtic romance. In seventeenth-century France the plays of Racine, and later of Marivaux, were real schools for sentiment. They imbued men and especially women with the desire for passion, while providing them (and this is vital) with a vocabulary to express it.

Art provides models for life, substance for the imagination and order for the mind. To the reader, a great book remains, now as in the past, a book of reconciliation with himself and with the world. 'A pious imitation of sublime moments may raise the weakest man above himself.' You ask for examples, for texts? Bishop Myriel at the beginning of *Les Misérables*, Pierre Bezukhov raising up Natasha in *War and Peace*, the great surgeon Desplein, though an atheist, having a mass said for the poor believer from Auvergne to whom he owes so much.[1] Such reading is productive of goodness. This does not mean that the writer must confine himself to the description of sublime moments alone. Such moments derive their beauty from the contrast with surrounding horror. The works of Dostoevsky, Mauriac or Graham Greene set the infinite value of the spiritual world against the imperfection of the world around us. The highlights stand out more clearly against a background that is black as ink. Out of the excess of suffering springs grace.

So far we have spoken mainly of the expression of emotions through fictional or dramatic characters, but it is obvious that poetry, essays and biography also provide voices through which human passions are expressed. Poetry indeed is the most powerful of all these voices. In times when the prose romance was virtually non-existent, the epic and then the elegy enabled great poets to voice the feelings and memories of a whole people (Homer), the anxieties and certitudes of a whole civilization (Lucretius), or the laments of lovers (Tibullus, Propertius, Catullus). The romantic poets of England, Italy, Germany and France, when they sang of their own emotions, lent their voices to humanity. Victor Hugo, 'at the heart of everything, like a ringing echo', spoke many a time not only for France but also for every Frenchman.

It must be noted, however, that the poet does not express things in the same way as the novelist, but more as a musician. Beethoven, with no words at his disposal, cannot touch us by creating characters resembling ourselves. Yet we feel that he speaks to us better than anyone. Sounds and rhythms have a powerful effect on us. The poet too has this resource. It may seem surprising that difficult poets can nevertheless by their incantations move even those who are barely able to follow or to understand them. The reason is, first, that rhythm is connected with an ancestral human need, and second, that certain words, because of their beauty or the ideas they evoke, have become 'spells' whose potential magic is released as soon as a great writer arranges and combines them in the manner required. We have said that the essential purpose of art is to fix life by giving it form. Poetry imposes on our errant emotions perfect forms which are fixed in the memory. It is a companion and a confidant.

The biographer seems to be in a much more difficult position than the novelist or the poet, for he is obliged to accept a life as constructed by chance, a shapeless mass made up of disparate fragments. But the fact that he must accept, from reality, the immutable materials of life is almost always for the artist a source of strength. It makes the work more difficult; yet it is

1. Balzac, *La Messe de l'Athée*.

218

219

220

221

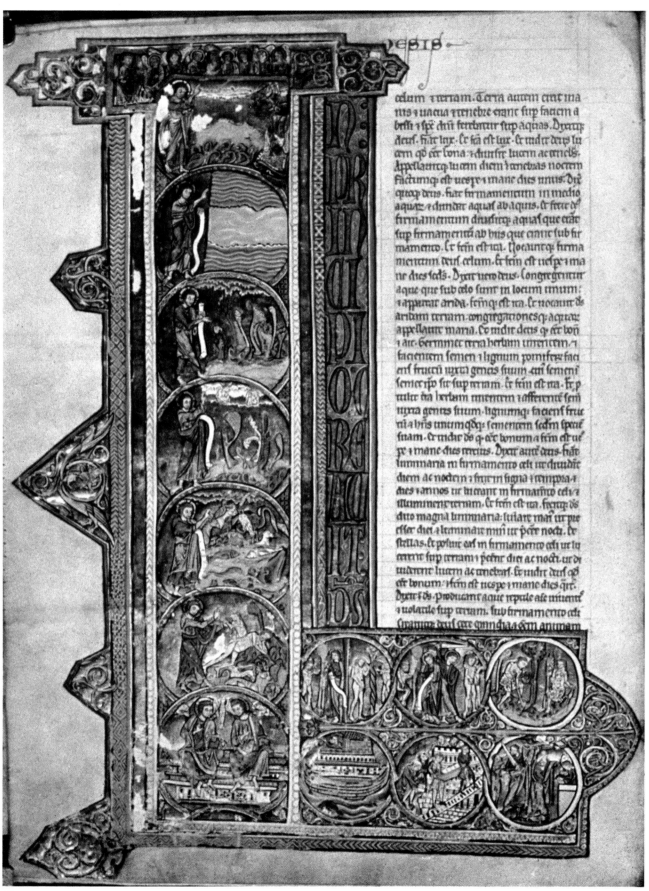

celum ⁊ terram. Terra autem erat ma
nis ⁊ uacua ⁊ tenebre erant sup facem a
brssi ⁊ spс сhui ferebatur sup aquas. Dixitꝗ
deus. fiat lux. Et fca est lux. Et uidit deus lu
cem qd ect bona. ⁊ diuisit lucem ac tenebs.
Appellauitꝗ lucem diem ⁊ tenebras noctem
factumꝗ est uespe ⁊ mane dies unus. Dix
itꝗ deus. fiat firmamentum in medio
aquaꝛ. ⁊ diuidat aquas ab aquis. Et fecit ds
firmamentum diuisitꝗ aquas que erat
sup firmamentum ab hiis que erant sub fir
mamento. Et fcm est ita. Vocauitꝗ firma
mentum deus celum. Et fcm est uespe ⁊ ma
ne dies secs. Dixit uero deus. Congregentur
aque que sub celo sunt in locum unum.
⁊ appareat arida. factumꝗ est ita. Et uocauit ds
aridam terram. congregationesꝗ aquaꝛ
appellauit maria. Et uidit deus ꝗ ect bon
⁊ ait. Germinet terra herbam uirentem. ⁊
facientem semen ⁊ lignum pomifeꝛ faci
ens fructu iuxta genus suum cui semen
semetipso sit sup terram. Et fcm est ita. Et p
tulit ita herbam uirentem ⁊ afferentem sem
iuxta genus suum. lignumꝗ faciens fruc
tu ⁊ hiis unumquodꝗ sementem secm specie
suam. Et uidit ds ꝗ ect bonum a fcm est ues
pe ⁊ mane dies tercius. Dixit autem deus. fiat
luminaria in firmamento celi ut diuidat
diem ac noctem ⁊ sint in signa ⁊ tempora ⁊
dies ⁊ annos ut luceant in firmamento celi ⁊
illuminent terram. Et fcm est ita. fecitꝗ ds
duo magna luminaria. luiare mai ut pe
esset diei ⁊ luminare minus ut peet nocti. Et
stellas. Et posuit eas in firmamento celi ut lu
cerent sup terram ⁊ peent diei ac nocti. ut di
uiderent lucem ac tenebras. Et uidit deus qd
ect bonum. ⁊ fcm est uespe ⁊ mane dies quar.
Dixit ⁊ ds. producant aque reptile ałe uiuentis
⁊ uolatile sup terram. sub firmamento celi.
Creauitꝗ deus cete grandia. ⁊ omnem anımam

223

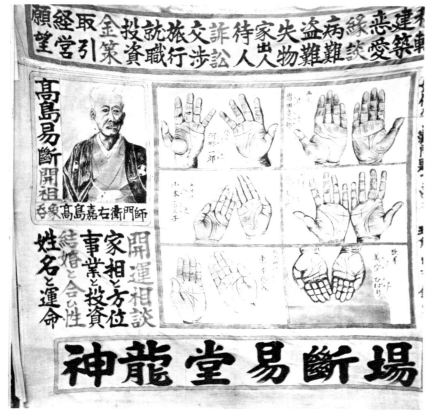

224

out of this struggle between resistant matter and a human mind that the masterpiece takes shape. Michelangelo would accept strangely shaped blocks of marble from his patrons; and by the limitations of the stone the sculptor was constrained to invention. Some of poetry's finest achievements are due to the constraints imposed by the rigid forms of sonnet or ballad. Thus the biographer, when describing a real life, may express just as many emotions as the novelist.

Biography is a difficult form. We demand from it the scruples of erudition and the delights of literature. Much prudence and much tact are needed to select the right proportions for this unstable mixture. Carlyle once remarked that a well-written life is almost as rare as a well-spent one. But however difficult the form, it is worthy of our toil and our emotions. The cult of the hero is as old as man. It offers examples that are lofty, but not inaccessible; amazing, but not incredible; and this dual character makes it the most persuasive of art forms and the most human of religions. Biography is a means of emotional expression both for the biographer (by the choice of a subject corresponding to his sensibility and his needs) and for the reader (by a more accurate knowledge of men and by the desire to imitate the best). Here too the ordinary man draws assurance from the knowledge that men and women of genius, despite those weaknesses which make them akin to the reader, have risen to great destinies.

We might attempt the same demonstration for all literary forms. When Pascal wrote his *Lettres Provinciales* he gave forcible expression, under the mask of irony, to feelings of anger and indignation. Those feelings were shared by his friends of Port-Royal who must have found unspeakable relief in reading their secret thoughts expressed in impeccable form. When Bossuet pronounced the funeral oration of Henrietta of England, he enshrined in his long harmonious cadences the profound grief of all who loved that unhappy princess. Swift in *Gulliver's Travels* draws a sinister and farcical picture of the absurdities of humanity, and in so doing he expresses both his own loathing and that of his readers. Literature, by depicting passions and the errors to which they lead, moderates, purges and sometimes eradicates them.

All emotions come within the purview of the writer. He can and should depict political passions as he does the others. Yet he is at his best when he rises above his own passions and those of the readers. Tolstoy is admirable in his novels, but is much less convincing when he is preaching or demonstrating. Balzac, a Catholic and a monarchist, depicted noble republicans and a generous atheist. In short, I believe that there is on the one hand the writer as partisan and polemist, and this aspect of his work has its beauty, as passion lends the piercing flame of the blowlamp to his style. On the other hand, there is the artist who purifies the emotions of others and his own. Marcel Proust, a passionate supporter of Dreyfus, ceases to be a partisan when he describes the affair in his novel. That is the highest form of art, the true aesthetic emotion, but it calls for rare greatness.

There are still two matters to discuss. First, there is what is called the 'new novel', or, more generally, literature which turns away from the portrayal of lasting human feelings. Many young writers refuse to depict emotions. Some describe the emptiness of existence and the efforts of wretched human beings to forget their misery, through eroticism or alcohol; others maintain that the traditional 'hero' is deformed by the author's interpretations and that the novel should describe only objects. This literature has its merit when the author has talent. But the general public continues to want what it has always wanted and remains faithful to the great authors who have tried to express their own emotions and those of all men.

The second matter has to do with the new techniques which, some say, may replace literature in their field. 'If you want stories, tales or characters,' we are told, 'you will find them on the cinema and television screens.' It is true that a great film (*La Strada*, *Hiroshima Mon Amour*, *Brief Encounter*) expresses deep emotions and that the spectator emerges purified in the same way as after reading a great novel. But such

films are rare and, in addition, their duration is necessarily limited by their screening time. How can the innumerable emotions aroused by reading a fine book be compressed into two hours? What is more, how can the spectator be given an opportunity to go back over his impressions and deepen them? The picture passes; the book remains.

If the modern writer has nothing to offer but despair or a system of hedonistic values, then eager minds will seek elsewhere the emotional pabulum which they need just as much as bread, water and sunshine. But there is every reason to hope that beyond despair and disaffection there will continue to flow, in an abiding literature which is now becoming worldwide, a current of undertanding, of pity and of love. It is not true that youth is interested only in pleasures. Consider the success of Chekhov's plays—*Uncle Vanya, The Seagull, The Three Sisters*—in every country. Who knows whether, as a result of our prodigious inventions, 'an incredible mutation is not engaged even now in producing a new man'? It is for literature to help that man to be born, to express and to understand himself.

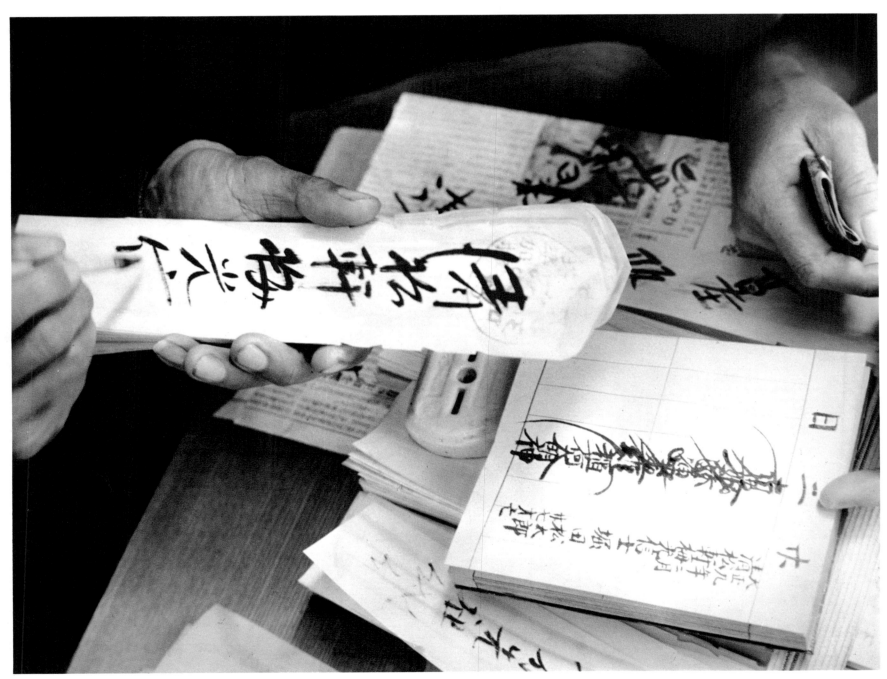

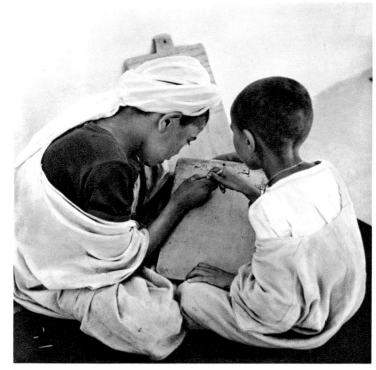

226

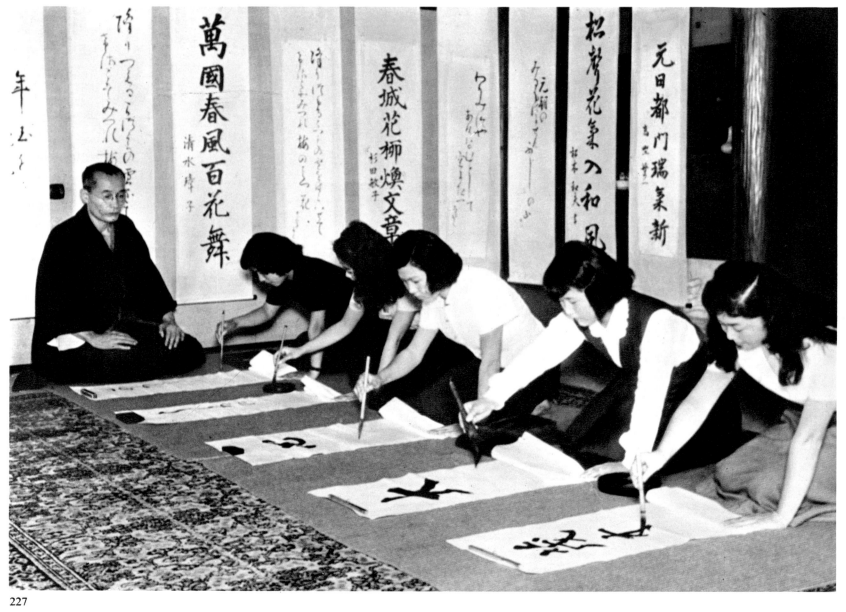

227

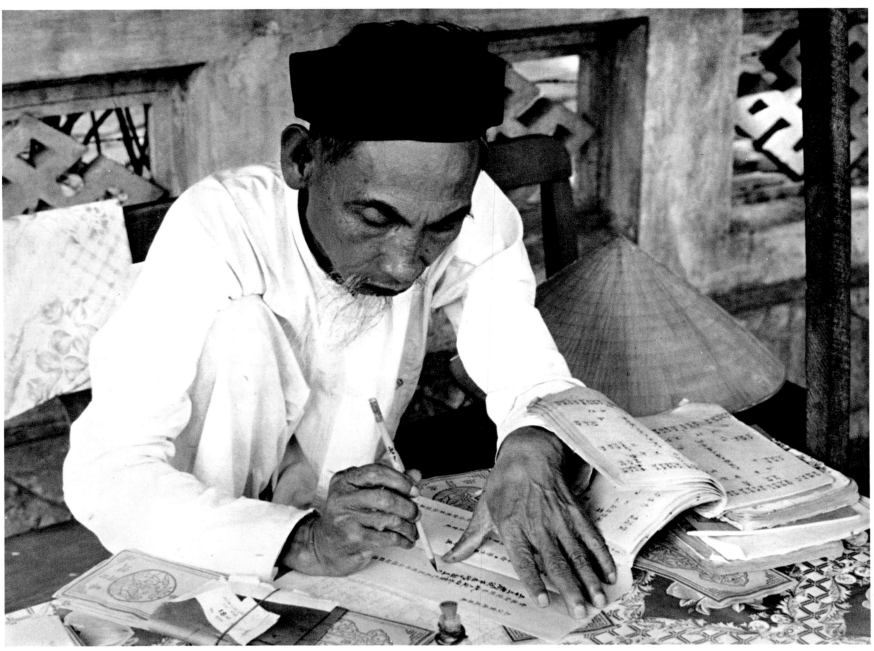

228

118

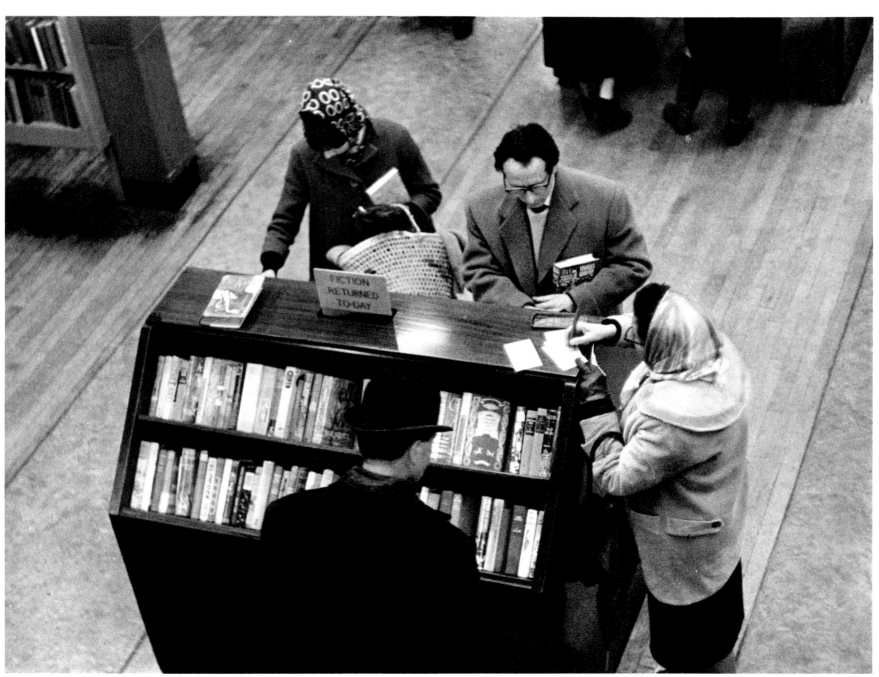

229

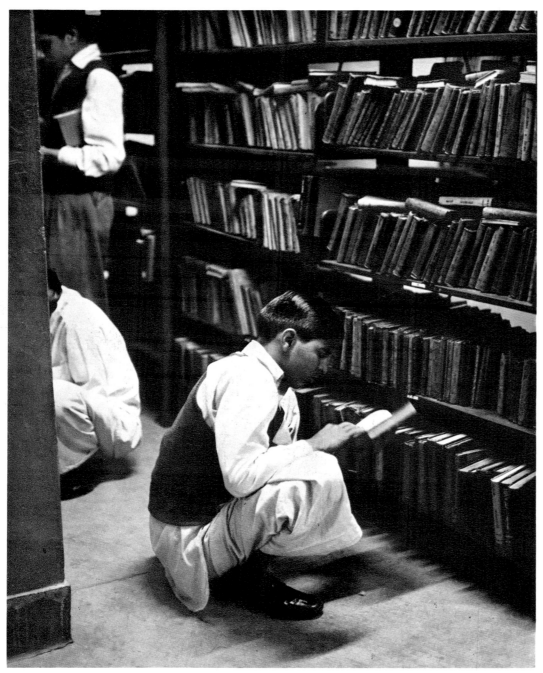

230

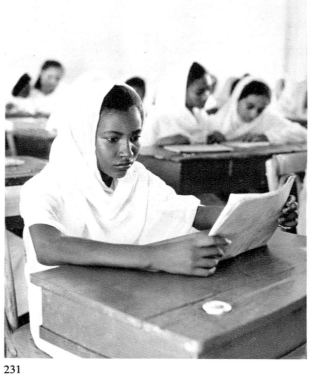

231

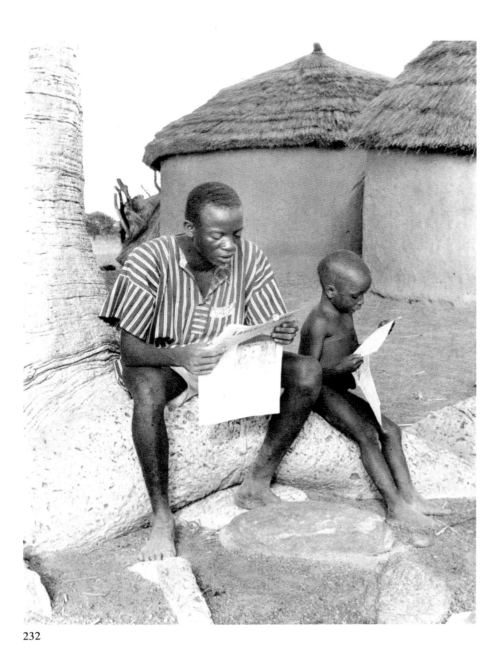

232

233

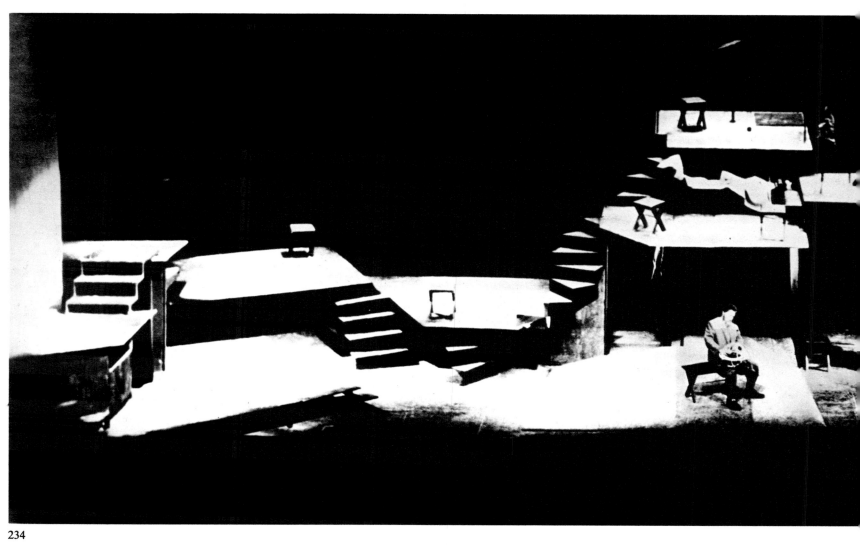

234

Chapter VII The theatre and
its continuing social function

William W. Melnitz

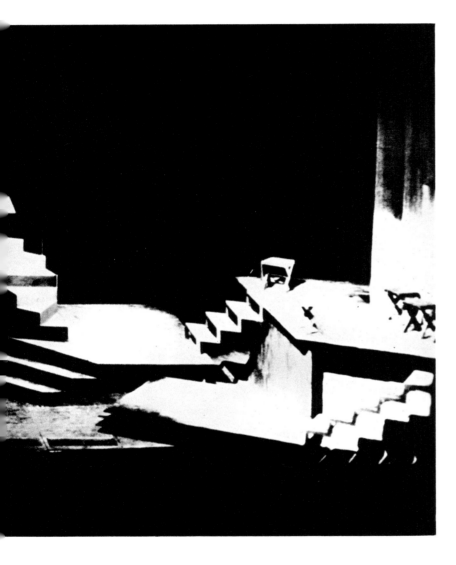

Drama and theatre are as old as the world. They begin with the first man who thinks that by imitating animals around the camp fire he can increase the game and ensure good hunting. Drama and theatre grow and become more elaborate as man moves beyond imitative magic. He discovers how to use dance and music, as well as masks, in rituals that he hopes will bring rain and increase his crops. He invents initiation ceremonies that require dialogue. His ancestors become gods, and he worships them with dance and song. Worship breeds myths, and myths must be acted out if this race is to live. At last he is devising tragedy, and after that Bacchic comedy, and then plays that are acted just for the fun of it.

Thus, the path to theatre seems fairly clear. Primitive man practises magic for material reasons. He creates initiation rituals to educate his youth. He tells the stories of his culture-heroes and his gods, and so combines religion with personal drama. The line beyond which religious ritual becomes commercial theatre and drama for the spirit's sake becomes paid mummery for pleasure, is hard to trace. Sometimes it marks the decay of classical tragedy, as in Greece. Sometimes play begins before religious drama appears, and then the higher art is never born. Of the Western world only two theatres—the Greek and the mediaeval—had their roots in religious ritual and spiritual legend. The ancient theatre was exalted because it was inspired by religion. The theatre offered another realm of religious experience in terms of dramatic art. There are all sorts of theatre today, as there are all sorts of literature. Theatre has become very powerful in its influence on society. The theatre has always a social function, whether its apparent purpose be religious, artistic, educational or merely commercial. Its social function is to unite people in a shared experience. The audience is as much a part of theatre as are the play, actors, singers, musicians, dancers and a place in which to foregather and share the performance. Theatre and society are firmly wedded.

In Greece and Rome the development of theatre and its plays followed a familiar pattern, a pattern in which there is always hope and accomplishment and always disappointment

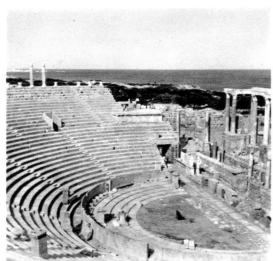

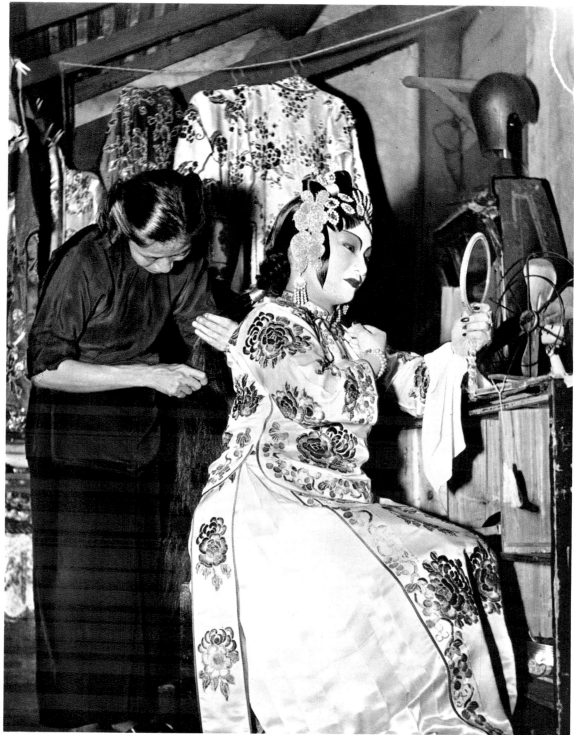

236

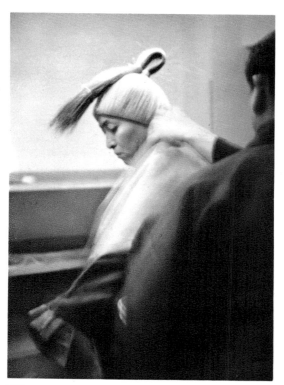

237

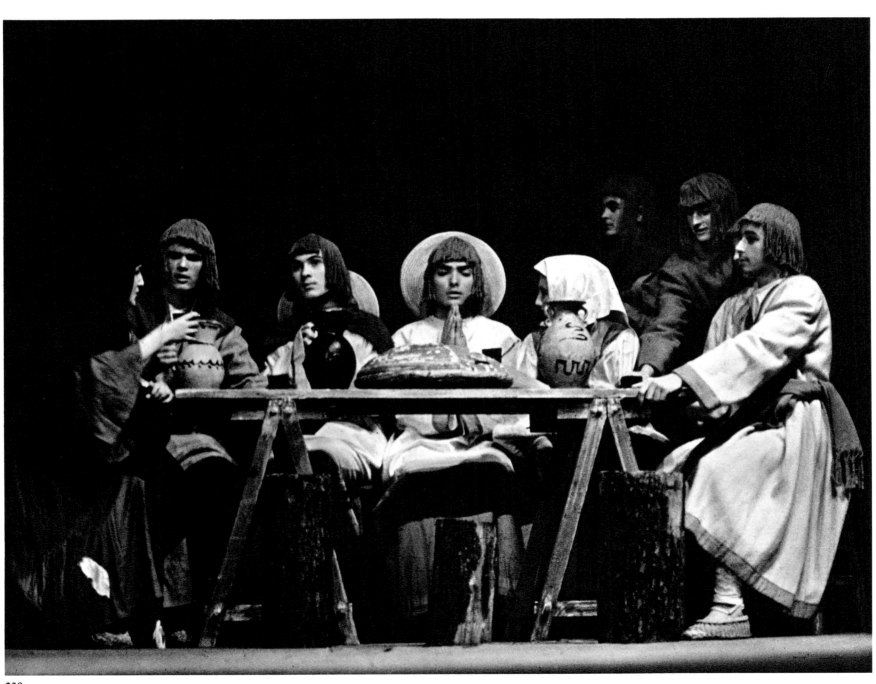

238

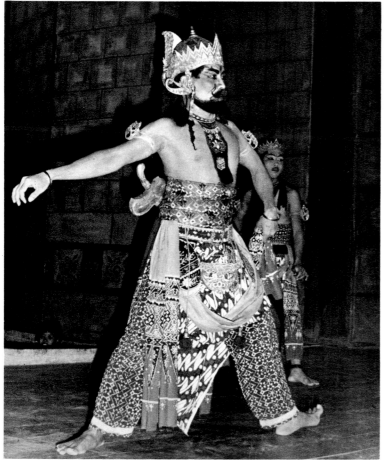

239

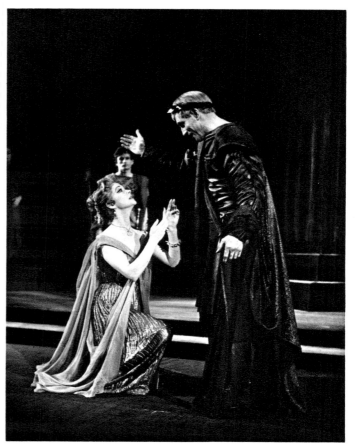

240

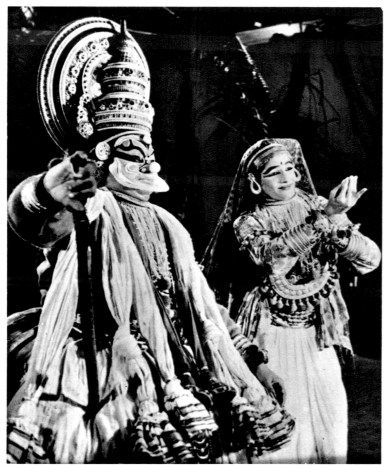

241

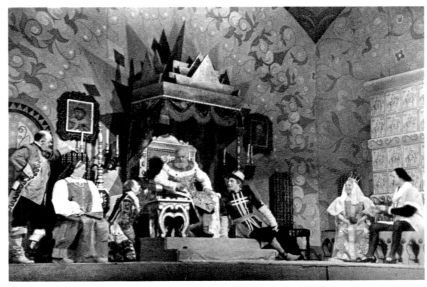

242

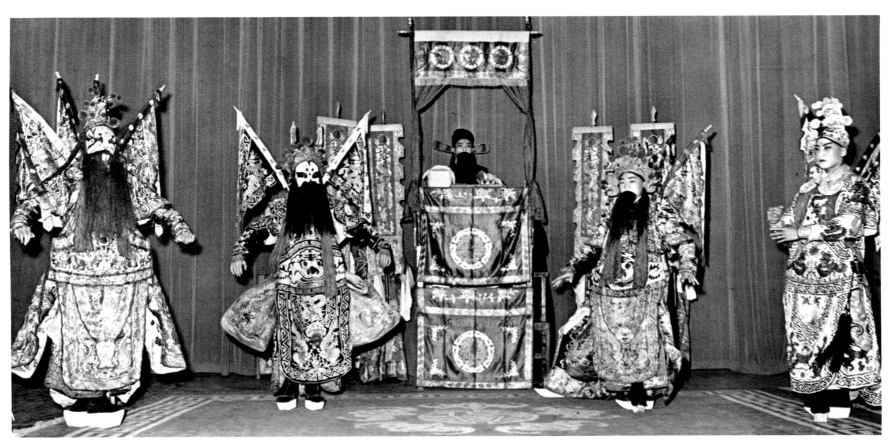

243

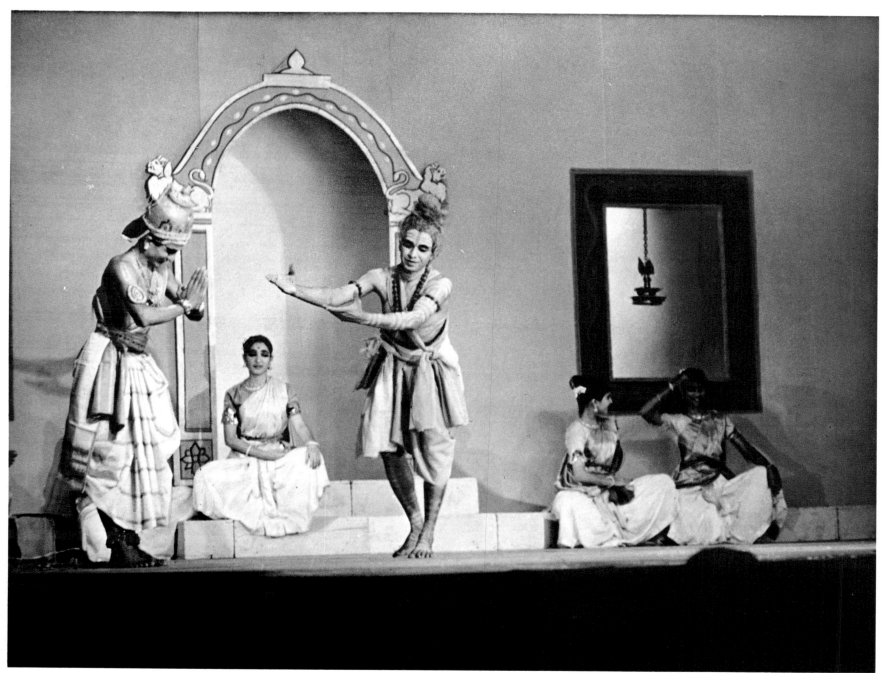

244

and death. The theatre began as a simple thing that imposed rather severe limitations and yet seemed to stimulate the playwrights through those limitations. Still more stimulating—and limiting, too—was the social and political and cultural atmosphere of the age. Tragedy was born in the heroic times when Athens defeated the Persian invaders and created the nearest approach to democracy that the world had known. Tragedy died in the spiritual confusions and decay that developed out of the Peloponnesian War. When the great playwrights of the fifth century were gone, and no one of equal stature came to take their place, the theatre tried to fill the void with physical display and new ingenuities of production. The collapse of the Roman Empire carried down with it a theatre that had fallen almost equally into decay.

For almost two thousand years the theatre of Europe lay dead. Between 400 B.C. and close to 1600, no dramatist wrote a single great play. From Euripides to Lope de Vega, Marlowe and Shakespeare, the stage was barren. The theatre of the Middle Ages was essentially the theatre of the Church. Its plays were holy plays. Created by the clergy and taken into the marketplace by the guildsmen, the 'mysteries' were acted by amateurs. The few professionals of the mediaeval years were, first, the strolling 'mimes', and later, the minstrels.

The Reformation and the Renaissance provided the drama with a new content and a new form. The international theatre of the Church gave way to national developments that culminated in Spain with Lope de Vega and Calderón, in England with Marlowe and Shakespeare, and later, in France with Corneille, Racine and Molière.

In Italy, the cradle of the Renaissance, scholars, painters and poets—blessed and bemoneyed by the princes of Church and State—evolved a spectacular stage for a rather insignificant drama. In the second half of the sixteenth century Italy built three permanent theatres, and accidentally invented opera. All this was the product of amateur effort, and it was limited in vital quality and appeal. This aristocratic theatre became professional and found a popular audience—two

essential steps in the development of theatrical art—only when Italy began to spawn opera a century later.

But another sort of professional theatre had found its popular audience even earlier. It was the *commedia dell'arte*—a theatre of boards and trestles, with an audience that stood in the public square. The influence of its actors can be traced through France, Spain and England, and later Germany. They influenced great playwrights from Shakespeare to Molière. The impact of their improvised playing was enormous. They performed with particular success in the courtyard theatres of Madrid. And we have it on the authority of Somerset Maugham that 'drama at no time and in no country has flourished so luxuriantly as in Spain during the hundred years that ended with Calderón's death'. In 1681, when he, the last of the great Spanish playwrights died, Madrid had forty theatres. It has been estimated that 30,000 plays had been written and produced. Most of them must have been pretty poor by any standards, but many were distinguished, and some are now world-famous.

Sociologically speaking, the story of the Spanish theatre is amazing because its drama mounted in vitality and importance as Spain sank. Playwriting began with the conquest of the New World. True drama developed, and better and more significant dramatists appeared even while Spain suffered from poverty and high prices at home, and the wars in the Low Countries drained her dry. Thus, by a strange cultural lag, the stage and the fine arts increased in stature as the nation declined. In a ruined and hungry land—where a gallant gave his beloved presents of food instead of flowers—theatres multiplied and men like Lope de Vega and Calderón won immortality.

By contrast, the theatre that the great Queen of England, Elizabeth I, sustained developed in an atmosphere of peace and unmatched prosperity. During the last half of Elizabeth's reign some quite extraordinary things happened to the English theatre in an extraordinarily short length of time. In 1576 James Burbage designed and built a new kind of playhouse—a structure that proved most influential on the 'open stage' of

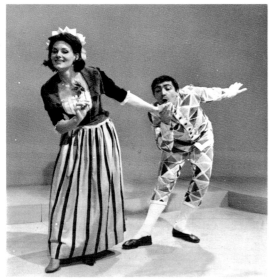

245

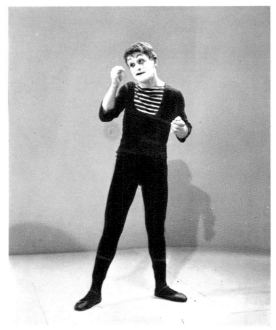

246

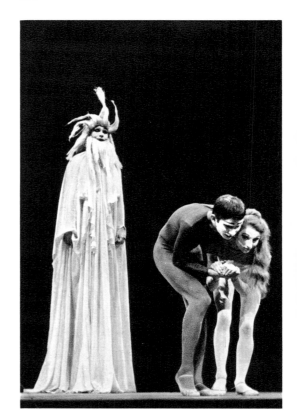

247

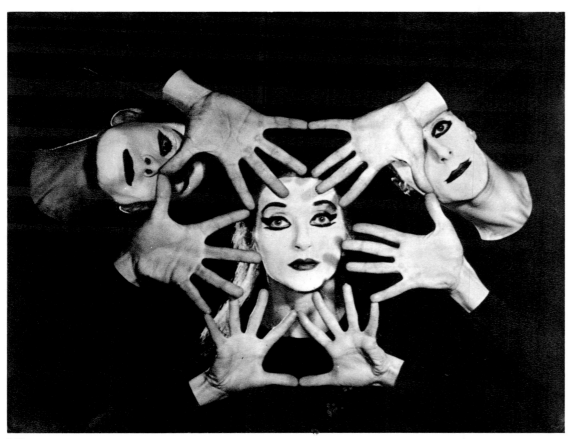

248

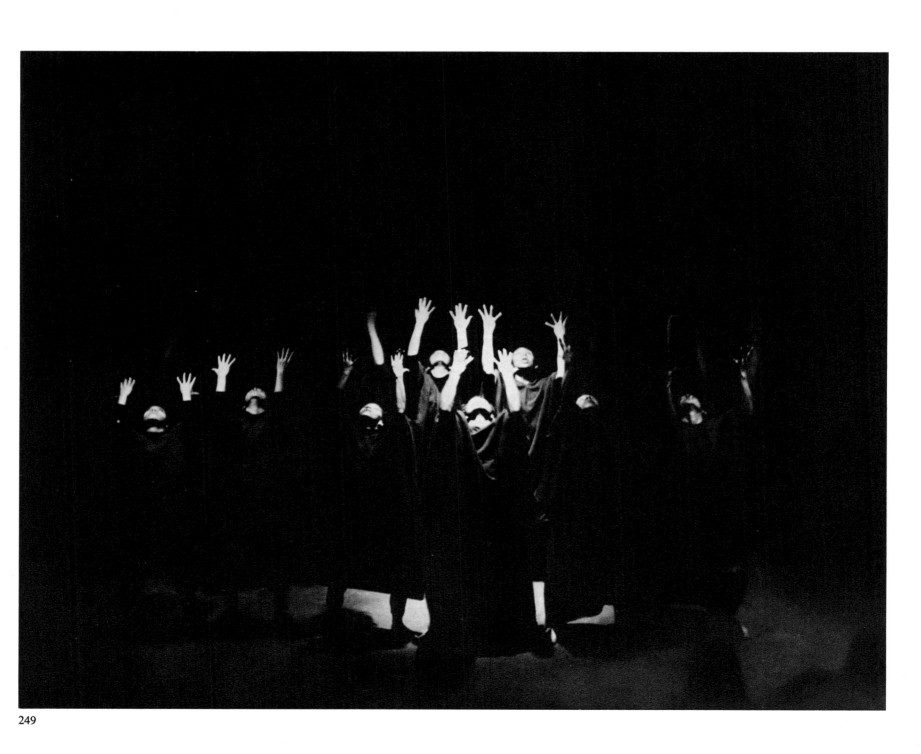

our own age. In 1587 the first great playwright appeared—Christopher Marlowe with his *Tamburlaine*. Within fifteen years, London saw Shakespeare's *Richard III*, *The Taming of the Shrew*, *Romeo and Juliet*, *A Midsummer Night's Dream*, *Julius Caesar* and *Hamlet*. Before Elizabeth died, in 1603, the work of ten dramatists of stature had reached the stage. In a quarter of a century the English drama had grown to full maturity.

Court and school contributed to the high distinction of the Elizabethan drama. The queen and her nobles accepted Shakespeare and his fellows with the same enthusiasm as the common people. And wherever a true people's theatre exists in our modern world, Shakespeare is its leading author. He was, as one of his most perceptive interpreters, the celebrated producer Max Reinhardt, phrased it, 'the greatest, the one truly incomparable boon that the theatre has had. He was poet, actor and producer in one. He painted landscapes and fashioned architectural scenes with his words. In his plays everything is bathed in music and flows into the dance. He stands nearest the Creator. It is a wonderful full-rounded world that he made—the earth with all its flowers, the sea with all its storms, the light of the sun, the moon, the stars; fire with all its terrors and the air with all its spirits—and in between, human beings with all their passions, their humour and tragedy, beings of elemental grandeur and, at the same time, utter truth'.

It has been the dream of every eminent stage director—from Reinhardt and Copeau to Granville-Barker and Leopold Jessner, or from William Poel and Tyrone Guthrie to Peter Brook and Zeffirelli—to re-create the world of Shakespeare on their stages. Shakespeare, the Elizabethan, has remained 'our contemporary' and can be interpreted, as Jan Kott so cogently does, in terms of the current theatre of the absurd.

If theatre as a social force is best if it is truthful the comic genius of Molière made a contribution to world theatre as imperishable as Shakespeare's. A social satirist of rare force, the author of *Tartuffe*, *The Miser* and *The Misanthrope*, wrote

and acted *The Imaginary Invalid* even as he was dying in 1673. This was, as John Palmer has said, 'a supreme gesture of the comic spirit—the play in which the great comedian passed from a counterfeiting of death to death itself'. No playwright has made so glorious an exit from the stage. All through his career, Molière had enjoyed the special favour of his monarch, whose attitude towards his court theatres and the Parisian public was a remarkable one. In his palaces from the Louvre to Versailles, Louis XIV provided all manner of performances for his courtiers and their ladies. But—and here he was unique among princes—the king turned over two of his palace halls, the Petit Bourbon and the Palais-Royal, to acting companies that played month after month to the general public. In addition, he gave goodly subsidies to his Italian players and the Troupe Royale, to Molière and the company at the Théâtre du Marais. No king ever did so much for the theatre as Louis XIV. Europe's first and most renowned national theatre, the Comédie-Française, is still a lustrous memorial to the Sun King of France.

The Renaissance came late to Germany. True theatre came even later. But by the end of the eighteenth century, Germany had, after Lessing, Goethe, Schiller and the promising Heinrich von Kleist, as well as the fine actor and director, Friedrich Ludwig Schroeder, Iffland, Schreyvogel—who was to direct the Burgtheater in Vienna—and August Wilhelm Schlegel, who inspired and participated in the translation of Shakespeare's plays. At that time the United States had just built its first true theatres, its stage would have to depend on English actors and their descendants for many decades, and there would be no native playwrights of real talent for almost a hundred years.

The nineteenth century was a time of change in Europe. Of all centuries, it was the century of revolution—political revolution and industrial revolution. And these movements appeared even before 1800. Political revolution began in 1776 and 1789, and it continued through 1830 and 1848 and 1871, each rebellion breeding reaction as well as progress. Industrial

revolution may be said to have started in 1765 when James Watt made a steam engine that could drive machinery, and this revolution ran a steadier course. The outcome of all these upheavals was a slow march towards political and social democracy.

The theatre was greatly affected by the peculiar nature of the nineteenth century. There was revolution in playwriting, and there was reaction, too. Creative minds sought fervently for change and betterment. Minds of another sort exploited the new audience of the uncultured who now had money to spend. Playgoers—and theatres—grew in numbers as industrial development swelled the ranks of the middle classes. The vast bulk of these new audiences was under-educated, and looked to the stage for an escape from the world in which they lived and worked. Between the years of England's Sheridan and France's Beaumarchais and the years of Ibsen and Shaw, the state of the theatre may seem, on the whole, depressed and depressing. Yet the story of the theatre through the full nineteenth century is a story of definite and important progress. It is progress that can be matched only in the fifth century before Christ, in the Elizabethan period, and in the time of Molière.

Playwrights moved from classicism to romanticism and to realism. Some few moved towards the poetic and even towards a hint of the expressionistic. Theatres increased in numbers and—more important—they shrank in size. Acting advanced from bravura display of star talents to well-rehearsed ensembles and to a natural style of acting that suited the realistic play. Science provided the stage with gas, limelight and finally the incandescent bulb. Scenery, along with costumes, became historically accurate. The stage gave up wings and backdrops and achieved the realism of the box-set. At the same time, theories of more imaginative staging developed.

The nineteenth century gave to the stage the realistic play and its fourth wall. The twentieth century provided settings and lights that were far more beautiful and expressive than anything the theatre had known before. The new stagecraft—as this movement came to be called—made over the production methods of the theatre of the civilized world. Also, it enabled plays to be written in new ways. It made the realistic drama more illusive, but it also helped the writer to develop a very different technique.

It was the Englishman Edward Gordon Craig who recognized that the theatre is a synthesis of many arts and many skills. It is not merely the play or acting, scenery, lights, music, movement or dance. The theatre, he felt, was all or many of these things. From this thought, he moved on to the ideal conception that one man and one man alone must create all these things. So was born the *régisseur*, the stage director as the controlling force of the modern theatre. It was Austrian-born Max Reinhardt who came closest to Craig's ideal. Reinhardt, who had begun his fabulous career of nearly four decades as an actor, combined the widest possible range of theatre talents. Through his epoch-making act of breathing new life into classical drama and infusing contemporary plays with poetry and import, he accomplished what every one of his contemporaries and the best of his successors tried to equal or strove to excel.

If we summarize the chief elements of the new stagecraft as established by the Swiss Adolphe Appia, its earliest prophet, and by Craig and Reinhardt, we see what changes they led to in the physical side of production. First comes simplification of means and effect. A simple setting emphasizes the actor and therefore the play. The complement to simplification is suggestion. A single Gothic pillar can create in the imagination of the audience the physical reality and the spiritual force of the church that looms about Marguerite in *Faust*. Finally, there is synthesis. The production must be a clean and clear fusion of settings, costumes, movement and perhaps music, so that the acting may present the play in its fullest effect.

What Appia and Craig accomplished for the physical theatre, André Antoine, Otto Brahm, J. T. Grein and Russia's Constantin Stanislavsky and Nemirovich-Danchenko achieved, even earlier, for the drama. The unique position their so-called 'free' theatres, whether named Théâtre Libre in Paris,

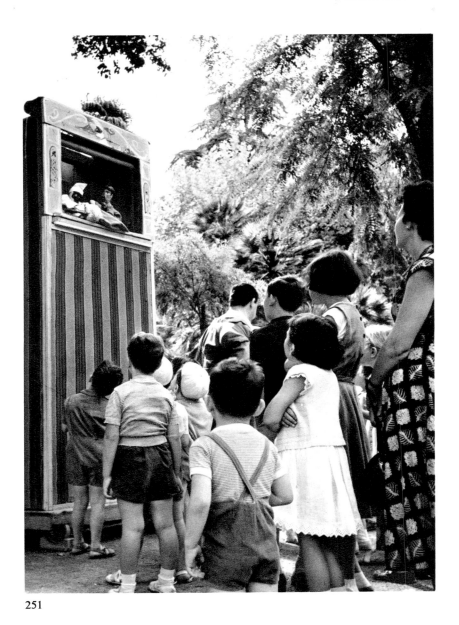

251

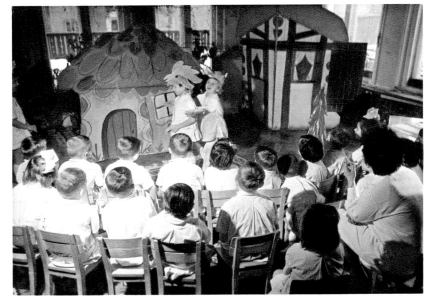

252

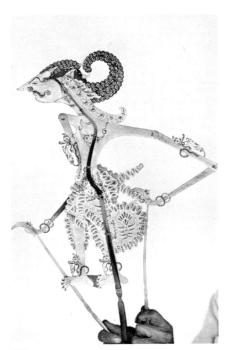

253

Freie Bühne in Berlin, Independent Theatre in London, or Moscow Art Theatre, occupy in the history of our modern theatre is due to the fact that they were, above all, playwrights' theatres. They would be forgotten today had they not given first hearings to Ibsen and Tolstoy, Strindberg and Chekhov, Gorky and Shaw, Zola and Gerhart Hauptmann. One of the giants in this group, the Swede August Strindberg, 'precursor of all modernity in our present theatre', as Eugene O'Neill named him, anticipated the demands of succeeding generations of playwrights from Bertolt Brecht and Tennessee Williams to Dürrenmatt and Albee and from Ionesco and Genet to Becket and Pinter, when he exclaimed: 'Let us have a free theatre where there is room for everything but incompetence, hypocrisy and stupidity!... where we can be shocked by what is horrible, where we can laugh at what is grotesque, where we can see life without shrinking back in terror if what has hitherto lain veiled behind theological or aesthetic conceptions is revealed to us.'

Theatre is a complicated medium; it is an organism that continually renews itself. It is certainly not a museum. At its very best, it should be in constant confrontation with modernity. In this respect theatre creates and reflects the society of an age. The theatre in our time must include, in a wide repertory, plays of protest as well as plays of conformity—and, obviously, it should not neglect the classics of the old and the new world. The contemporary drama can dictate a new style of production. In Germany, for example, after the First World War, there had emerged new indigenous plays. Most of these—all expressionistic in character—are, rightly or often wrongly, forgotten today. But it should be remembered that their influence on the theatre scene was far-reaching. Not that the State theatres or any others of the numerous subsidized and private play-houses, all of a sudden, offered a repertoire of *avant-garde* fare only. The new plays appeared regularly, even if sometimes before empty houses. But the style of a new drama invigorated the theatre so strongly that the classics were seen in a new light. This is happening in England and France today, and it is exactly what the Pole, Jan Kott, implies in his remarkable Shakespeare book. In devising an ideal repertoire for the theatre a *dramaturg* ought to be mindful of William Butler Yeats' timely warning: 'Our plays must be literature or written in the spirit of literature. The modern theatre has died away to what it is because the writers have thought of their audiences instead of their subject.'

Theatre has always been a good and legitimate companion to education. In Europe numerous highly subsidized Court, State, municipal and even private theatres have long taught by example and to this day the Comédie-Française, the Viennese Burgtheater, the Moscow Art Theatre, England's Old Vic, or the Berliner Ensemble are unequalled institutions of learning. Some of these theatres have supplied training in acting and often also in the ancillary skills of the stage. In certain European universities there were seasonal amateur productions—distinguished ones at Oxford, Cambridge and the Sorbonne—but it was only at the beginning of our own twentieth century that theatre seriously entered at least a few university curricula.

In Berlin, Professor Max Herrmann laid the foundation for a new academic discipline, the *Theaterwissenschaft*, with his lectures on theatre history which he began in the summer of 1900. For the laboratory exercises he introduced, he insisted on experiments in staging methods and, above all, 'reconstruction'—a term that still describes best the character of his endeavour—of the history of the theatre going back to the Middle Ages. As *Theaterwissenschaft* was envisioned by one man, so theatre found its way into the American university through the initiative of one college professor, Harvard's and later Yale's George Pierce Baker. It must have been quite a struggle to establish in 'that university world which now', according to Eric Bentley, 'whether you like it or not dominates American culture', theatre as a respectable academic subject. Although, as often has been asserted, the college and university programmes in the United States are unique and although in no other modern country has theatre made so

large a place for itself in higher education, they have still to formulate their ultimate goals to the full satisfaction of both the academicians and the professionals. In one phase of its activities, as a 'playwright's theatre', the university stage has made an estimable contribution. There is also evidence that it turned out many gifted performers, directors and designers. As a matter of fact, in design, in lighting, in short in physical production, theatre on American campuses has long met and matched the highest professional standards. Moreover, in aiding the theatre to maintain and advance its social function, it has steadily and conscientiously educated large and new audiences for the new theatrical centres, the resident and repertory companies, springing up all over the country. It is the establishment of such centres, with their ever growing need for adequately trained professional personnel, that has forced many universities to re-examine the position of the arts, and in particular the theatre arts, in education in an attempt to discover and to define what their role should be in the training of professional artists. Whoever learns more about theatre becomes part of the participating audiences needed to create great cultural centres.

Through a hundred centuries theatre has never died. It will continue to exist as 'a school of weeping and of laughter', as Garcia Lorca so felicitously called it and 'a rostrum where men are free to expose old and new standards of conduct, and explain with living examples the eternal norms of the heart and feelings of man'.

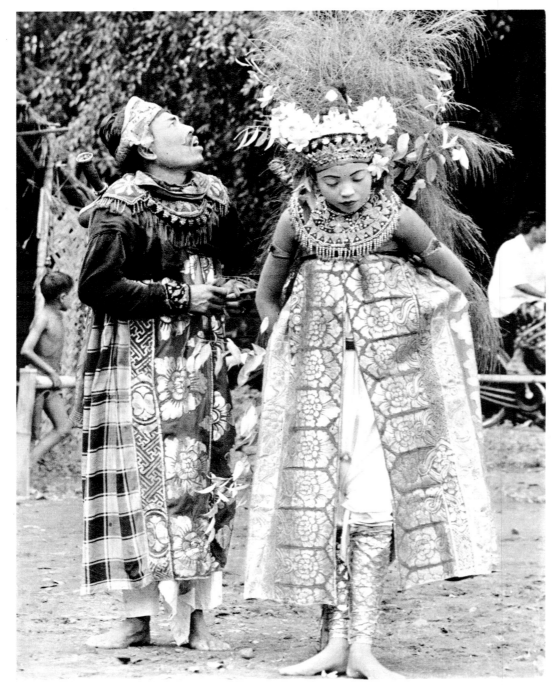

254

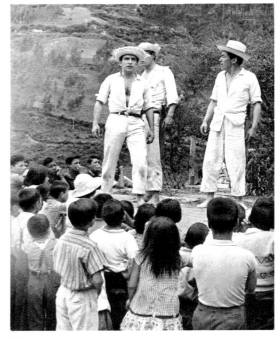

255

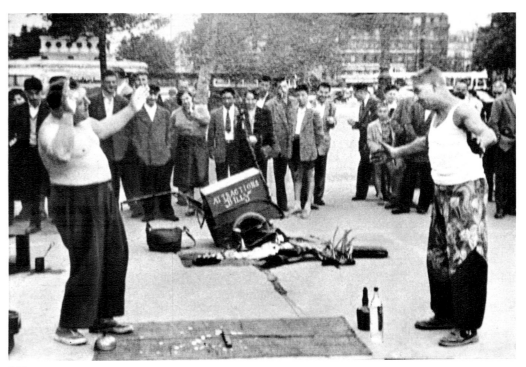

256

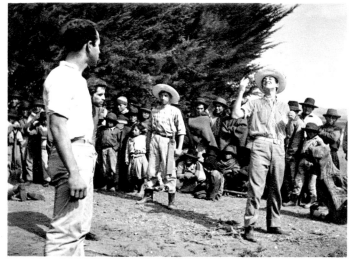

257

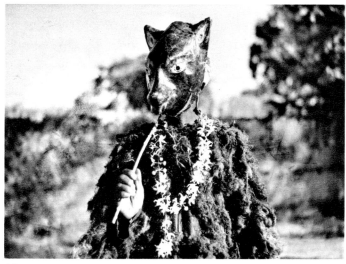

258

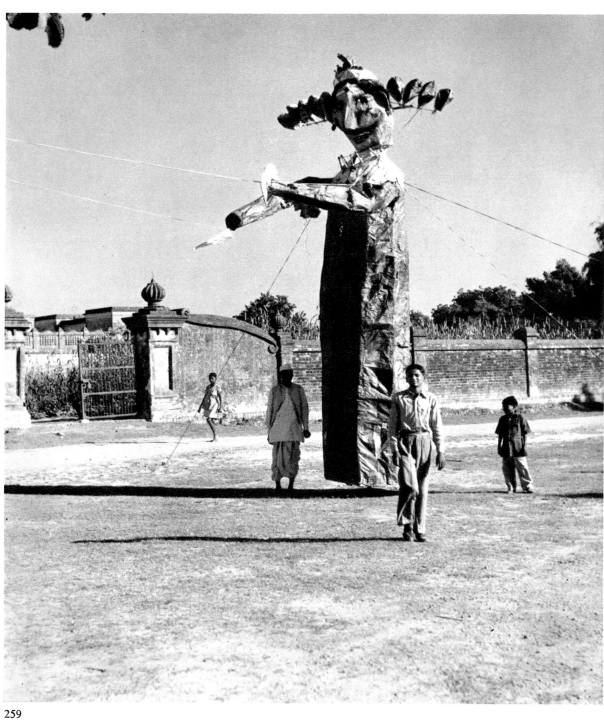

259

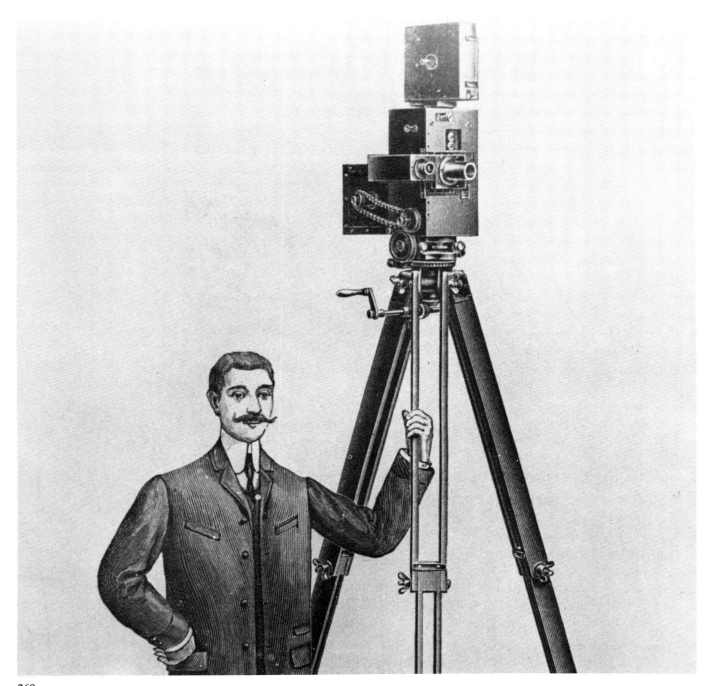

260

The cinema and our time

Grigory Kozintsev

We can never forget, in talking of films, that the head of Nefertiti, from the fourteenth century B.C., looks modern and contemporary, whereas a 1914 film—even one of the best—is hopelessly dated. Dante we can understand, and the musical language of Bach, but film dramas from before the First World War only make us laugh. The convulsive movements, the exaggerated gestures and the extraordinary subtitles—where on earth do they belong? Yet there are people still alive who wept at these dramas, laughed (and how they laughed!) at burlesque that today seems a prehistoric curiosity.

The new art grew up at phenomenal speed: a few years, literally, before films appeared that have taken their place in the history of twentieth-century culture, it was still magic lantern, an unpretentious entertainment to amuse a crowd.

An ugly duckling hatched out in a muddy street, this fun-fair attraction, this electrical gimmick, aroused not only scorn, but horror in the refined; to them the brightly lit picture palace, with its crude posters, was a presage of the end in cultural matters. A technical counterfeit, a mechanical substitute for creative art was taking over and rudely elbowing out the age-old culture of the stage. One literary critic before the First World War dismissed it as 'Hottentot art'. The situation was not unprecedented: the first printed book would have seemed horribly crude alongside an illuminated manuscript whose every capital was a work of art.

It was not easy to sort things out. Technology and commerce reigned supreme. What possible relation could there be between artists and photographers and shady businessmen, or the celluloid trade and art? The cinema grew up in disreputable offices. Attempts to instil some order or good taste in the 'miracle of the twentieth century' were of no avail. Performance by theatre artists, and the screening of classics, offered no improvement. Eleanora Duse and Sarah Bernhardt left nothing of their art on film, and the classics made poor scenarios. The theatre and literature refused to graft on film.

Soon, however, the 'live photograph' was to show that it had a character of its own: the screen could not only reproduce the action that took place in front of the camera, but transform it. Sequences shot from different angles could be put together, incidents simultaneously occurring in different places could be cut and edited, giving the cinema a power of expression unheard of in the theatre. The speed and variety of changes in plane, rapidly switching viewpoints, and the virility of movement, in time and space, filled the screen with life.

This concentrated speeding-up has something in it of the rhythm of traffic or of modern sport.

No one bothered about content. Psychological drama and literary plays had as yet no place in the cinema, but popular shows were easy to make. Circus, music hall and boulevard entertainments paved the way for the first comic films: melodrama came into its own in the films of Griffith; and it was largely the Wild West and pioneer folklore that produced the Western. But these were only sources. The camera brought to everyone a wider range of vision, the modern dimensions of visual reality. However primitive the subject or naïve the character on the screen, it was filled out and realistic. Life itself, so to speak, confronted the spectator and, through the eye of the cinema, he could regard the world.

It was an eye that looked only at the surface. It was always on the move, constantly seeking variety. The show began with a newsreel. On the electrobiographer's dirty and often patched canvas, kings and presidents, military parades, floods and fires were shown, photographed in many countries. Next a travelogue: somewhere in Norway, fishermen drawing in nets out of the sea, or a smoking volcanic crater. Then a comical figure careered along the streets playing the fool, policemen with improbable moustaches shot past in a car, custard pies landed in faces, a fire brigade drenched everyone with water.

Spectators everywhere were horrified when the villain (vilest of villains) pursued the enchanting heroine (purest of maidens), and the struggle between snow-white good and coal-black evil went on in express trains, submarines, the back streets of great cities and the roofs of skyscrapers.

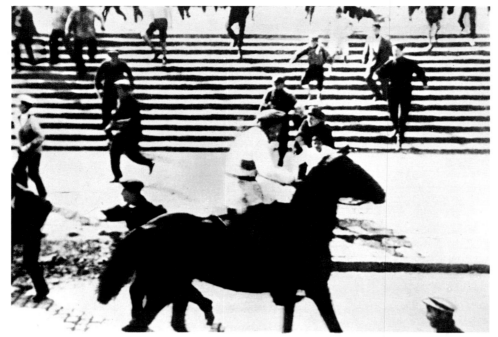

261

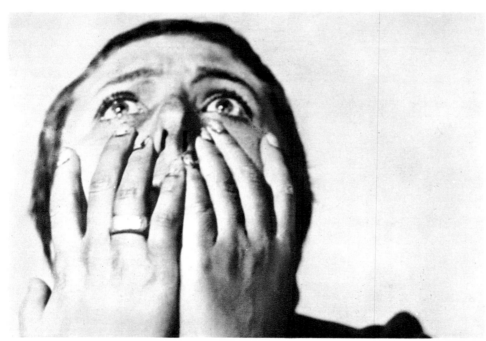

262

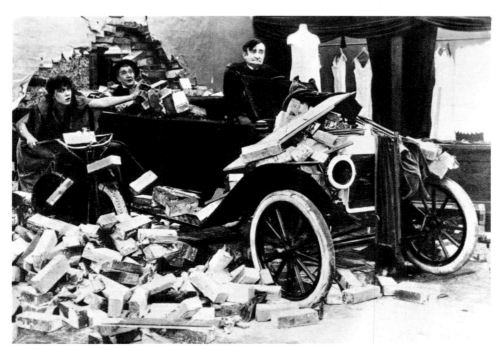

263

264

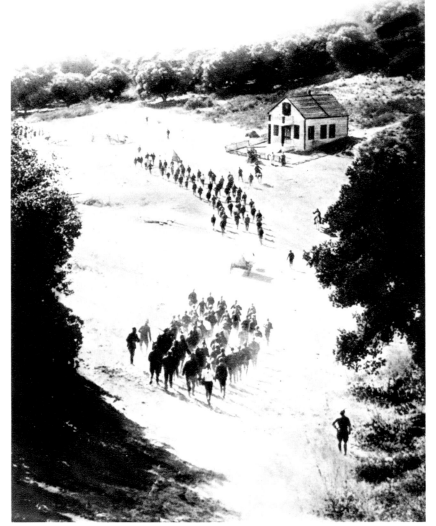
266

270

271

265

267

268

269

The world was being brought closer. For the moment, it was only the limited, external world of parades and sensation, with a folklore kin to the cheap story serialized in the big dailies, but the action could take place in the city streets, away up in mountain passes, or at the bottom of the sea. The twentieth century had conquered space.

For a few pence, a whole world could be seen in half an hour. The journey cost less than a theatre ticket. Democracy was a characteristic of the cinema, organic and built-in, for it was within everyone's reach.

Films entered people's lives and lived alongside them, not only providing entertainment, relaxation and aesthetic satisfaction, but becoming part of reality itself, related to life more like a newspaper than an art. People do not read a newspaper as they do a book, but glance through it, picking up a few facts and ideas at the breakfast table; an occasion for laughter (cartoons, topical satire), horror (murder stories and accidents), and the latest in sports records and fashion. The influence of films grew. Boys began to model themselves on film heroes as the epitome of manliness, girls learnt to smile like actresses as well as to copy their clothes. The world had found its patterns of beauty and behaviour.

It was soon realized how very profitable the new type of entertainment could be. The days of amateur cinema passed, film production went on the conveyor belt. Gone was the artless poetry of the first films of Georges Méliès and Louis Feuillade. And with expansion, as in all industries, came standardization.

For the film industry the speed of expansion was unprecedented, but the development of the art of the cinema was something distinct from the growth of profits and the acquisition of technical skill. In certain films, despite the mass production, the director's personality triumphed, and it was at this point that the concept of the cinema changed and became far more complex. The screen was already entering people's lives in a different way. The film was suffused with the thoughts and feelings of artists, and the screen reflected the real lineaments of our life and times. The cinema became the eye of mankind, turned upon our own age.

Since the early twenties, the cinema has been fighting the cinema—or to put it more precisely, the cinema as art has been struggling against the inanity of the mass product. Directors in different countries have experimented in their own individual ways, but all have been united in their contempt for celluloid standards and in the quest for a film language capable of expressing modern life, its outward features and its spirit. Art threw off the commercial yoke to become an expression of man's spiritual development.

A new relation developed between screen and spectator that no longer depended on elementary dynamics. Films were made which could not simply be looked at—they had to be watched. The cinema began to demand the spectator's full attention. The art proved to have unexplored potentialities. The laws based on box-office takings were by no means irrefutable and might be abrogated.

Charlie Chaplin—one of the founders of the art of the cinema—tells us in his memoirs about his clash with a Hollywood producer who had worked in films from the earliest days. He cut out everything in Chaplin's film sequences that the latter thought effective. The discussion developed into a fight. The experienced producer, incensed at the presumption of a novice, said Chaplin did not understand the first thing about the cinema; pace was everything, he shouted; success depended on the speed of the final chase.

Chaplin says that, however little he might have known about the cinema, he was already convinced that nothing counted more than the actor's individuality.

The point at issue was a far deeper and more serious one than might appear at first glance. It was not a matter of the relative merits in film production of 'tempo' (editing) and the 'actor's individuality' (acting), but something more fundamental—the nature of cinema, the lines along which it was to develop and the actor's role in it all.

Mack Sennett, the king of comedy, with whom Chaplin

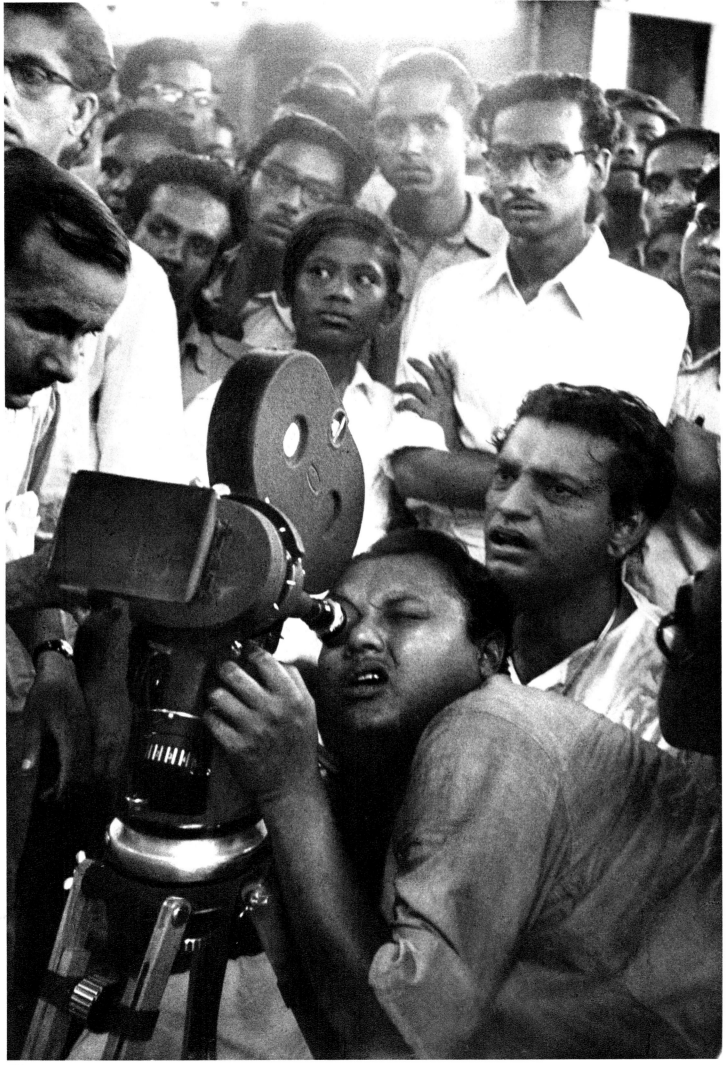

273

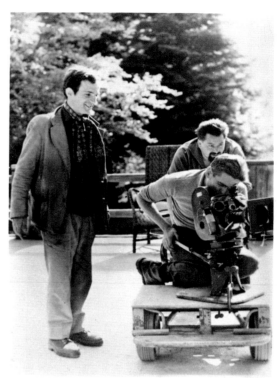

274

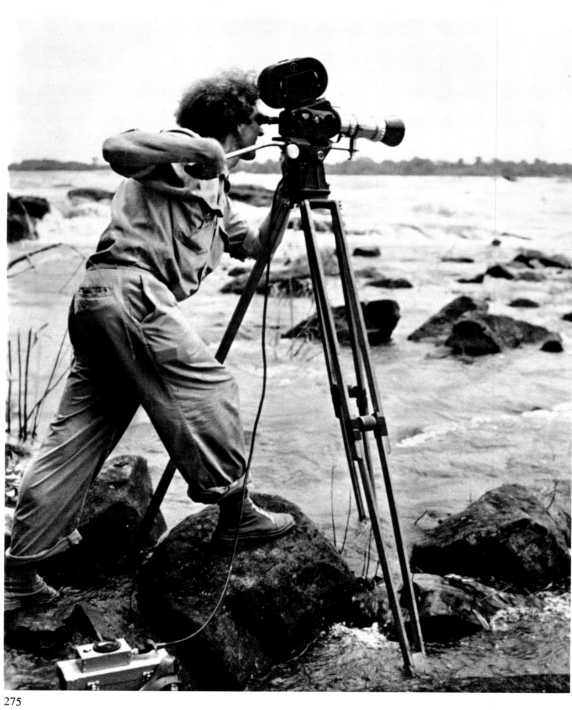

275

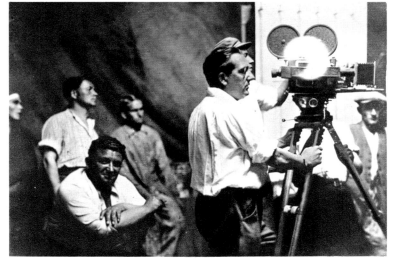

276

277

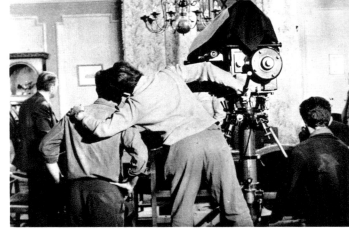

278

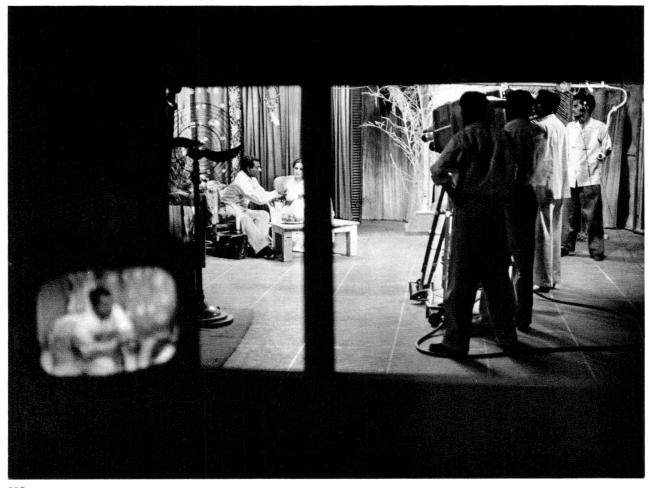

279

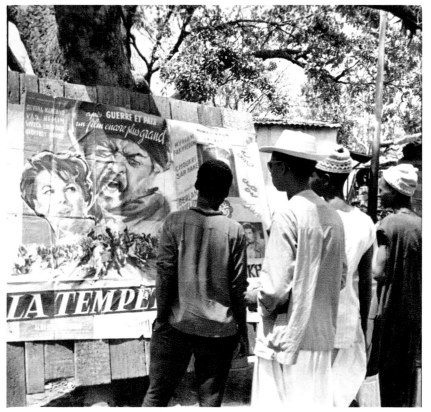

280

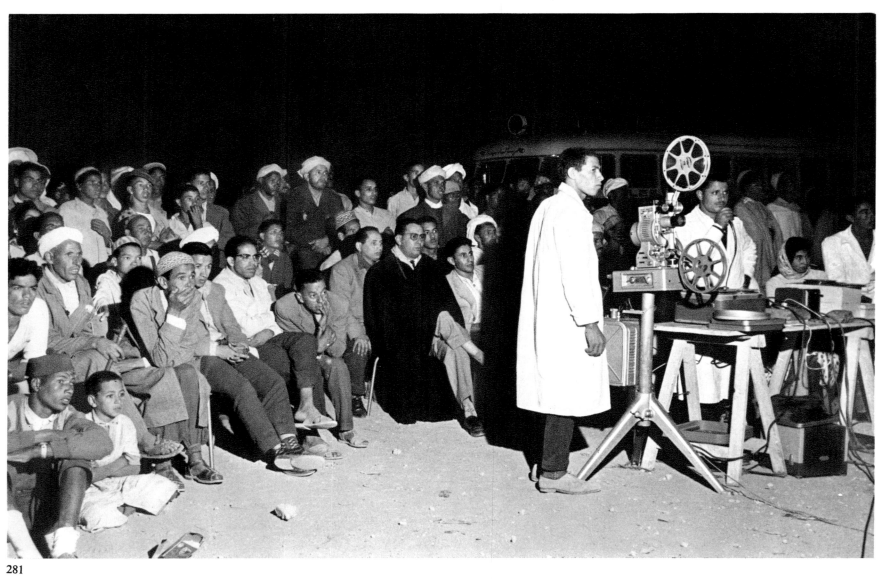

281

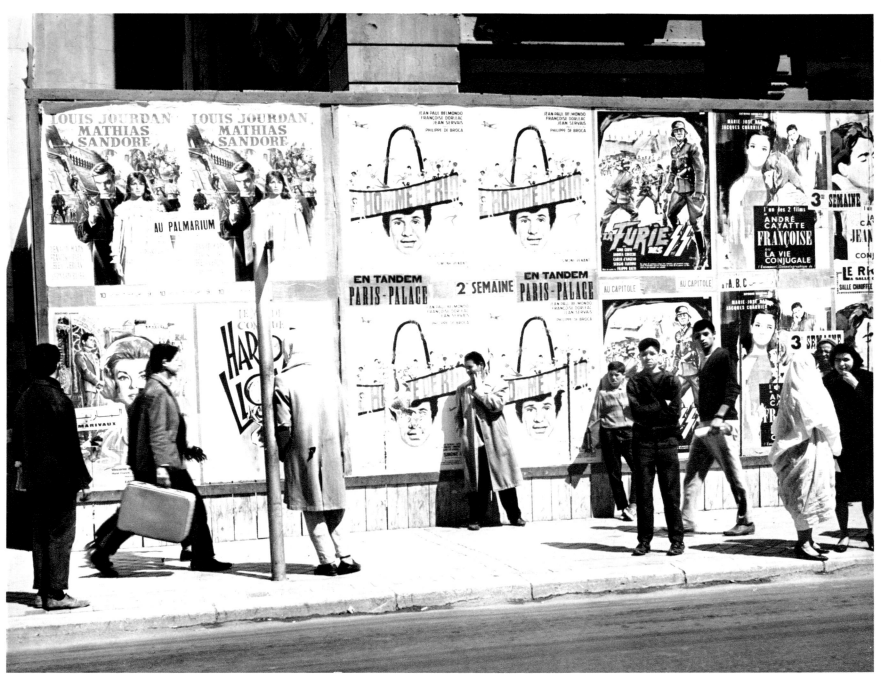

282

first worked, though a producer gifted with both fantasy and humour, could not outgrow the beliefs of his day about the cinema. Yet times were changing. People now expected from the cinema, not only the excitement of brawls and topical comments, but the mirror of their own lives, thoughts and feelings. As the industry developed, artists protested more and more against its clichés. The duality, the contradiction inherent in the very nature of the cinema (being both industry and art) was not disappearing but, on the contrary, becoming accentuated. At every stage, the old battle flared up again with renewed bitterness.

In 1923-24, Eric von Stroheim produced *Greed*, based on the novel by Frank Norris. In the interests of realism, he decided not to shoot the film in the studio, and the action took place where the events occurred—in the streets of San Francisco, in real restaurants where trams, cars and the passers-by could be seen in the street outside. The final episode was shot in difficult circumstances, during an expedition in the desert. The film met with bitter opposition from the conventional cinema. Spectators, as Stroheim said, were weary of cinema sponge-cake, their stomachs were ruined with saccharine.

Stroheim loathed prettiness and sentimentality. He explored the nature of greed, which turns human beings into animals. His characters—starting off as decent people—go crazy when the heroine wins a large sum of money in a lottery. The pretty girl gradually becomes a horrible, mad old woman, her husband a drunken vagrant and a murderer. Self-interest makes them destroy one another. Stroheim claimed for the cinema the right to speak seriously about important things, and not be afraid of portraying them as they really are.

The fate of *Greed* was tragic. It was one of the worst box-office failures. Nobody went to see it, even in the modified, mutilated version, and the tills were empty. As we know, few like bitter medicine.

The genuine voice of the times in a work of art does not often gain an immediate hearing, nor is it always understood when heard.

The years passed and, finally, Stroheim's film was placed among the first at the competition for the best films of all time at the Brussels World Fair. The importance of *Greed* became obvious, and it took its place in the repertoire of cinema clubs and in film libraries. Today's audiences find the picture neither complicated nor offensive.

This is not only because the methods first adopted by Stroheim are now common practice. There is, I think, a more important reason: the world has known fascism. The possibility that the humanity in man may be destroyed, and that the bestial may dominate, alas, no longer seems inconceivable. Stroheim foresaw much. Could his anxiety and abhorrence have been expressed in the conventional cinema?

Shortly after the Brussels competition, I was at the Cannes Festival, when Federico Fellini's *La Dolce Vita* and Michelangelo Antonioni's *L'Avventura* were booed and hissed by the audience.

I may add that most of the people who packed the festival cinema were not in the slightest degree upset by night-club programmes or by the covers of certain magazines on view at all the newspaper stands; their annoyance was therefore not due to moral indignation.

Even now, the cinema has barely won the right to look seriously at life, or to picture it truly. Yet the cinema's place in the contemporary world and its enhanced intellectual influence is due not to the money spent in the film industry or to the perfection of its modern techniques, but to the thought and artistic conviction that give it spiritual life.

It is interesting to note that nine of the twelve films considered at Brussels to be best films of all time were silent (the list was drawn up by cinema historians, and the jury consisted of notable directors of the younger generation) —*The Battleship Potemkin*; *The Gold Rush*; *The Passion of Joan of Arc*; *Greed*; *Intolerance*; *The Mother*; *The Earth*; *The Last Man*; *The Cabinet of Dr. Caligari*—and only three were sound films—*Bicycle Thief*; *La Grande Illusion*; *Citizen Kane*.

Any jury's decision, of course, is open to question, and

anybody familiar with the history of the cinema would no doubt have his own suggestions to make; but most of the films in the list could hardly be overlooked.

Probably the film that changed people's ideas of the role of the cinema in modern life more than any other was *The Battleship Potemkin*. Sergei Eisenstein discarded all that seemed to ensure success in film-making—a scenario based on a story and 'star' performances. He showed that a people's struggle for justice can make film material. Historical events, in all their terrible power, appeared on the screen. Everything acquired a spiritual connotation—the sea, the ship, the candle in the hands of the dead sailor. Such feelings as tragic compassion and pathos, lost for a century, reappeared in art. Film images became huge, living frescoes.

The cinema no longer just entertained: it startled. This art has now not only entered into contemporary life but, without losing its mass appeal, has become part and parcel of our culture. Film cans make light luggage; in a few hours they can cross frontiers by aeroplane. And while a film is a work of art, it is not only the artist who speaks to the audience but one people which speaks to another. Akira Kurosawa brought Japan to Europe; Satyajit Ray has enabled people in many countries to know India better. The spectator today follows a wholly different route. The film paints a chronicle of the times. People see new generations arriving and the old fading away, they see the unravelling of past and the genesis of future tragedies. Seeing both themselves and their age, they come to know more of both.

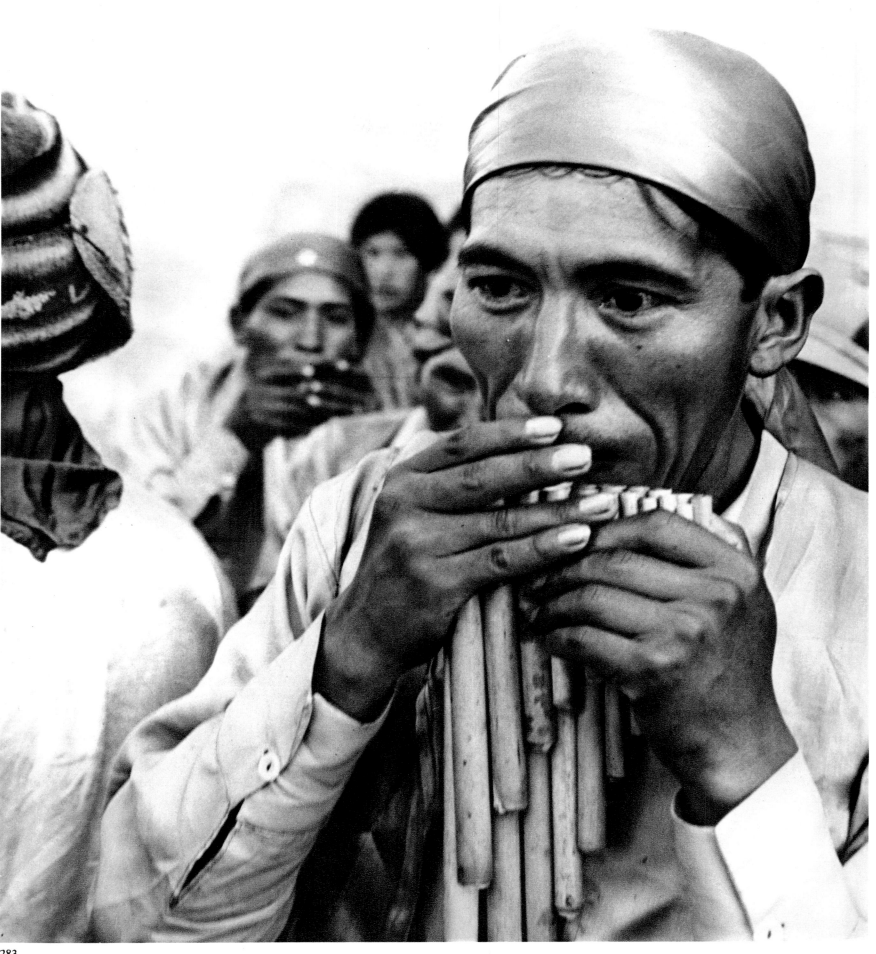

Chapter IX

Music and
the nature of its contribution to humanity

Yehudi Menuhin

Music creates order out of chaos; for rhythm imposes unanimity upon the divergent, melody imposes continuity upon the disjointed and harmony imposes compatibility upon the incongruous. Thus as confusion surrenders to order and noise to music, and as we through music attain to that greater universal order which rests upon fundamental relationships of geometrical and mathematical proportion, direction is supplied to mere repetitious time, power to the multiplication of elements and purpose to random association.

It is no wonder that ancient sages sensed music in the movement of the heavenly spheres. Thus the fundamental relationship of one-to-one, as man to woman, or *yin* to *yang*, finds its audible rendering in musical form: exposition-recapitulation, a form which gradually extends around its seed to produce and embrace a content—the development section.

The more rapid frequencies find their musical counterpart in the tidal (as it were) increase and decrease in volume and in the contrasting characters of the musical elements. The physiological frequencies of breathing and pulse, of pressure and relaxation, of work and rest, find their musical counterpart in the basic pulse and counter-rhythms, in the rise and fall of a phrase and its interweaving counterpoint, and in the increase and decrease of tension. The faster frequencies of pitch and the simultaneous sounds and the changing relationships of notes at different pitches affect us deeply and irresistibly as they penetrate and reveal the subconscious and the intangible.

For only musical sound can communicate the intangible, the yearnings, aspirations, the sensations and moods of life; our other senses reveal the presence of palpable objects and by the same token limit our vision, except as our mind and experience reinterpret them.

Music almost can be and almost is an immediate revelation requiring little interpretative effort on the part of the initiated and submissive listener.

Sound waves can penetrate more deeply our subconscious, can more profoundly affect our emotions, than any other impressions. Man's ultimate leap, when approaching his God, is through music; man's ultimate release of exuberance can again be through music, from drinking songs to dances; he marches to war with blood-curdling drums in Africa and driving brass in European civilizations; he falls in love to music. Music serves the shepherd, as a companion in his solitude or to communicate with other shepherds, as it does the Tibetan lama, or the sovereign of England, to solemnify great public ceremonies. Through music we share and become part of all great occasions. We are welded into one group sharing one another's sense of sorrow or exhilaration.

Music can also reveal more penetratingly the nature of peoples alien to each other: our understanding, for instance, of the African temperament and character has come about more through their influence upon our daily music than through any intellectual, social or other contact. In fact music begins where words end. It is the only medium which recalls us inescapably to that sea of creation and existence, the one infinity of which we are a fraction, but not the detached fragment we might be without music.

As humanity reaches out to this infinity, endeavouring to understand and, perhaps unforgivably, to control it, it finds itself ensnared in a trap of its own making; for it is the very faculty of rational enlightenment, that very reason which reveals the unity of which we are a part, that, for lack of another unspoken awareness such as faith or music, could sever us from that same unity. For even reason, the most objective of all our gifts, is itself only a part of life and cannot engage or subject within its realm the living motives that lie outside its scope. To quote Pascal: '*le cœur a ses raisons que la raison ne connaît pas*'—and Pascal's *cœur* comprises for us today not only heart but the subconscious memory of each moment of mysterious evolution and history. Music is the river bed which can guide and contain this powerful and eruptive flow coming from our subterranean levels of consciousness, a course which unites us with that ocean I speak of.

It is a wry commentary upon our age which has so lavishly produced such fruits of reason as the myriad scientific

153

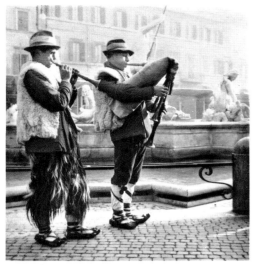

284

285

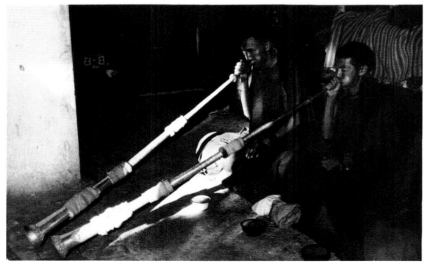

286

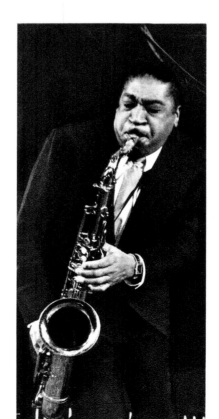

287

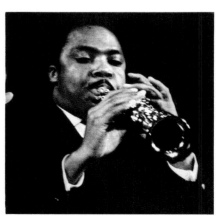

288

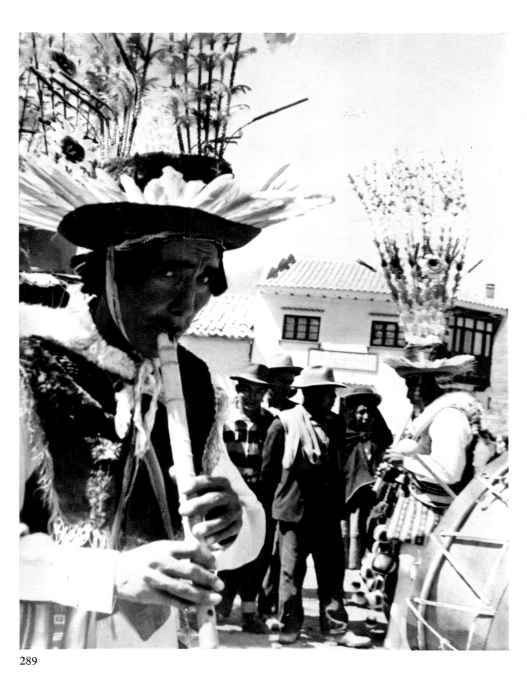

289

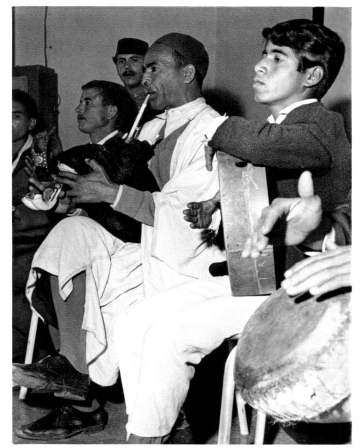

290

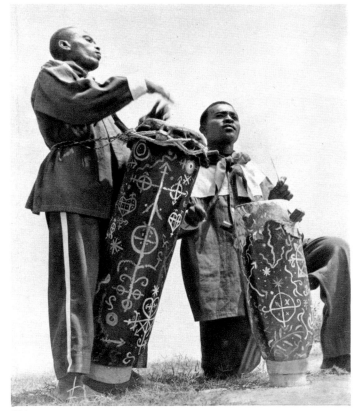

291

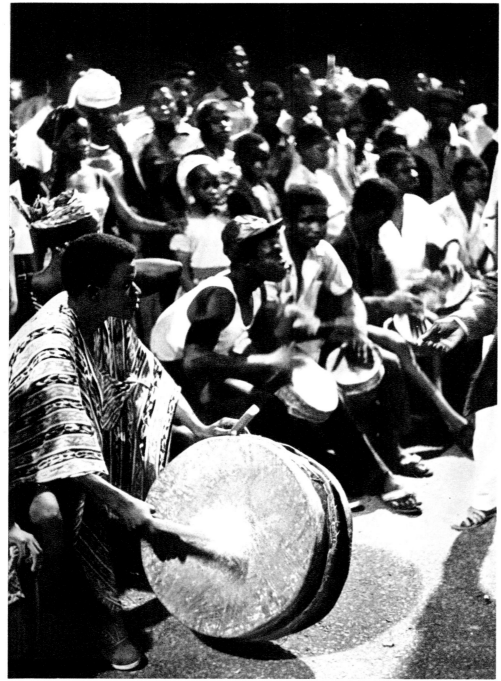

292

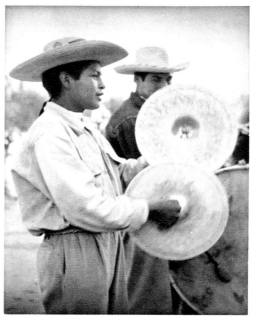

293

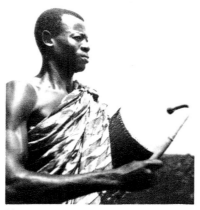

294

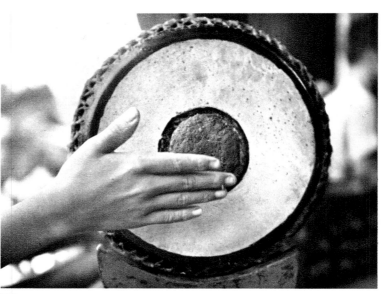

295

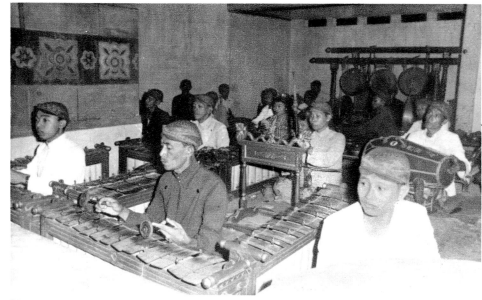

297

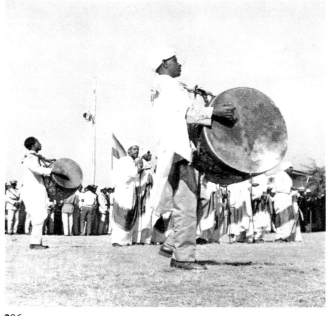

296

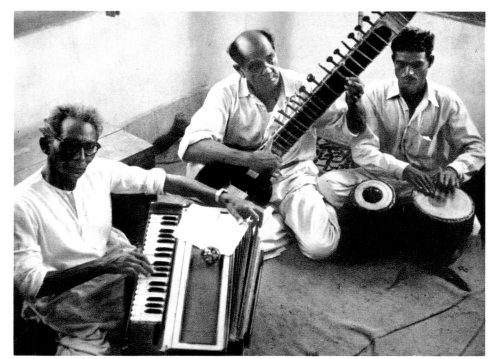

298

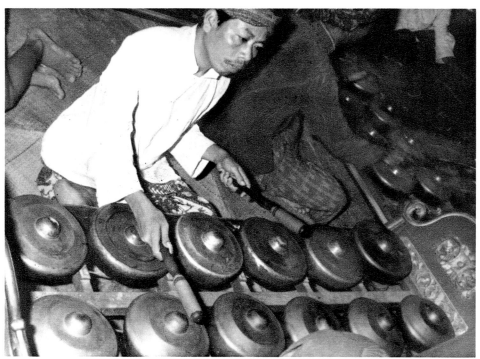

299

disciplines, their tangible practical results in terms of power, means of communication and methods of multiplication, that the supreme fruit of reason (and heart) has so far eluded humanity at large, a balanced human being in a balanced society. It should however be no wonder, for it is the very arrogance, the apparent omnipotence of limited reason which refuses to recognize, to come to terms with and genuinely to embrace, its counterpart—the heart as I described it.

Only that person who serves his muse, who serves music (and today this no longer has an exclusive connotation but must embrace music of many different cultures past and present), only the one who can translate and transfer the code of deep musical experience into commonplace behaviour, into the reactions and reflexes of daily life, can find his own thoughts and actions, both towards himself and towards his fellow man, influenced in the direction of self-discipline, towards a form of aesthetic morality and a more penetrating understanding of himself. Setting 'art' up on a pedestal, without suffering for and by her, belonging to her, must remain both morally and socially an utterly useless pursuit.

Today, when the human being, like human society, is threatened with exposure and imprisonment in a world regimented by impersonal demons of his own invention, forces economic, mechanical, social and spiritual, it is more than ever imperative to his existence to restore him to a spontaneous and complete expression of himself, preferably one achieved by himself and through his own body as in singing and dancing, one built to his own measure, serving his own biological entity, spiritual and physical, and enveloping him and his community in a protective environment of benign sensations as the silkworm's cocoon. It is for these reasons that music today, liberated and spontaneous, holds out more hope for humanity than ever before.

Every child in some one hundred schools in Hungary begins his scholastic day singing Kodály and Bartók chorales. The class read them at sight, write music on the blackboard by ear, literally 'toning' themselves up with oxygen, invigorating their whole spiritual, intellectual and psychological capacities with this daily one-hour routine. Carl Orff in Germany brings to the children there a synthesis of music, dancing, mime and words reduced to simple components which can be freely handled by the very young. Both these approaches are now spreading to England, Canada and the United States; students there are learning actually to play the sitar of India and the gamelan of Bali with expert teachers, much as they would learn a foreign language and its literature and culture.·

At the other end of this rainbow we find released the spontaneous improvisatory urge for self-expression and adventure in the various forms of impulsive sounds or noises produced by jazz groups and others using ingeniously constructed instruments varying from sardine cans to steel barrels. Out of this has grown a tremendously heightened interest in all forms of music played directly from the performer's heart and mind with no reference to the printed score, as is the case with all the music of India, Africa and the Far East, the gipsies, the village fiddlers of Norway and Scotland, the bagpipe folk songs and dances, and so on (aleatoric interludes in otherwise composed scores are an example of an effort to combine the composed and the improvised). This is a development utterly new to our world, the satisfaction, through the deeper study of our own past and of our neighbour's, of a hunger long suppressed by the tyranny of the printed word, of the superficial and rigid, of the Ukase, the Verboten, the dead hand of industrial slavery and middle-class bourgeois conformity.

No longer is it sufficient to hunt down and kill strange and wonderful animals in Africa, no longer should we wish both cannibalistically and symbolically to eat our victim's heart, or to sell it; today we begin to sublimate these urges by hunting with a camera, by learning tribal languages and communicating with birds and dolphins, by identifying ourselves intellectually, spiritually and aesthetically with those whose way of life differs entirely from ours, encouraging one another to be free and independent to express what is peculiar to each, rather than to count heads and trophies from the dead.

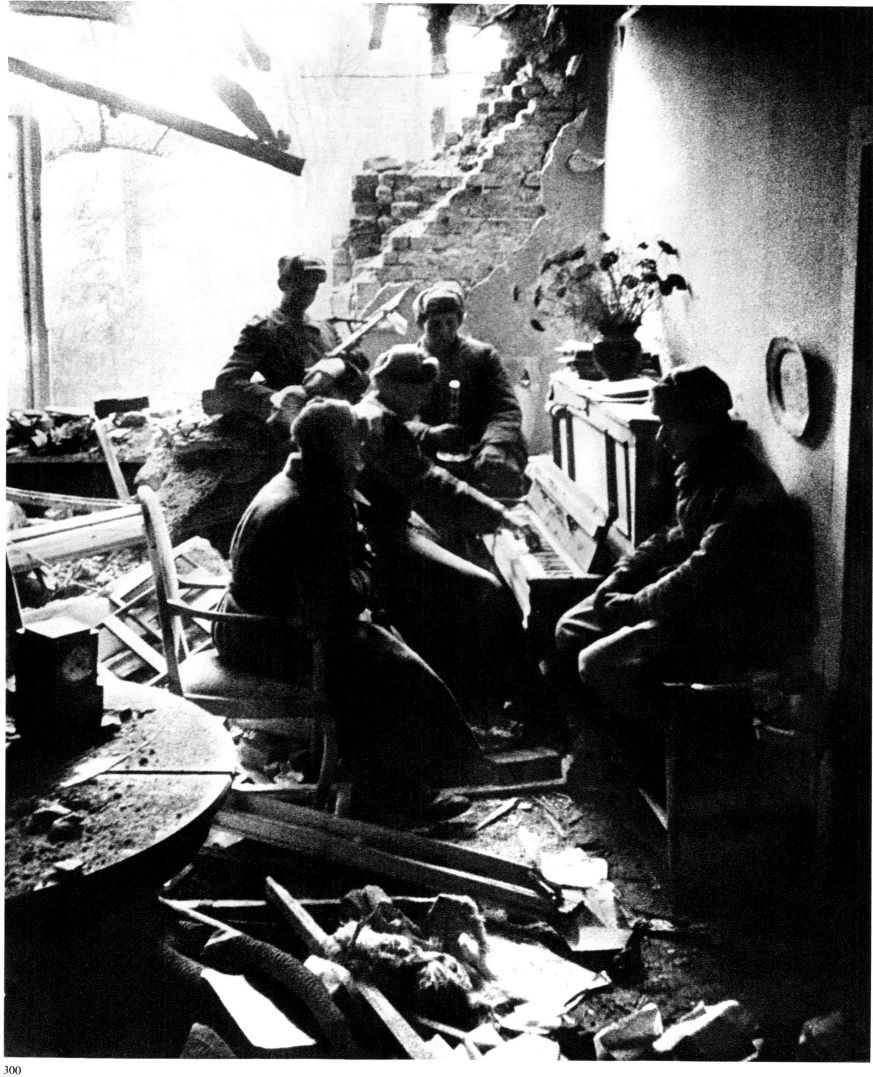

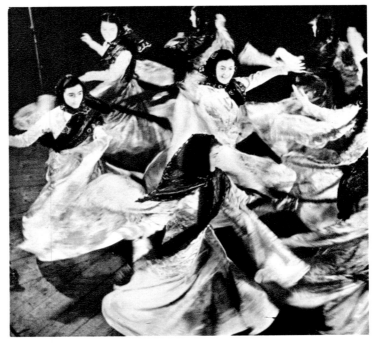

301

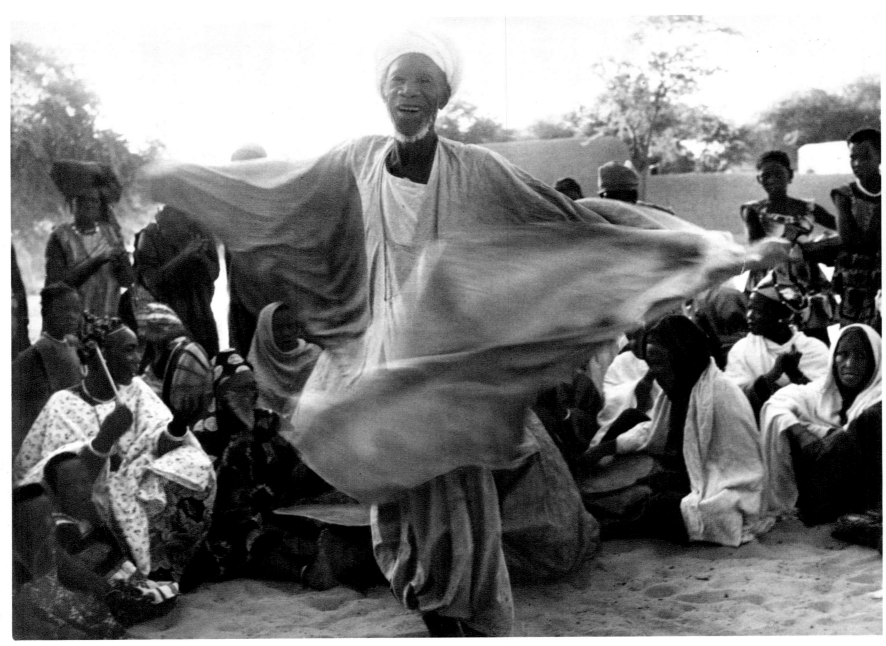

302

160

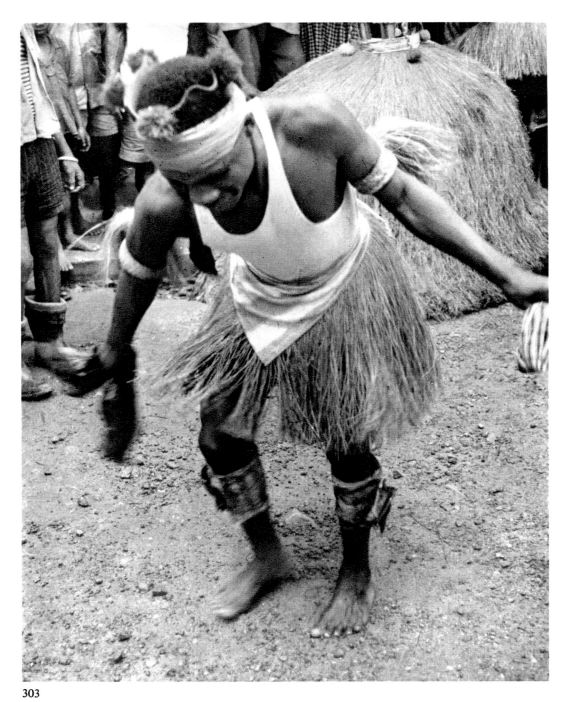

303

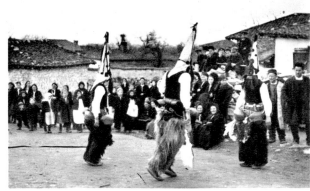

304

305

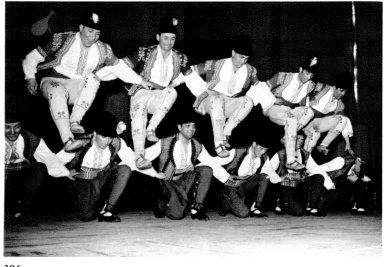

306

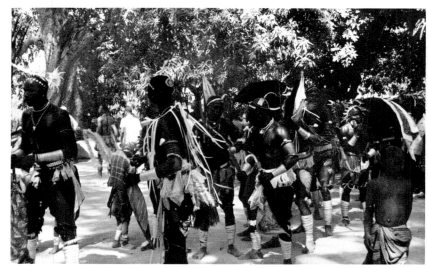

307

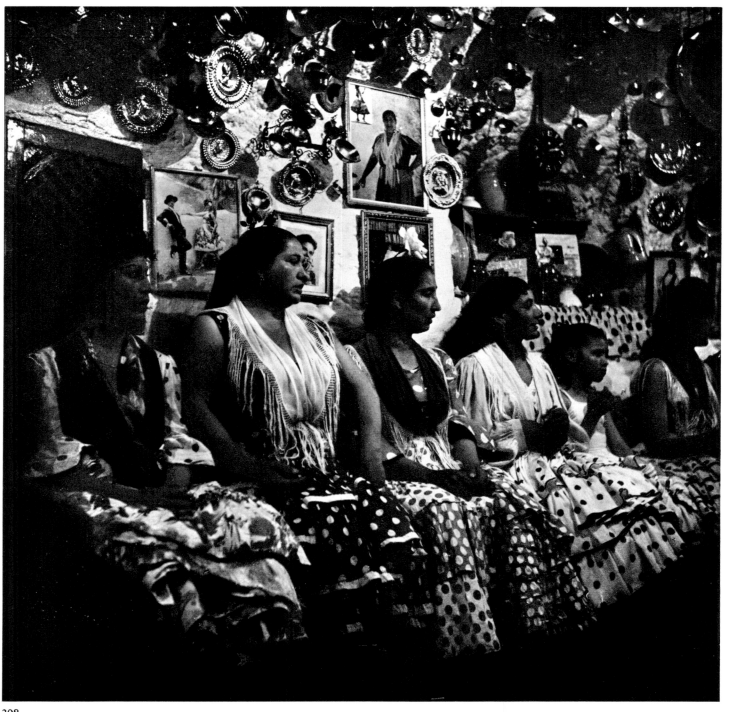

308

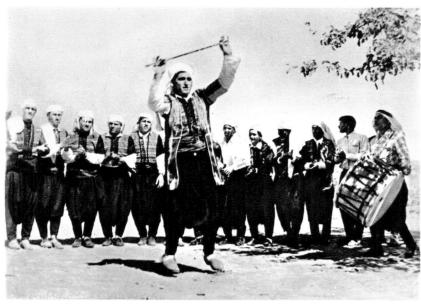

309

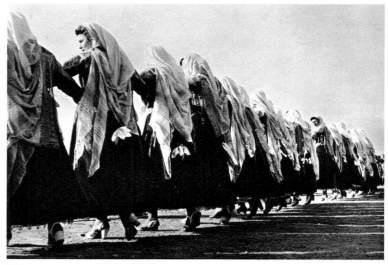

310

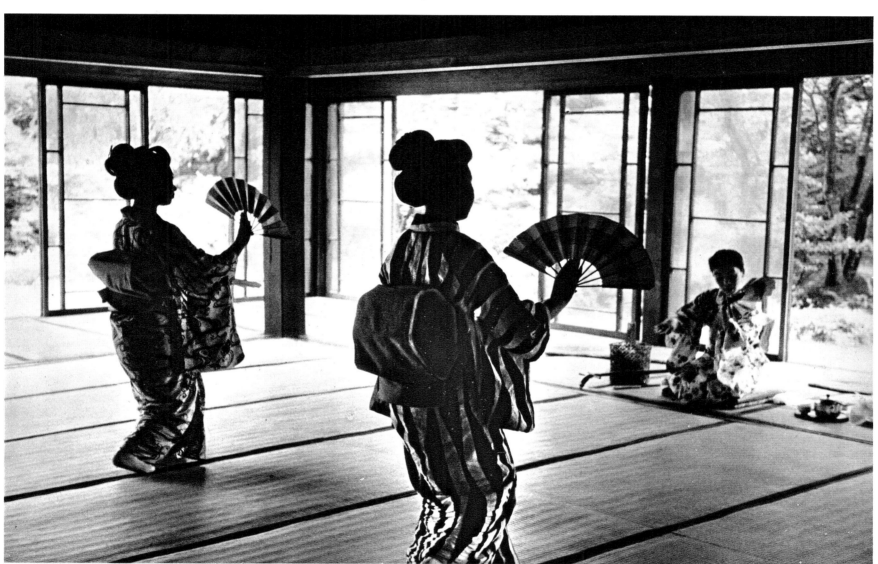

311

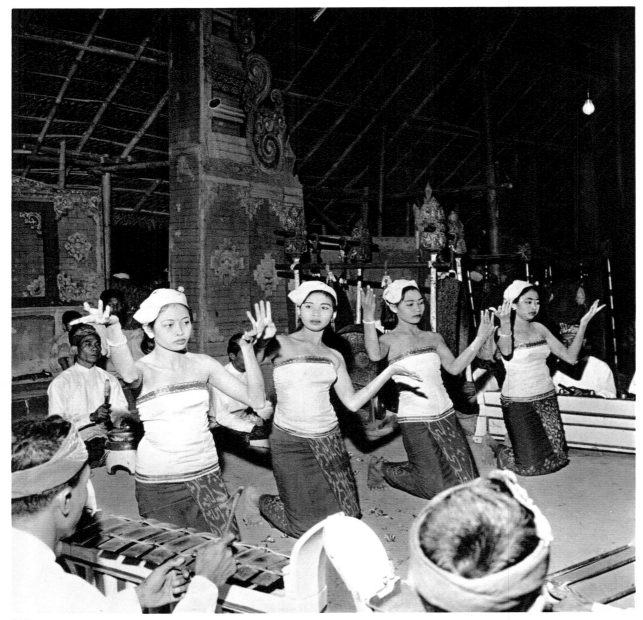

312

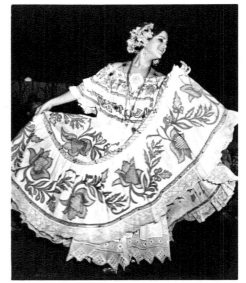

313

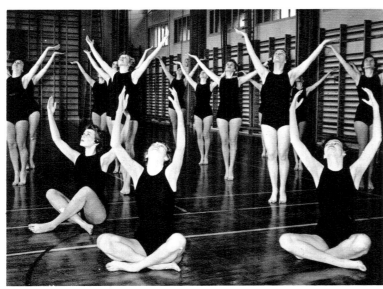

314

315

316

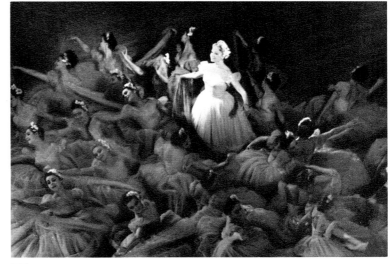

317

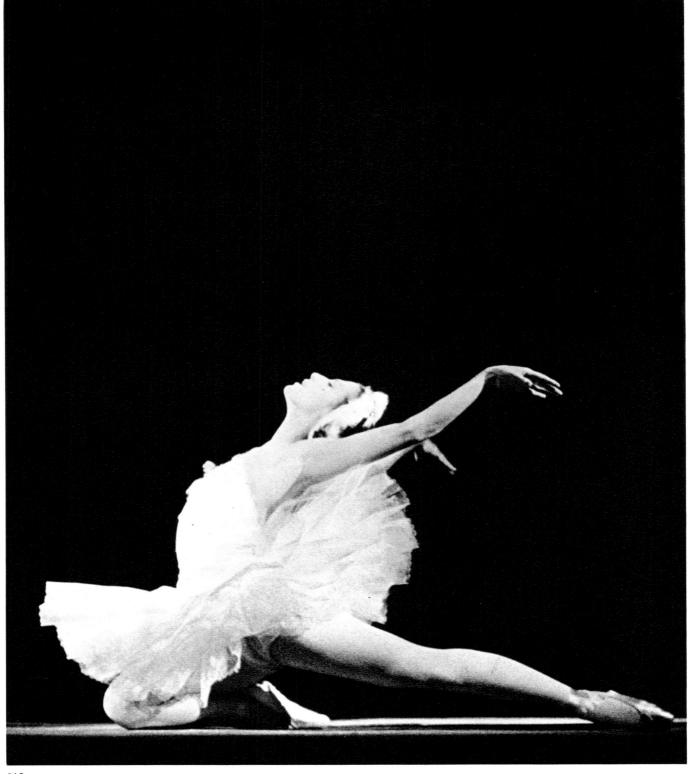

318

The urge, is the same, but sublimated. It remains curiosity, conquest, covetousness, even greed, but turned to life and not to death. This new later twentieth-century approach to music, even more than to painting, is perhaps the most promising avenue of human and humanistic evolution. I say music even more than painting, for music as sound occupies us quite literally, physically and spiritually, as it occupies time itself. As I said earlier, we are immersed in a living sea of sound from which there is no escape and which must, if well used, condition us more profoundly than might a purely visual art which is more objective.

It was no coincidence that Einstein played the violin, for 'time', as a fourth dimension, is no mere abstraction to a musician, but rather an infinite living, pulsating continuance, varied and mobile, sometimes dense, sometimes weightless, sometimes eruptive, sometimes still, its laws identical with those interacting laws of gravity, speed and weight which govern spatial phenomena. It is no wonder the ancient Greeks found music in the heavenly spheres. I wish I knew enough about science and astronomy to relate accurately, for instance, intervallic proportions and their mutual attractions and repulsions, or overtone progressions, to their spatial counterparts.

The fantastic thing about music is its ability to reflect every conceivable occurrence and situation, whether animate or inanimate, whether an infant's cry or the sound of thunder, or whether the travails of love as in a Schubert song, or of intellect as in a Bach fugue. The very quality of sound is identical with touch and it is, in fact, verbally rendered as warm, cold, silken, velvety, sensuous or dry.

How extraordinary is the paradox that music is once removed from reality, reality reinterpreted and reflected in the apparently intangible dimension of sound, and at the same time can be as immediate as a slap in the face and as voluptuous and erotic as the act of love. It can also be cold, clinical and calculating.

Above all, music is a wonderful master and mentor. For one thing, we cannot overshout it: we must listen, as in itself it is a pure exercise, it exercises a sublimating effect on the otherwise cruder urges to concretize. Therein may also be its dangerous side, for it offers a ready escape from reality. I for one believe that the musician should constantly renew and retravel the paths between a full experience of living and his isolated private muse, for otherwise the muse—his inspiration, his driving power—will wither.

Who better than a musician can span the range between the silent and the strident, between the still small voice—the softest sound we know, inaudible to everyone else, and yet inevitably the most compelling—and the overwhelming crash of destruction and resurrection?

And what of sound itself, the supreme element in communication, the uninterrupted and continuous apprehending of our environment which the aural gift ensures? It is the vibrations of sound which give birth to words, to messages of every description, and even as we read these words silently with our eyes, we are in fact listening to their remembered sound with our inner ear. Sound is indeed the supreme medium of communication, and how much more do words mean when they are restored to sound in the voice of our beloved, or a great actor, statesman or teacher.

It is the music in the words which actually lends them meaning; it is the music in our intellect, as well as in our hearts, which spells the capital difference between the dead hand of the vacant printed symbol and the living resonant communication of intent, feeling and conception. How important to the infant are the first voices and the quality they impart, for during an entire lifetime those words will carry the resonance, the quality and meaning they first possessed. Far more numerous than the words we write or even read are the words we think and dream, filling our inner ear and mind with an almost continuous babel, that private and privately audible world which memory, thought and dreams inhabit and which to our conscious existence is an unending torrent of words. What a difference it must make how these myriad words sound to each of us, for we human beings spend the greater part of our

days and nights with them. And how blessed the poet and the musician who can escape this verbal invasion and occupation by returning to pure sound and metre and by restoring the word to its original medium and dimension, that of sound, or by circumventing the word as such altogether and restoring the non-verbalized feeling and thought directly to music.

What better understanding of another people can we have than through their music? Nothing has revealed the Negro soul in its nostalgic, noble sadness—long before the torrent of words or dissertations by sociologist and psychologist—more than the Negro spiritual, nor their tribal society and collective abandon than their percussion.

What key could unlock more completely the devout and spiritual, the symbolic and exalted world of Bach than his cantatas? Can anyone penetrate the solitary, mystic search of the Indian more deeply than through the improvisation of Ravi Shankar, or understand more completely the fateful resignation of the Hindu than through the tabla beats of Chatur Lal?

We cannot afford to confuse abandoned exuberance with artistic exuberance. I knew a lady who early in life succumbed to a few of the deadly sins; she said quite truthfully: 'It is the gipsy in me.' No doubt, but a gipsy grows old nobly, bringing his people and the world the reminder of a way of life which, although impoverished, harassing and exacting, is free of office clocks and all convention and expresses itself in a characteristic and beautiful style of violin playing, which is bought at the price of the comforts and security which we hold so dear, but won through the loyalty of his fellows. Artistic exuberance only flourishes where pruning is a deliberate first measure, man's determined, self-disciplined anticipation. Only thus can art, the exuberant, enter every human voluntary act—our choice for life, not nature's choice for death.

Using oneself to the hilt, using and refining every capacity one has in achieving an expression of oneself, independently of others, but not necessarily excluding others, in terms of one's own initiative, ability and imagination, upon an object (as a canvas, a slab of marble, a piano—but in the first and final analysis upon oneself), effects a reflection, transformation and sublimation of the basic urges both of the artist and of his audience. And this effort of our senses to get beyond themselves is their sublimation; it is this release of light, enveloped in all matter (as we now know), which may replace the particular and too specific God who is apparently now dead.

I often think of the symbolic Japanese legend in which the master, while casting the great bronze bell which must resound with a sound more beautiful than any heard before, is called upon by an inner imperious voice to cast himself into the molten mass. And thus, as I tried to convey, music is an effort to express through our senses all that is within and beyond their reach. Music is a call, a union—like love—with that which, while within and part of ourselves, is also and by this same token greater than ourselves. This is why music and deep religious feeling have so often been inseparable.

A devotion to the timeless and the infinite while making the most of this moment and this place, this is a philosophy of serenity with which to release the spontaneous, as is the ability from repose to seize upon creation. I would submit that the mainspring of artistic endeavour is that ideal least likely to corrupt, to debase and to bestialize, provided it exacts its own dedication and discipline. Lucky indeed the artisan, the master cobbler working away on his bench, proud of his craft —even the armourer fashioning a coat of mail, or the master blacksmith—for such are protected to a great degree from the temptations to stray into those darker fields that are part of the great landscape of every man's artistic vision.

Our civilization is almost a vicious circle of which the driving force is denial—denial of the creative moment, the creative act. Fig leaves were perhaps the first such denial and led the way to ever more elaborate, subtle, tantalizing, deceptive and sublimating forms of art and artifice; creative art and growing consciousness always went hand in hand, not without some embarrassment. But the universal mechanical and commercial denial of the spontaneous creative impulse today

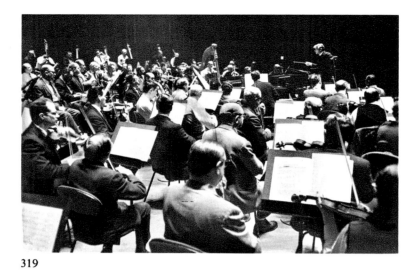

319

320

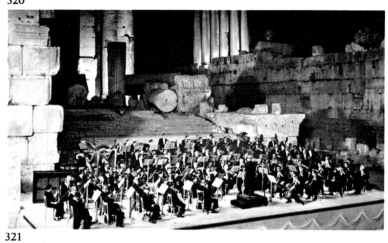

321

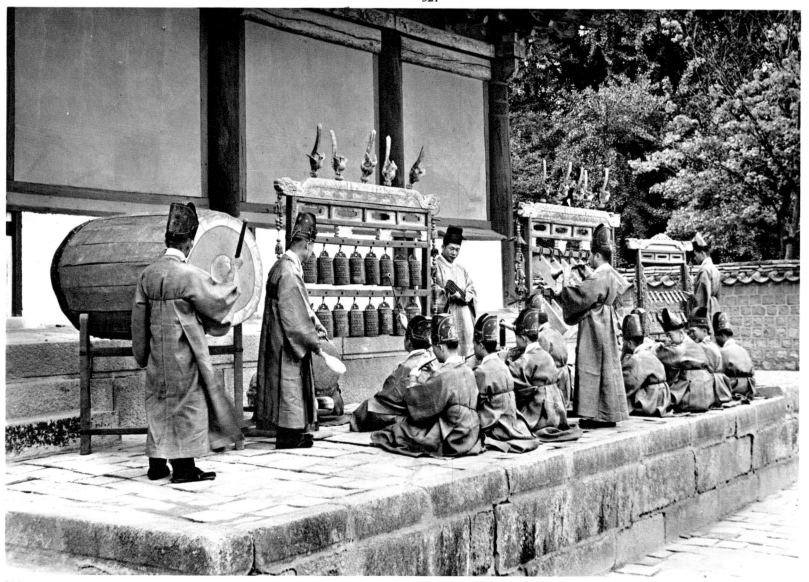

322

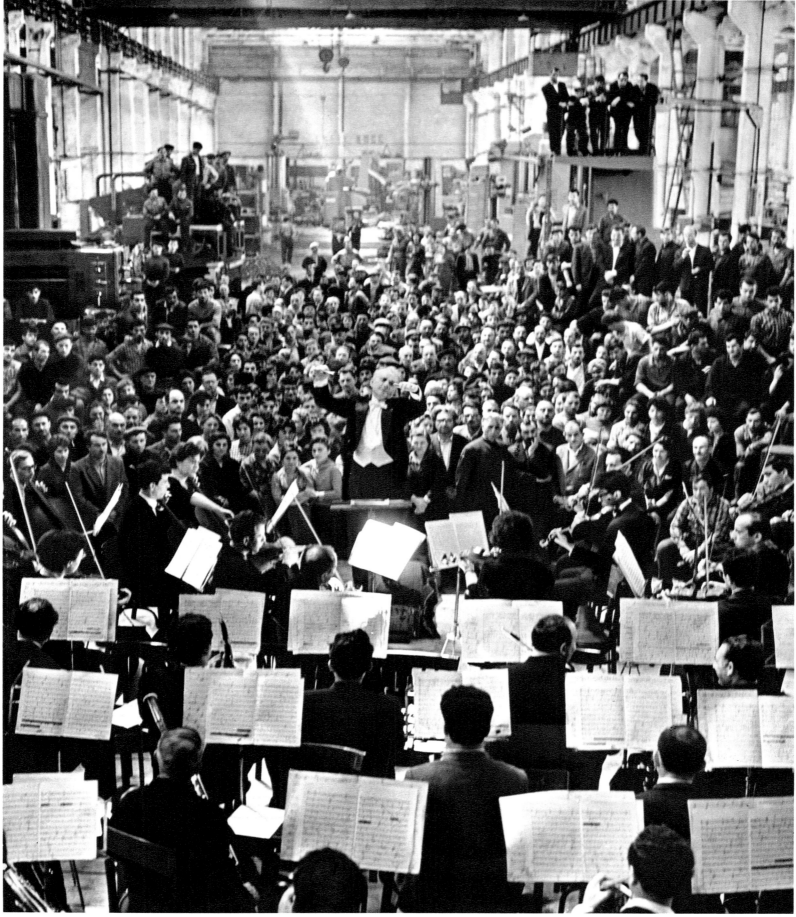

323

is precisely that device which maintains the unappeased hunger for sensation, for agony and ecstasy, for the greed which, denied the satisfaction of natural variety, requires the new fashions, the new models. It is like keeping people deliberately thirsty by polluting the sources of water to further the profits of a bar selling only bottled drinks. It is almost as if we were deliberately making life intolerably frustrating only to further the sale of appeasers and narcotics to forget and to escape, at a price. For what is new today is the conviction that it need no longer be so, that man can and must make himself and his existence more worthy of his capabilities and his dreams.

Until we can restore the spontaneous elation that comes of one's efforts with one's own capacities—upon a piece of wood, a sheet of paper, a length of cloth or leather, or upon one's own mind, as does a philosopher, or upon one's own physique as does a dancer; until a substantial proportion of our population is acquainted with the sensations of artistic endeavour, we will not successfully overcome the debasement of human values.

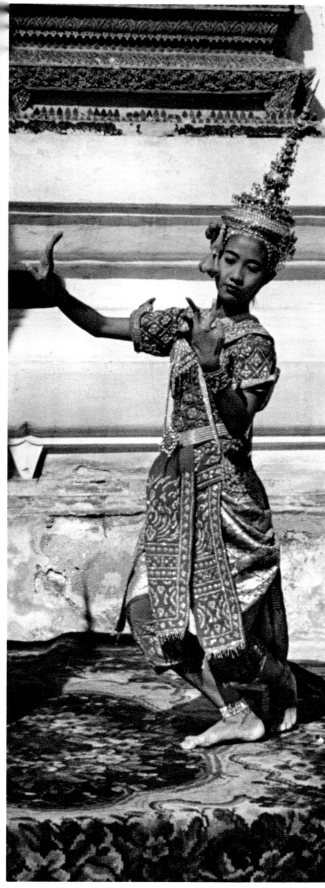

324

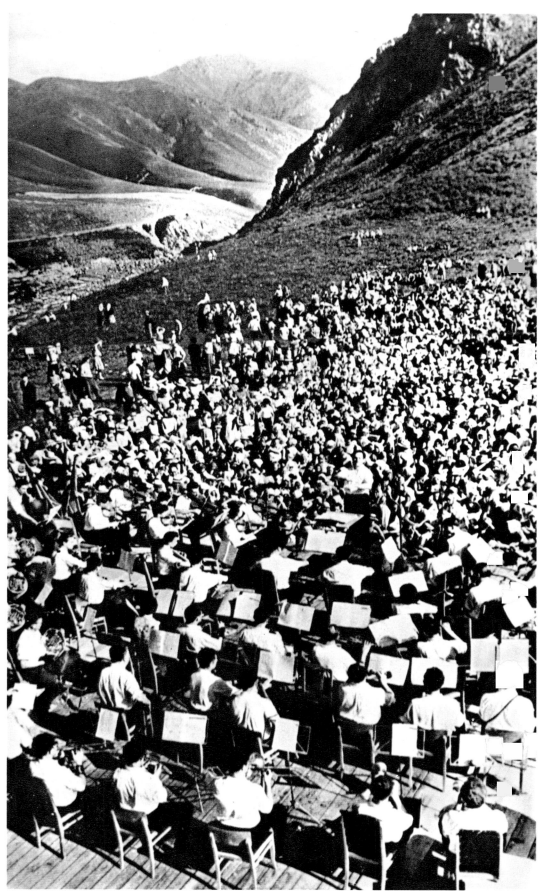

325

Captions to illustrations

III Architecture and the human requirements of our age

IV The contribution of industrial design to twentieth-century aesthetics

V The artist-scientist-inventor

VI Literature considered as a means of expression

VII The theatre and its continuing social function

VIII The cinema and our time

IX Music and the nature of its contribution to humanity

293	Mexico	Cymbalist of the village band
294	Ghana	Drummer
295	Thailand	Playing the drum
296	Ethiopia	Priests dancing to the accompaniment of native musical instruments to celebrate a *Timkat* or baptism according to the Old Testament
297	Indonesia	One section of the Gamelan orchestra
298	Pakistan	Musical ensemble using the sitar, tablas and harmonium
299	Indonesia	Kenong player
300	Union of Soviet Socialist Republics	In the ruins of a bombed house, music survives
301	Union of Soviet Socialist Republics	Folk-dancers
302	Mali	Village dancer and musicians
303	Liberia	Dancer in a village ceremony
304	Bulgaria	Dancers in traditional village festival
305	Spain	Traditional dance of Andorra
306	Bulgaria	National dance for men
307	Senegal	Villagers taking part in a ritual dance
308	Spain	Flamenco dancers
309	Syria	Traditional male dancers and musician
310	Greece	Folk-dancing
311	Japan	Geisha dancers and musician
312	Indonesia	Young dancers from Bali accompanied by a Gamelan orchestra perform at a local festival
313	Panama	Traditional Panamanian dance
314	Sweden	Students of the dance
315	United Kingdom	Dance lesson offered to the community members through the Adult Education Programme
316	Uruguay	Girls' dance class
317	Union of Soviet Socialist Republics	Classical ballet
318	Union of Soviet Socialist Republics	Classical ballet
319	United States of America	Leonard Bernstein conducting the New York Philharmonic Orchestra
320	France	Page from an early musical score
321	Lebanon	Symphony orchestra performing at the Baalbek festival
322	Republic of Korea	Classical Korean orchestra
323	Union of Soviet Socialist Republics	Symphony orchestra performing in a factory in Tbilisi (Georgian S.S.R.)
324	Thailand	Temple dancer
325	Union of Soviet Socialist Republics	Music festival staged in a natural setting

Photograph credits